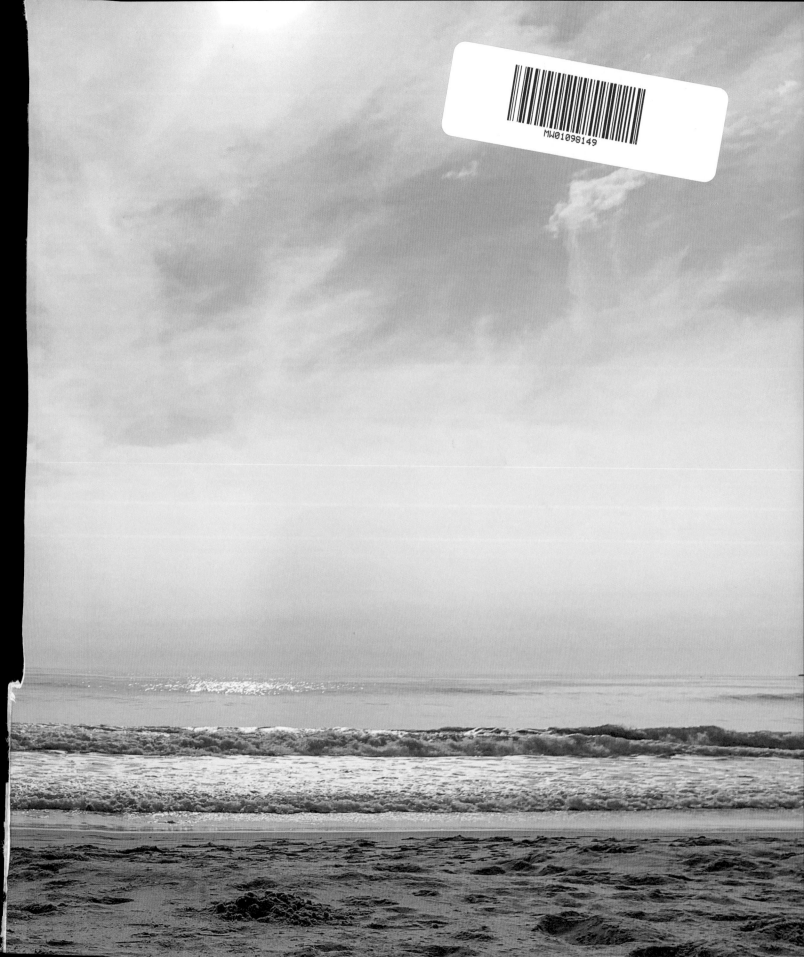

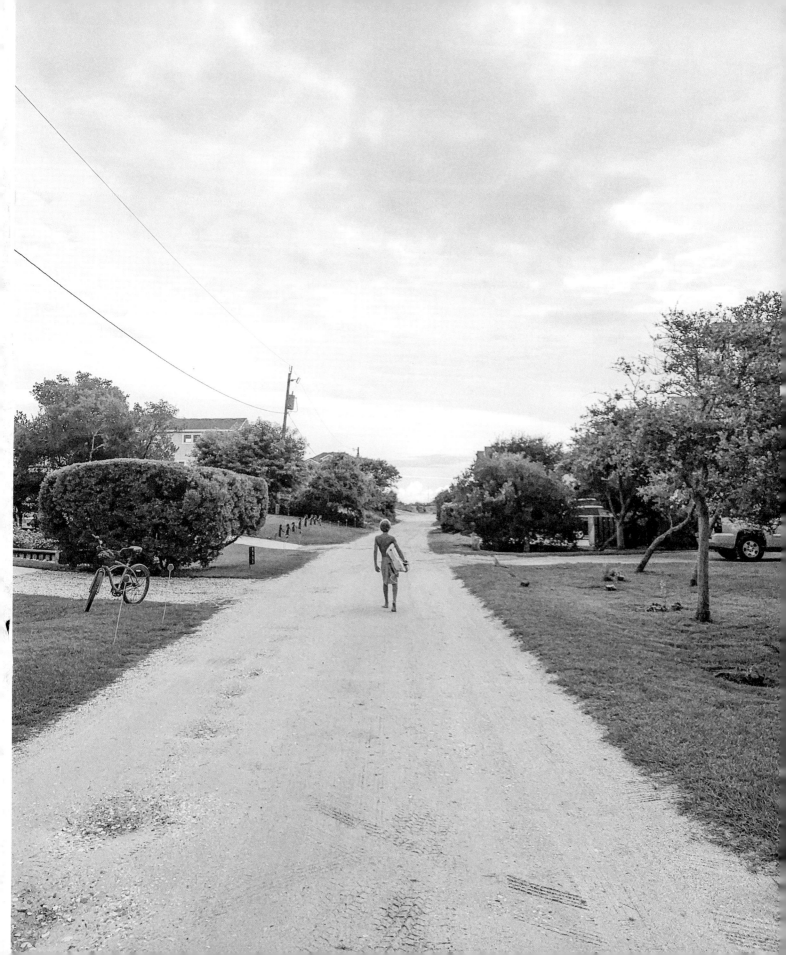

beach life

LAUREN LIESS

ABRAMS, NEW YORK

home, heart & the sea

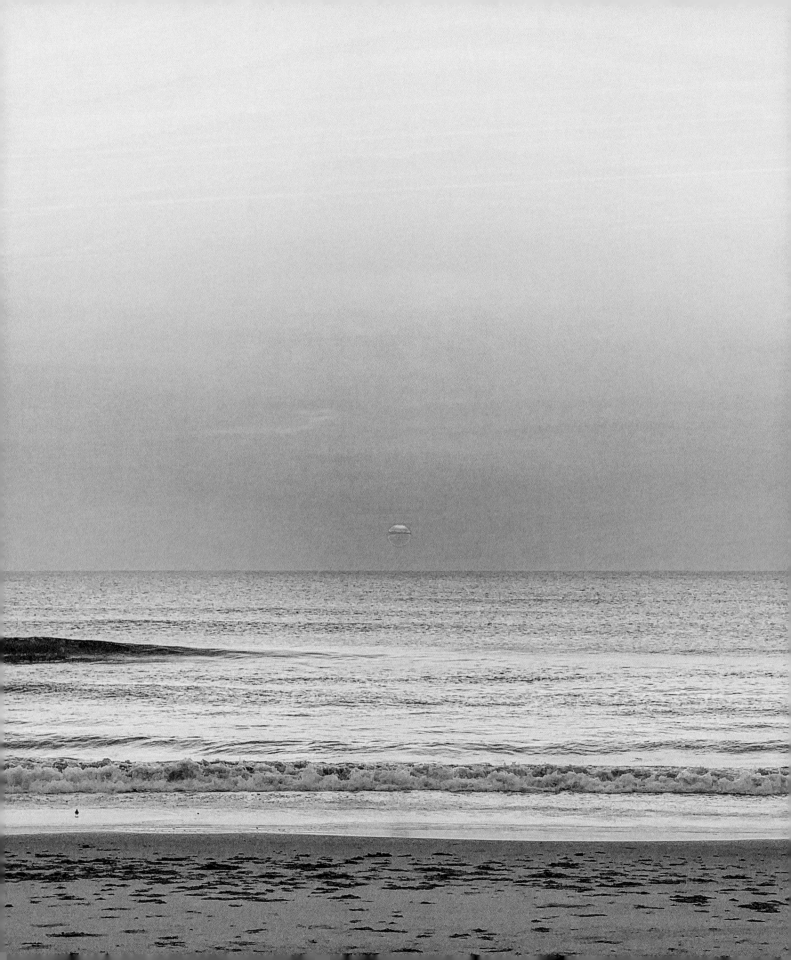

To the ones Corolla has lost—
may there be an ocean in Heaven with endless waves.

contents

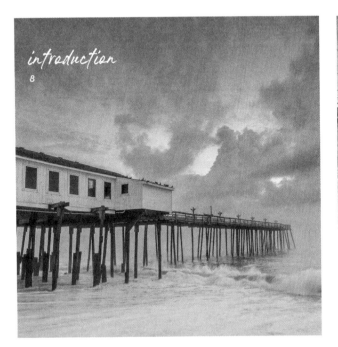
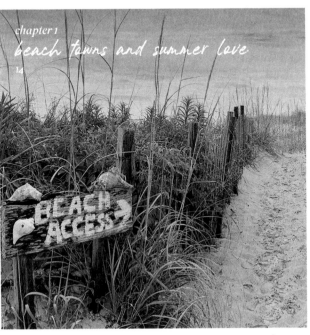
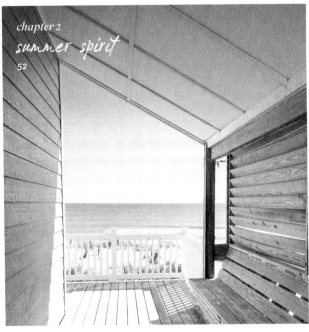
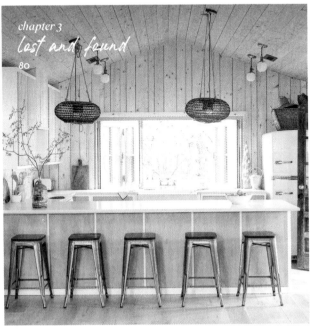

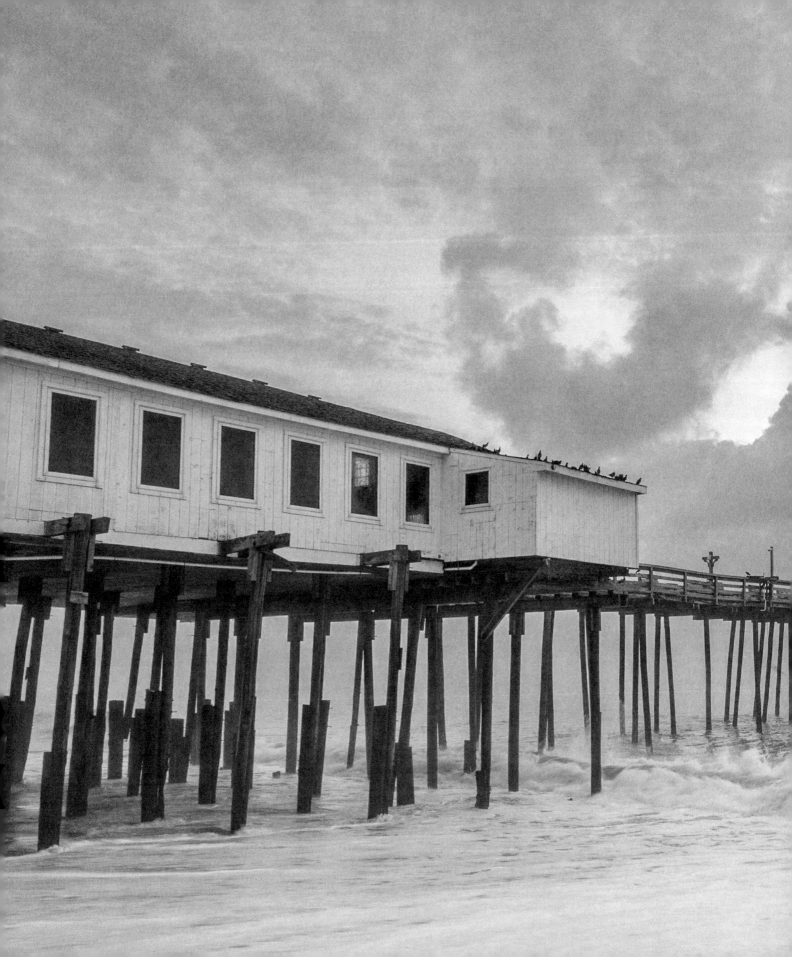

introduction

"Beach life is about living effortlessly and authentically, but most important, soulfully, something the ocean demands of everyone who visits, if they listen for it."

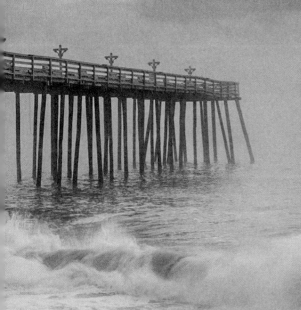

"I can feel my summer spirit," my (then) six-year-old daughter said to me one warm spring day at home.

"What do you mean?" I asked, though deep inside, I knew.

"I can feel my summer spirit coming back, and when I get to the beach, it's going to be there."

I asked her what it felt like.

"It feels like happiness and brightness. And it's wild."

I asked her where it was, and she put her hands in the center of her chest, saying, "It's here, in my heart."

And I knew she was right. This little person was instinctively in tune with nature and understood how it affected her inner being, her heart, her soul. I think we all know it at some point, but we often forget. We grow up, we get busy, we get distracted, we grow tired.

"You know it's always there, right?" I said. "Even when it's not burning as bright?"

"Yeah," she said nonchalantly. "I know."

And she does. She knows better than me.

Thankfully, our children are often more in touch than we are with the knowing we all have inside . . . The knowing that we as a society expend so much effort on unknowing . . . through the filling up of any free time with work and structured activities, through the fostering of the myth that we

must "have it all," by being glued to our phones, by living sedentary lives, and by removing ourselves from nature. We *choose* to unknow deep, primal truths, and in doing so, we *choose* to be less in tune with our true selves.

But what if we didn't? What if we resisted the pull of unknowing? What if instead of unlearning the inner knowing, we listened to it, stoked it, and let it burn brighter?

I've noticed that at times doing just that comes easily, and at other times it's hard. I've noticed that certain practices, experiences, and places fill me up and leave me ready for life, whereas others drain me.

In my past books, I've written about how time in nature is grounding and affects our moods, and how because of that, I work so carefully to connect each of the interiors I design to the natural world. It's why even though I design interiors and products for the home, my favorite place to be is still outside. It's why "down to earth" encapsulates my philosophy of living and why I'm passionate about understanding how our environments can not only be beautiful, but also help us *feel* and *be* our best selves. And I believe our "best" selves are not some version of our future selves, but rather are waiting deep inside each and every one of us right now. We have the potential at any moment to be that person, to free that "summer spirit," as a little someone I know calls it.

Throughout the years, as I've searched for understanding of how our environment affects us, it's become clear that the feeling of being free in the moment is more powerful when the landscape is awe-inspiring and we can't help but experience it. When we connect with the raw beauty of this world there is no room for stress, worry, or thinking about the past or future.

The charge of energy in the air just before a storm, a fleeting moment of connection shared with a wild animal, seeing a shooting star in the night sky or mist crawling over fields in the early morning, rounding a bend in the forest and being stopped by the beauty of the newly revealed treescape . . . These moments fill us with awe and we then know—even if only for an instant—that our spirits and nature are all connected, and we're grateful simply for being a small part of the vast whole.

There are many natural environments that affect us in this way, but in *Beach Life*, I want to explore the biggest of them all—the sea.

. . . Because the ocean doesn't let you ignore it. The ocean demands we pay attention to the present moment. It's powerful. It covers most of the earth. It's loud even when it's quiet and it fills up your soul . . . or maybe it's because the waves make a clean slate with every wash upon the shore.

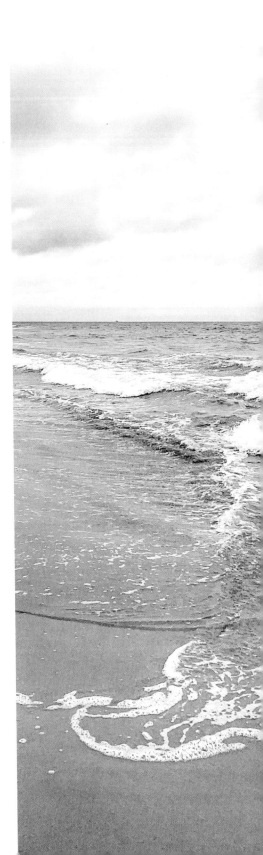

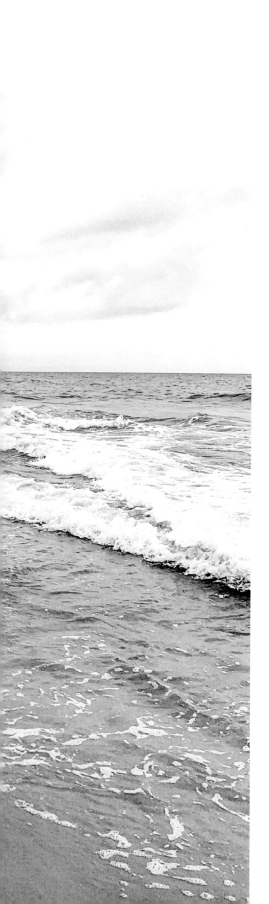

. . . But maybe I want to take this exploration of the sea because it has a piece of my heart. I think the ocean must take that piece from each of us the first time we lay eyes on it. And, I wonder, does the ocean hold on to it to keep us coming back so that our hearts might be renewed each time we return? To grow brighter and stronger? So that we might go back out into the busy world and be a little kinder, a little more refreshed, a little more free? Because like each wave washing up, we ourselves can be the same yet new and perfect in every moment.

We feel different at the beach, where we often live in a barefoot, unplugged, unbridled, and wholly present kind of way. At the beach, we put down the phone and take a break from work. We let our feet touch the earth, experiencing it fully with all our senses. We have the mental space to let our minds wander and grow creative. We get to be alone with our thoughts (or without them if we're capable of that). We bond with loved ones and make memories. All pretenses are dropped. We become connected with nature, more grounded, more true to ourselves. We gain perspective. We heal. We dream. We breathe in, we breathe out. It's exhilarating yet utterly peaceful all at once.

This magic doesn't have to end abruptly when we go back inside. Homes that feel more in tune with their natural settings and connect us with the environment they sit upon let us remain in that reverie longer. Food that is seasonal, nutritious, and local feeds our bodies and fills our hearts with a sense of place. People with whom we can be authentic put us at ease and challenge us. Clearing away all the "clutter"—both physical and emotional—frees us up to be fully present. All these things put us in tune with our truest selves, helping us hold on to our summer spirits. Beach life is about living effortlessly and authentically, but most important, soulfully, something the ocean demands of everyone who visits, if they listen for it. ✦

beach towns and

summer love

Beach towns. We all have one that means something to us.

And you know it's yours because even if you're only there once a year, it feels like coming home.

Every beach town has its own way of doing things, its own culture. It gets quiet in beach towns in the off-season. Most people living there year-round appreciate the beauty of the ebb and flow and wouldn't trade it for anything, but they have to prepare for it. Everyone in the tourist industry works hard in the shops and restaurants all summer, knowing, come winter, the beaches will empty and the businesses will hibernate. Used to operating at breakneck summer pace, during the rest of the year locals have to adjust to a quiet town and endless months of free time with very little income. It can be lonely for some.

Beach towns often have tight-knit communities that feel more like families to help everyone through the off-season. I've watched sadly too many times as the community in my beach town has banded together after loss. And though painful, this "all hands on deck" lifting up of one another without hesitancy demonstrates an inspiring resiliency.

Most locals live intentionally, making time every day for nature, savoring it with a walk or bike ride to work, yoga on the beach, fishing, surfing on days off, or squeezing in beach trips with the kids before their shifts start. Locals have a raw grit and determination I don't see as much of at home. They laugh easily and tell it like it is, speaking directly and openly, and know how to have a good time. I've noticed a remarkable inner strength, a steel core of sorts, in many of them. It must have something to do with the beautiful harshness of the ocean and its effect on those who spend the most time with it.

OPPOSITE Our beach access at daybreak

FOLLOWING LEFT The same beach access on "red flag day," when no swimming is allowed due to riptides

FOLLOWING RIGHT My friend Nadya at her restaurant, Corolla Cantina

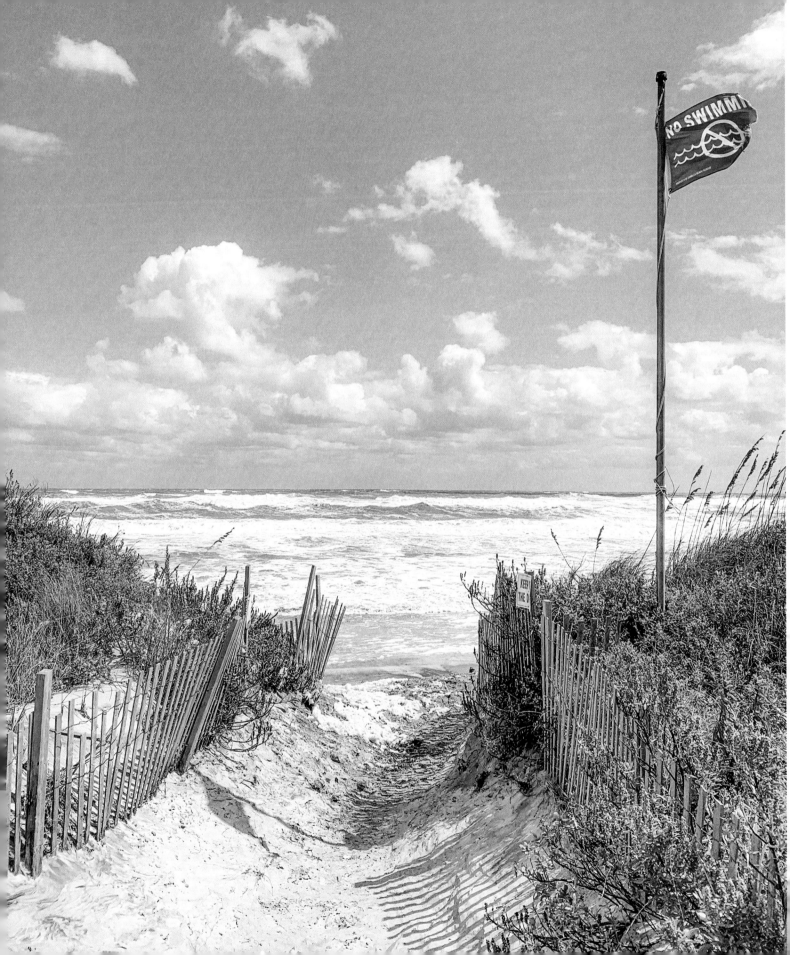

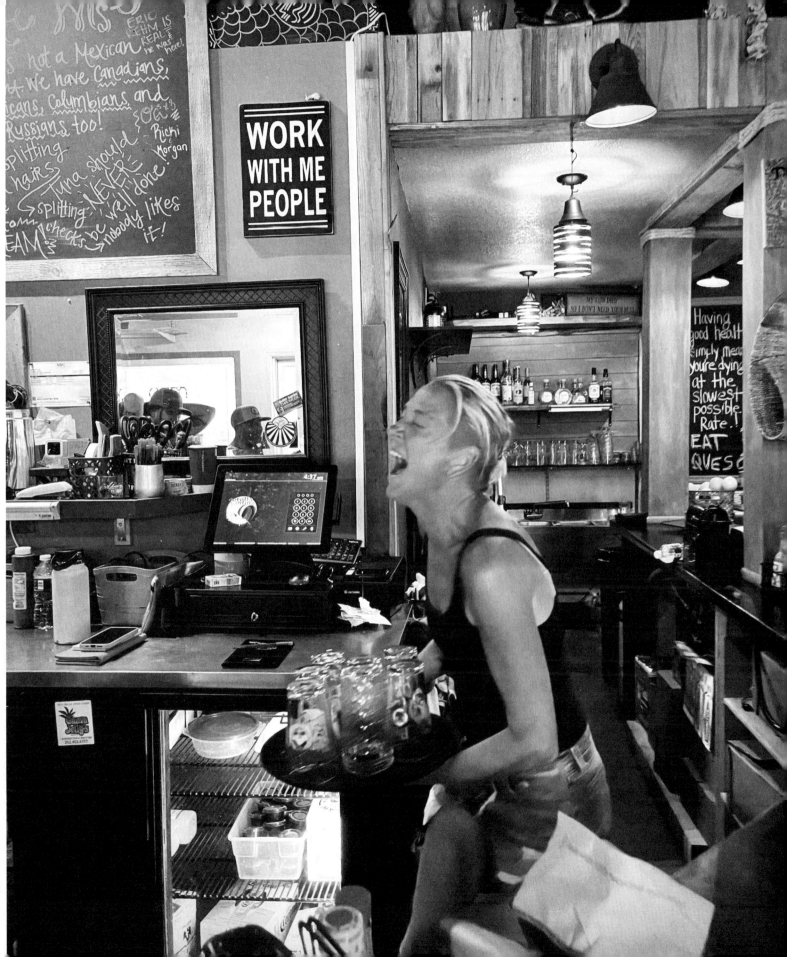

My beach town has always been Corolla (pronounced "car-rah-la"). It's located at the tippiest top of North Carolina's storied Outer Banks, known as "the Graveyard of the Atlantic" where numerous shipwrecks took place and pirates like Blackbeard are said to have hid their treasures in its many inlets during colonial times.

The road ends in Corolla. If you continue, you are driving on the beach in what we call "4×4 country," or Carova. If you drive far enough up the beach in Carova, there is a fence with a gate that separates North Carolina from Virginia Beach. Only a few original families who have owned properties there since before 1979 are left with "a key" (a key card that can operate the gate) to get into Virginia that way. The rest have to make a three-hour trek back down the peninsula, across the bridge, over the sound, and then back up the mainland until they arrive in Virginia again.

When I was growing up, Corolla felt remote, with untamed live oak forests that tumbled to a stop at the salt line just before hitting the beach. The wild horses could be found eating your garbage some mornings and they roamed free down the peninsula. There are still seemingly protected natural areas like the stretch of beach where the navy used to practice bombing in World War II, and various nature preserves dotted here and there, but the untouched land is disappearing as house after house is built in what's become an incredibly popular vacation destination. The wild horses are now fenced in for protection in Carova and many of the live oak maritime forests are gone.

I have been visiting the Outer Banks with my mom and some of her friends and their kids since I was seven or eight years old. We'd go for a week at a time and usually stayed in a different house each year depending upon how many people we had in our group. After riding in the car down from Northern Virginia, legs aching to be stretched from the hours in traffic, we'd hit the Wright Memorial Bridge. I'd roll down the window and yell, "Vacation time! Vacation time! Vacation time!" into the wind over and over . . . and then again when we hit Route 12 to go back up the coast. (I still do it sometimes despite my kids' shaking heads.)

The days were mostly spent swimming, sandcastling, playing volleyball, and reading. Evenings were for roaming the beach, finding crabs, and meeting more kids. Some nights all of us kids would camp out on the decks, playing truth or dare for hours, staring up at the crazily bright stars in the night sky with the waves crashing in the background. We always got ice cream that week and I loved going to the bookstore in the evenings when I'd finished a book and "needed" a new one. I remember how long a week felt back then. I remember the rainy days spent reading or heading to the shops.

FOLLOWING LEFT My little summer spirit, Gisele

FOLLOWING RIGHT Avalon Fishing Pier in Kill Devil Hills

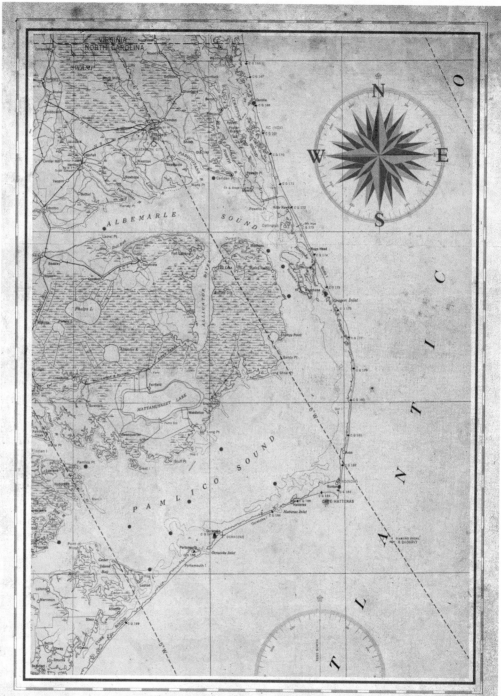

OBX

OUTER BANKS

THE BEAUTIFUL BEACHES OF COASTAL NORTH CAROLINA

McDonald & Daughters Mapworks

1889

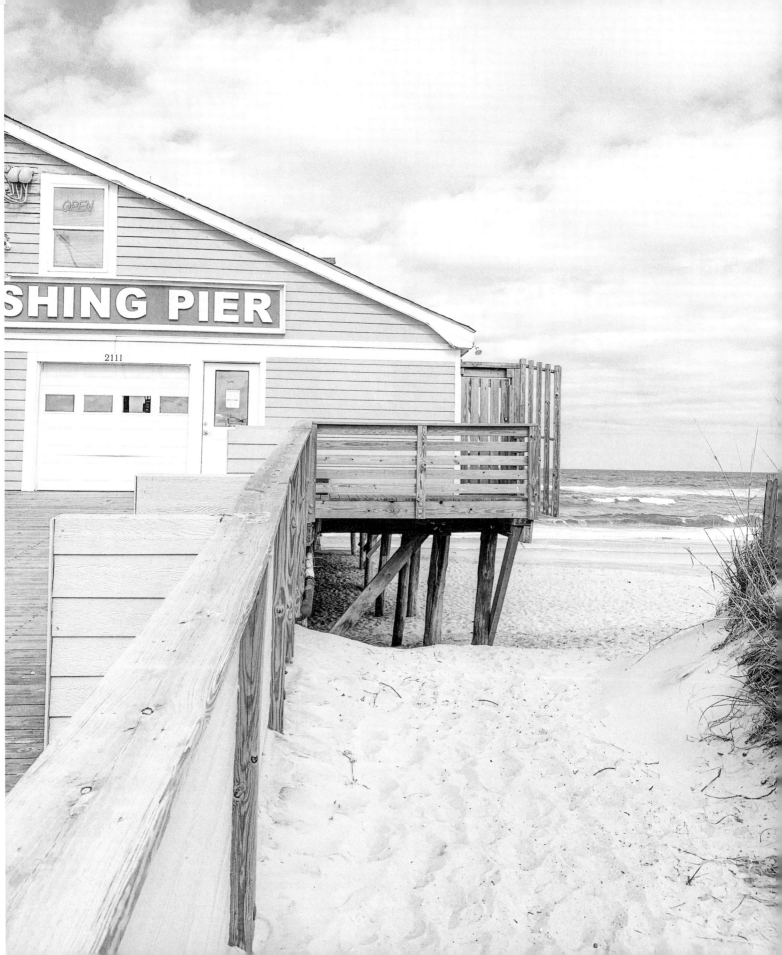

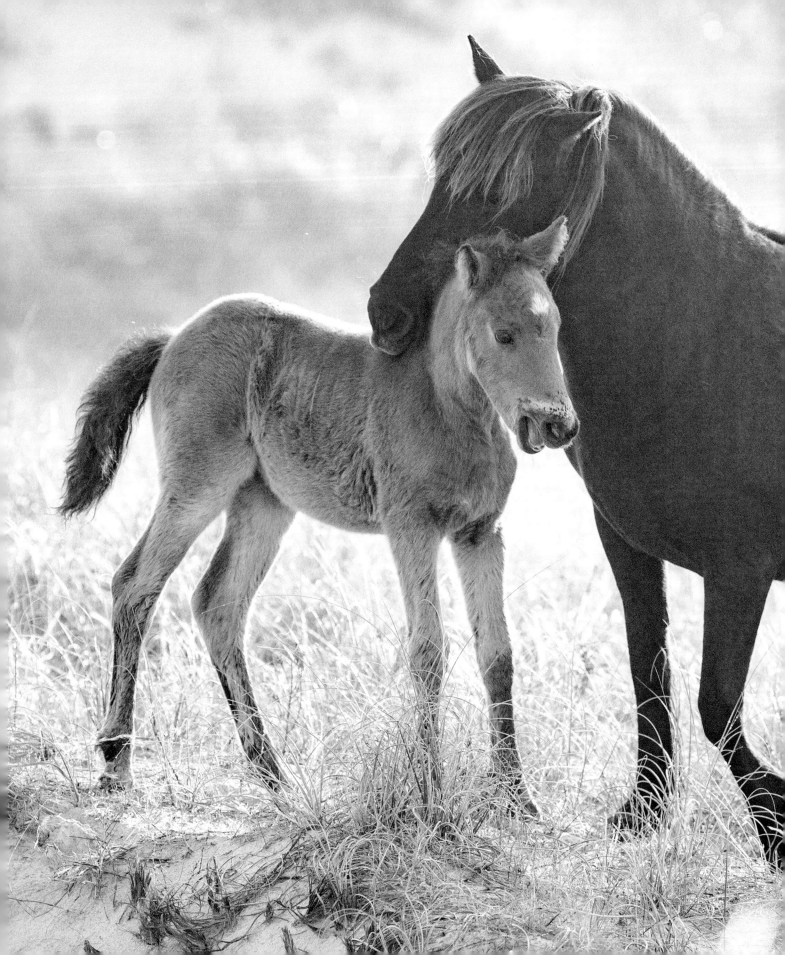

"At the beach, life is different... We live by the currents, plan by the tides, and follow the sun."

—SANDY GRINGAS

Each beach town
has its own history,
vibe, and culture.

**LEFT AND
OPPOSITE** Some
of my favorite
buildings in Historic
Corolla Village

beach life

a corolla mansion by the sound

The Whalehead Club was built in 1922 by the Knight family because Mrs. Knight was not welcome at the all-male hunt clubs and Mr. Knight wanted to be able to hunt with his new bride. It's now open to the public and the grounds are available to rent for events.

FOLLOWING Visitors can still climb all 220 steps of the Currituck Beach Lighthouse in Corolla. A bird's-eye view of the Keeper's House can be had from the top.

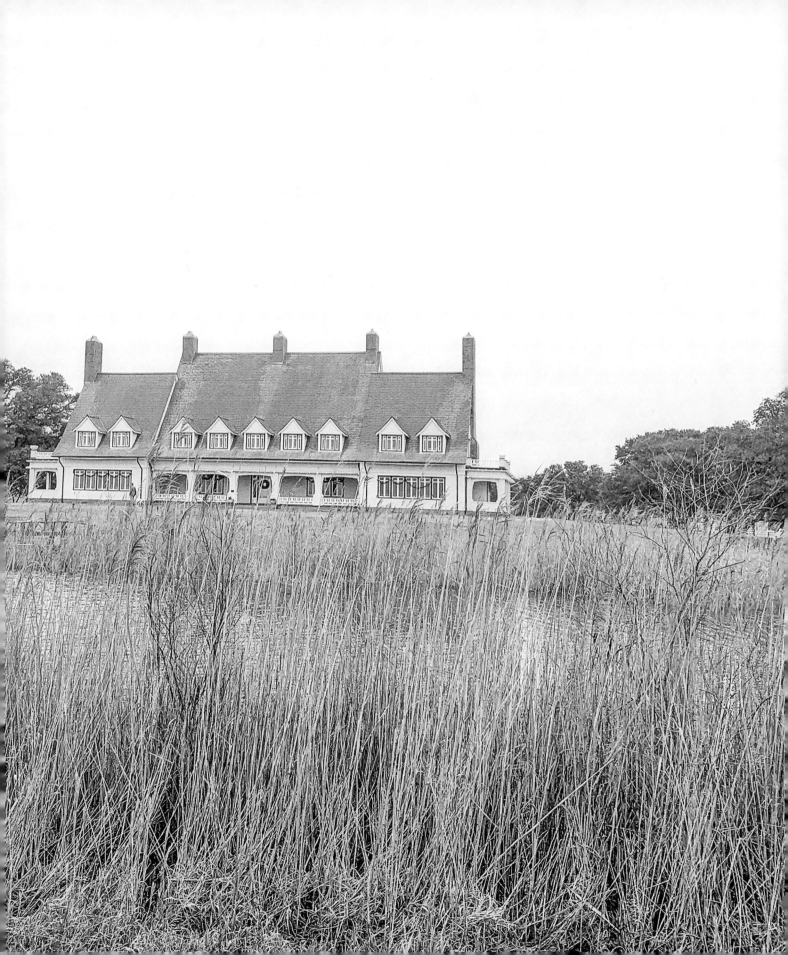

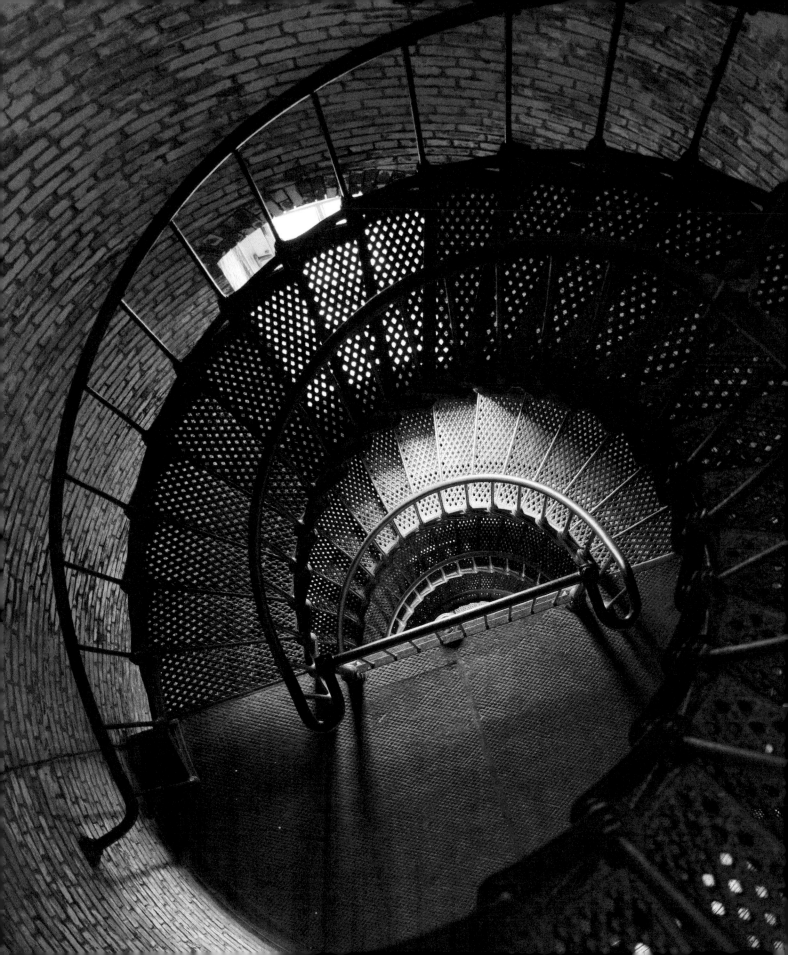

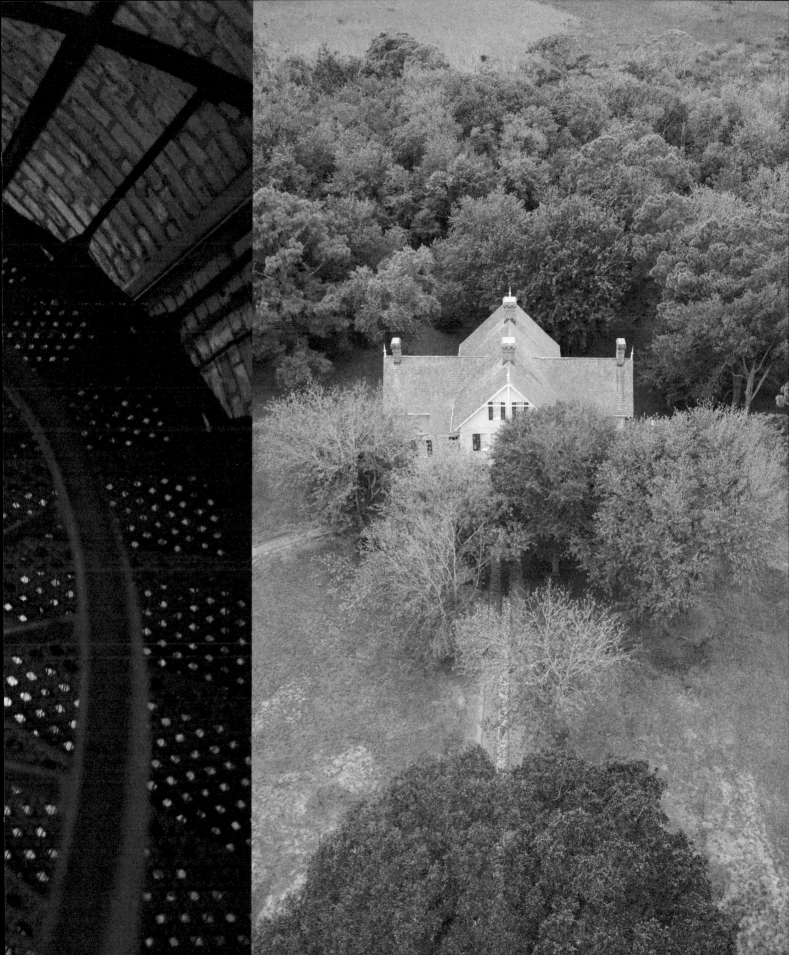

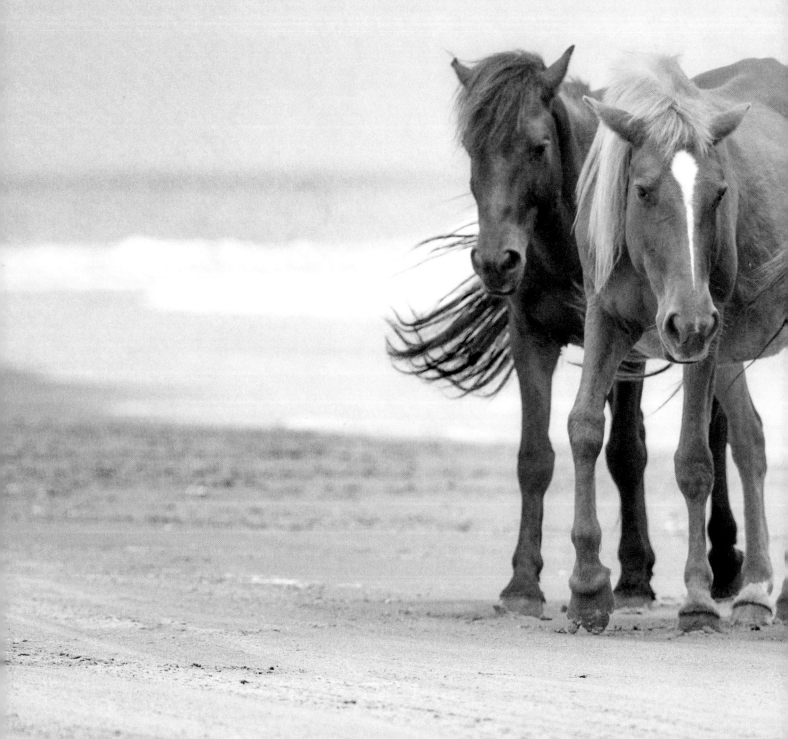

"Stories have been told of wild fire in their eyes, and freedom in

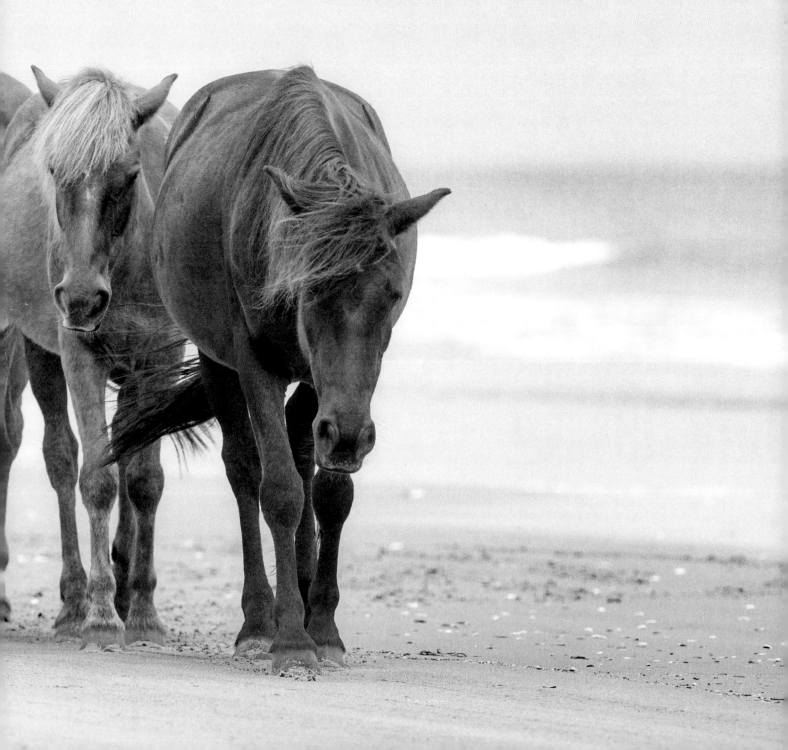

horses with wind in their manes,
their hearts." —TERRI FARLEY

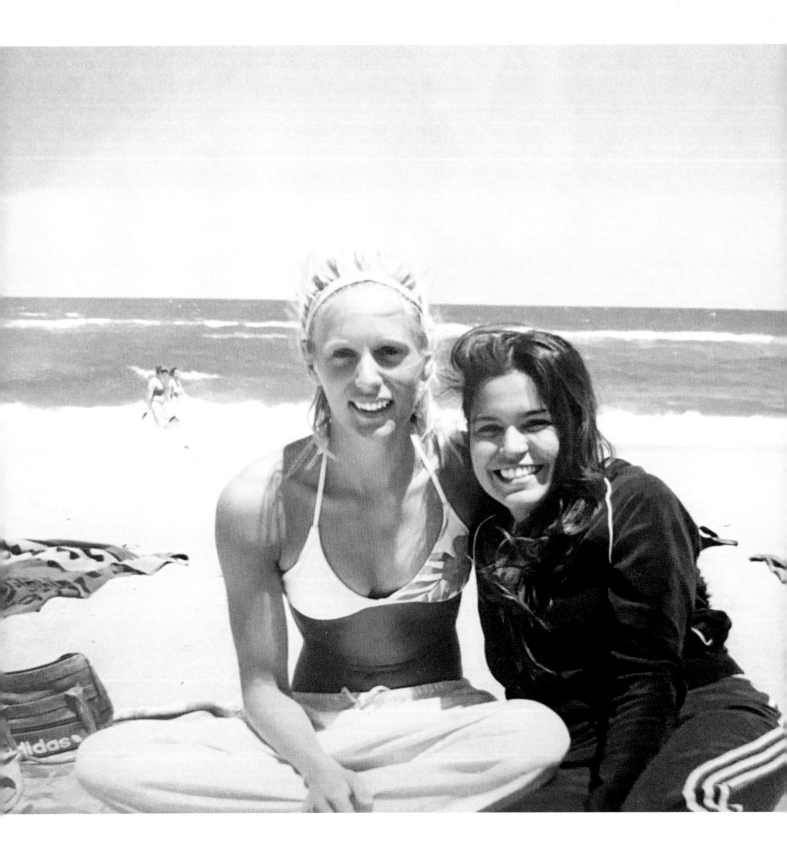

During my college years, I lived in the Outer Banks for a summer, working with one of my best friends at a restaurant. We shared a small two-bedroom apartment with way too many other kids. Being a "local"—even if only for a summer—changes things. You see a place differently and you appreciate all the work that goes into making a town—its shops, activities, and food—ready for the steady stream of vacationers. I bonded in the trenches with the other servers, cooks, and bartenders at our restaurant, and after only a couple of weeks, we felt like we'd known one another for ages. A level of respect passes unsaid between you and the people working at the other places in town. I'll never forget saving up for a flower-shaped larimar necklace at my favorite gem shop. I went in one day to finally splurge on the necklace, and when the clerk rang me up, I felt like I really belonged there when I saw that she'd given me a "local discount."

I got to experience what the beach feels like on changeover day when the week's vacationers leave to go home but next week's vacationers haven't arrived yet and it's mostly empty except for a few locals and the seagulls. I worked a lot of doubles that summer but I was still on the beach almost every single day, knowing I'd miss it come September. I got through a good number of books that summer, and was fascinated by the stories of Edward Teach (Blackbeard) and the pirates who once sailed by the very same beach I sat on. That summer changed Corolla forever for me because I got to see it from the other side.

OPPOSITE Beaching with my bestie, Alissa, in college

BOTTOM LEFT A broody photo I took of Dave during our college beach week

BOTTOM RIGHT The energy surrounding a red flag day is palpable.

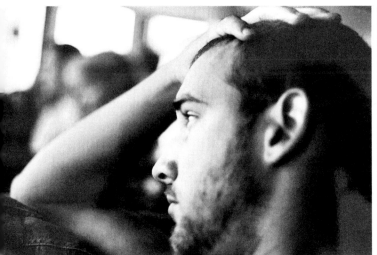

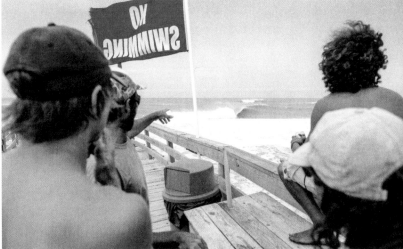

I met my future husband, Dave, in a college English class after my summer at the beach and, as it turned out, he'd been going to Corolla since he was a kid too. When the next August rolled around, we both headed down with family and friends.

It was a bittersweet week. He had just graduated from college and was moving to China right after the trip. I'd be returning to school for my senior year and we'd be saying goodbye. Suddenly a week at the beach didn't feel as long as it once had. I tried not to count down the days.

I'm pretty sure our people didn't see as much of us as they wanted that week, because we spent every waking moment we could together. On one of the last nights, we took a walk to the beach and sat on the edge of the sand dunes a little way down from our beach access. The skies in the Outer Banks are some of the darkest on the East Coast and so its stars feel the brightest. The sea breeze was warm and I could feel the heat from the sun on my skin earlier that day. He held me in his arms and I let go of the tears I'd been holding in. I didn't want to say goodbye but how could we not? China was halfway across the world. And he was leaving and that hurt. I didn't fully understand why he had to go. But he let me cry and kissed my forehead, telling me it would be okay, that we'd be okay.

And we exhaled to the sound of the crashing waves, and it felt okay.

I woke to the sunrise, covered in salt and sand. Still secured snugly in the crook of his shoulder, I shook him awake. Amid my internal freaking out that we'd spent the entire night on the beach and that our people might be worried about us, I marveled at how incredibly comfortable and warm I'd been in his arms without even a blanket. I'd slept soundly. We raced back into the house and slipped in just before everyone woke for the morning. We still reminisce to this day about what a good night's sleep that was.

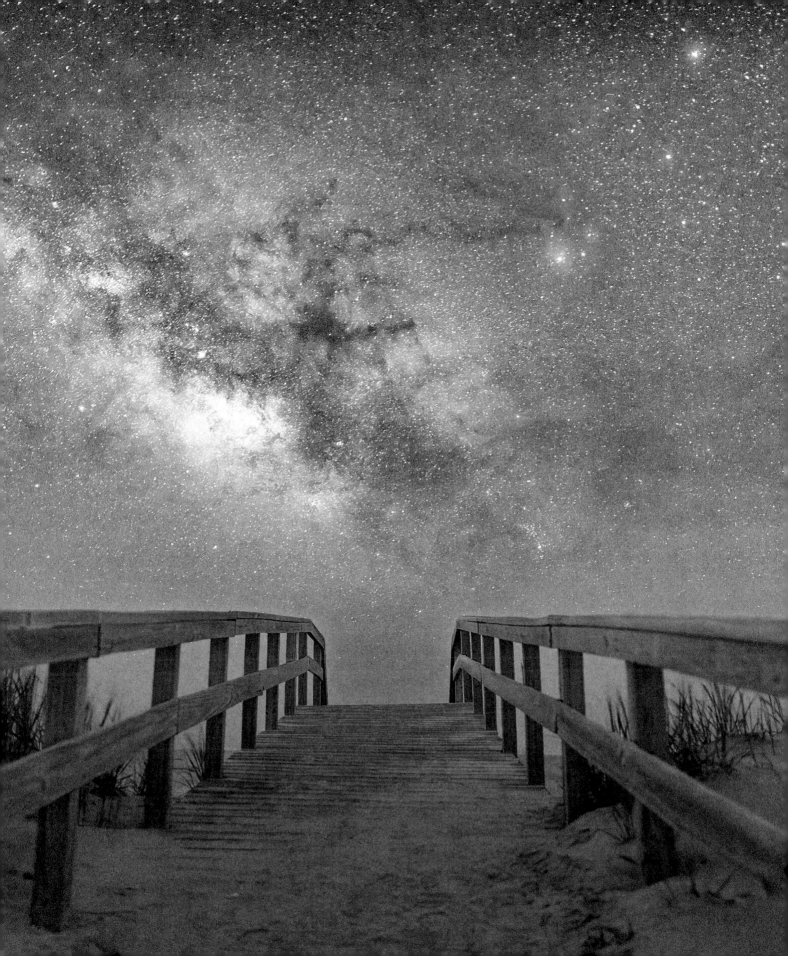

"And we exhaled to the sound of

the crashing waves, and it felt okay."

We were married just over two years later—a year after he came back from China—and we continued to return to the Outer Banks each summer. Less than two years after that, we brought our one-month-old son, Christian, with us and I remember him pushing up into a standing position on my lap so he could see it all— the sand, the water, the sky. "Surfer dude," I used to call him as he tried to balance on his spindly little legs.

Every year we visited, staying for a couple of weeks at a time with our growing family. We introduced each new baby to the beach and delighted in their reactions—Justin ate the sand, Louie and Gisele chilled under the umbrella, and Aurora—who was born on our usual beach week in August, meaning we had to skip a year—didn't know what to make of the sand and preferred to spend her time on the blanket, which made lifeguarding a little easier. In the evenings we'd sneak away while my parents babysat the kids, getting the chance to hang with old friends and go out on dates, a fairly rare occurrence for us at the time with lots of little ones.

Daydreaming about finding a beach house of our own one day was a favorite pastime. Though it felt outside the realm of possibility, we always said we'd buy something that needed a lot of work and fix it up so that we could stay in it during our beach weeks, and rent it out the rest of the time. For years, we'd pull up real estate listings and pretend we were serious . . . until the Saturday morning in June when we woke up before dawn and decided to pack up the kids in the car and head south to our beach town to see what we would find. Our beach story continues in chapter 3, "Lost and Found." ✦

OPPOSITE Nap time on the beach with Aurora, our fifth

FOLLOWING Life in the Outer Banks

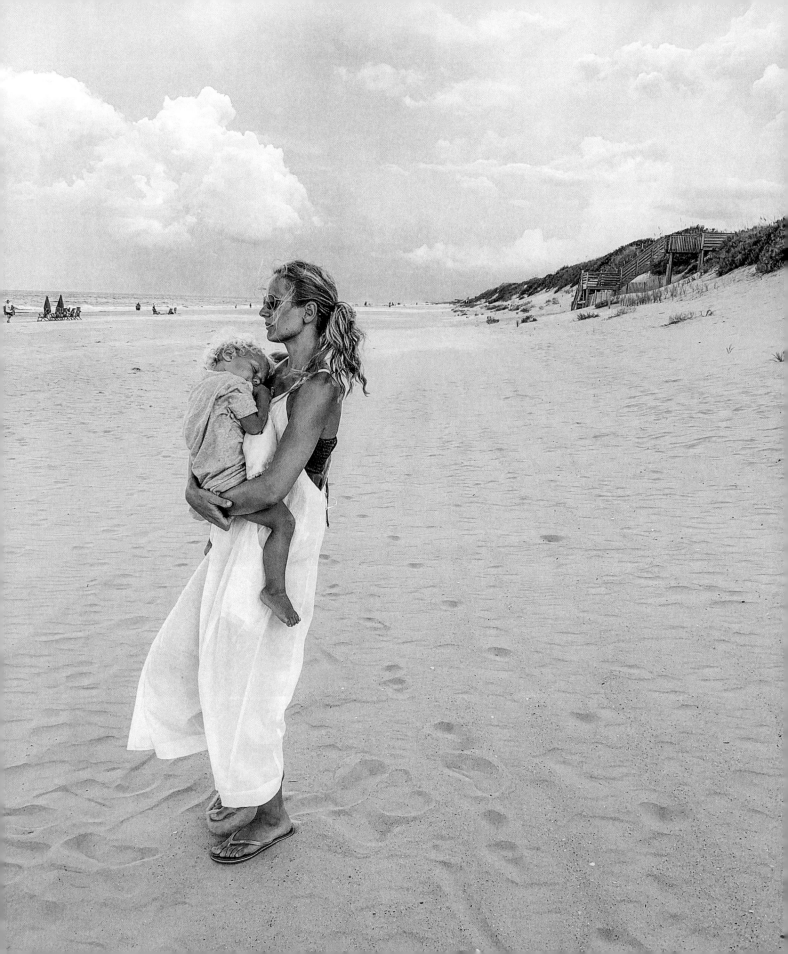

ICE

Shovel	$1
Basket	$4
Barrel	$

Ask about ICE and COLD STORAGE Available HERE!

Most Asked Questions

1. Dolphin
2. ow Fin Tuna
3. Mackeral
4. hoo
5. Very Sharp
6. In the mouth
7. They're all good
8. 20 - 30 miles
9. No cat food or fertilizer plants
10. In the sound

?

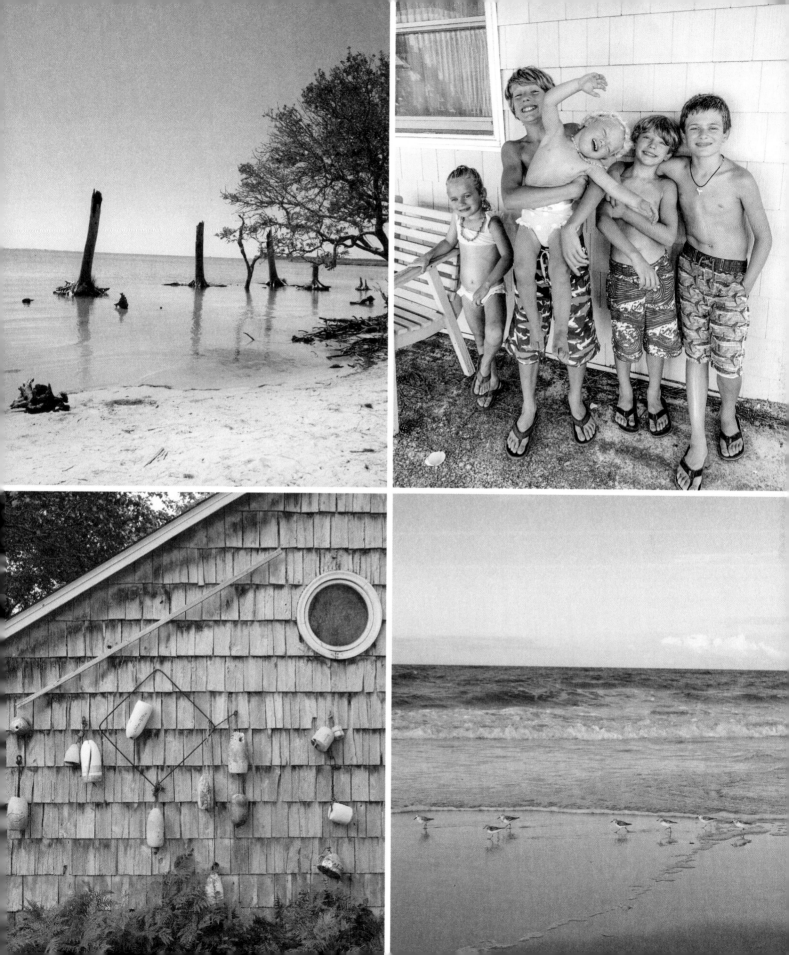

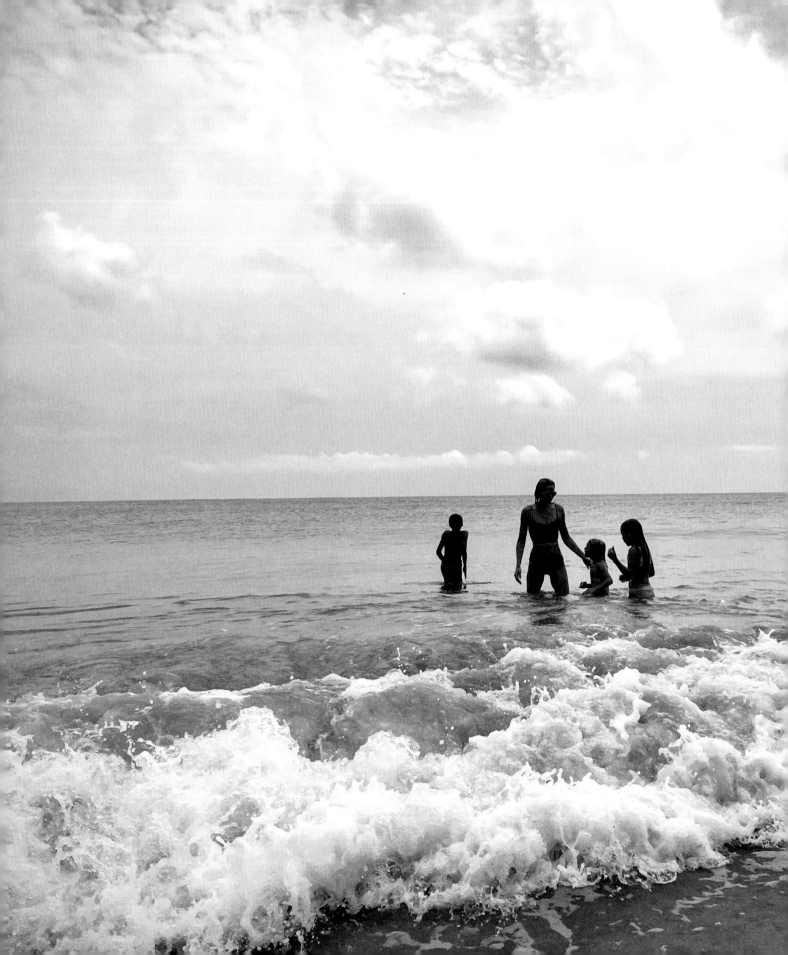

"Medicine heals the body; the ocean heals the soul." —UNKNOWN

"The cure for anything is salt water . . . sweat, tears or the sea." *ISAK DINESEN*

the saltwater cure

SINCE ANCIENT TIMES people have believed in the healing properties of the seaside. Those with ailments were sent to the coast to swim or "bathe" in the ocean, breathe in the salt air, and heal. Most of us can attest to being reinvigorated by the ocean . . . I can't count how many times I've shown up at the beach, ready for a vacation from work, excited to be there yet depleted from my frenzied pace of life, in desperate need of rest and fun. We tumble out of the car, exhausted, stretching as we gather our belongings. I hear it and feel it first. The steady cadence of the waves crashing consumes me and resets the rhythm of my heart before I even lay eyes on the ocean. I inhale the salty air and let out a long exhale. If I'm near a kid or my husband, they're getting a hug and a kiss because I'm giddy inside. I feel that warmth in my chest—my summer spirit, perhaps—swell at that first moment of spying the ocean beyond the crest of the dunes. My bare feet are welcomed by the sand and I know that I am home. Words are unnecessary as we run to the water and let it splash up our legs with a chill. I feel my soul peeking out and life is beautiful.

Of course the ocean is romantic and stirs up powerful emotions and memories, but there are also chemical and biological forces at work. Salt, sunshine, sea spray, sand, waves, swimming, and even electrical charges all come together in a coastal environment to create the perfect emotional, physical, and mental health cocktail.

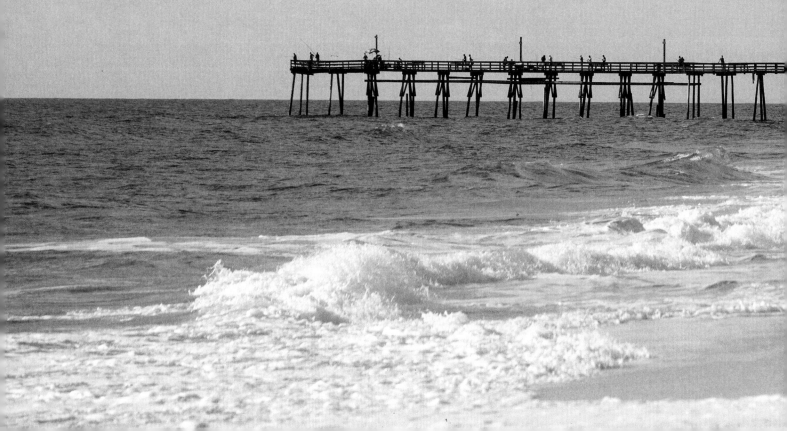

the ion effect

Ions are invisible molecules with either positive or negative electric charges.

POSITIVE IONS

+ Positive ions lead to inflammation, stress, anxiety, difficulty breathing, low energy, irritability, and depression.

Positive ions are found in:

+ pollution, toxic chemicals, mold, dust, fluorescent lighting, electronic devices like computers, TVs, and phones, and in typical household goods such as paints, cleaning supplies, carpets, and furniture.
+ areas with high levels of positive air ions include polluted cities and towns, commercial buildings, and, sadly, our very own homes.[1]

The seaside is one of the areas with the highest levels of naturally occurring negative air ions in the entire world.

NEGATIVE IONS

+ Negative ions reduce inflammation, boost the immune system, help with oxygen absorption, revitalize cells, and reduce stress.
+ There is also evidence that negative ions improve sleep, reduce cortisol levels, relieve pain, calm the nervous system, and balance out serotonin levels, resulting in higher energy.[2] Negative ions act like antioxidants: they neutralize oxidants and free radicals.[3]

Negative air ions are found in:

+ sea spray, rain showers, and waterfalls.
+ sunlight.
+ the air just after thunderstorms.
+ plants, particularly blade-shaped ones such as dune grass.
+ the seaside, mountains, and forests, all of which have high levels of these ions.

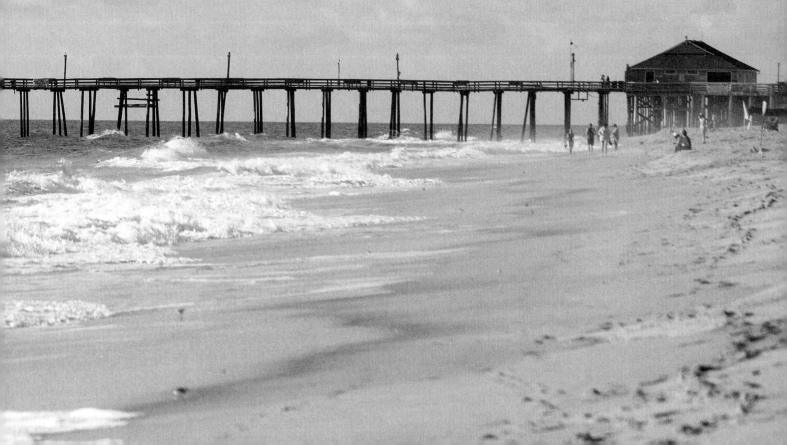

seawater

Seawater is rich in minerals like sodium, chloride, magnesium, zinc, potassium, and calcium. These minerals calm our nervous system, resulting in clearer skin and fewer stress-induced breakouts.[4]

Cold water reduces inflammation and activates brown fat, a beneficial fat that helps burn calories.

The shock of cold water pulls our attention directly to the present moment, acting as a sort of mindfulness meditation in which we have just enough bandwidth to focus on our breathing.[5]

Open-water swimming—with the tides pulling at the swimmer—demands more control, muscle strength, and endurance than swimming in a pool. It also releases endorphins.

salt air

Taking deep breaths of salt air calms the mind and heart, reducing tension throughout our bodies. Sea air is full of negative air ions, which boost our immune system and, when inhaled, make us happier.

Breathing humid salt air can help cleanse our airways.[6] That cleansing helps protect against both illness and allergies. Sea air also has higher oxygen levels, which makes us sleep better.[7]

the sound of the waves

The soft lull of waves gently crashing on the shore is pleasing to the brain. The sound of waves causes the body to slow down, allowing us to relax and feel more engaged.[8] Waves help us focus while awake and encourage deep restful sleep at night.

sunshine

Negative air ions are found in sunshine and so is another important element, vitamin D. Studies have shown sunlight can alleviate symptoms of depression.[9] The FDA recommends ten to fifteen minutes of sun per day for natural vitamin D exposure, but keep in mind that sun rays can cause sunburn and be sure to use a mineral-based sunscreen for prolonged exposure, especially at the beach, where there is no shade and increased sun exposure due to the sun reflecting off the water and sand.

awe

Whether it's the vastness of the ocean, the power of its waves, the color of the water, the fresh salt air, the sand between our toes, or the constant rhythm of the waves upon the shore, the ocean is awe-inducing, demanding that we be fully present. It makes us aware of our own smallness and of how beautiful that can be.

chapter 2

summer spirit

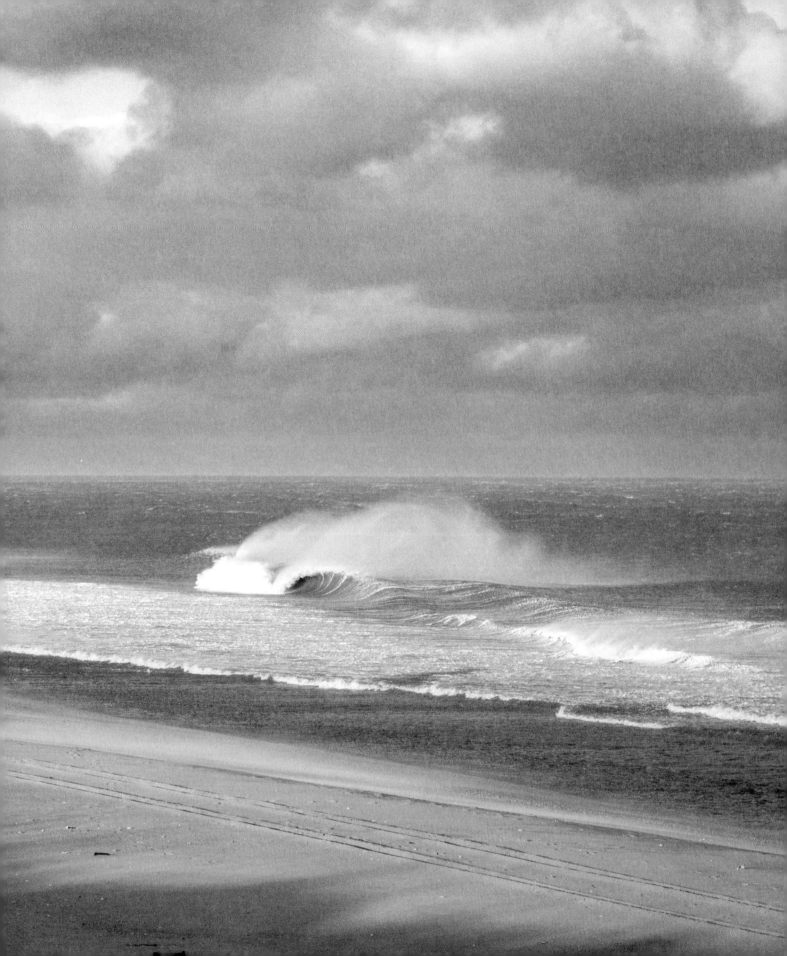

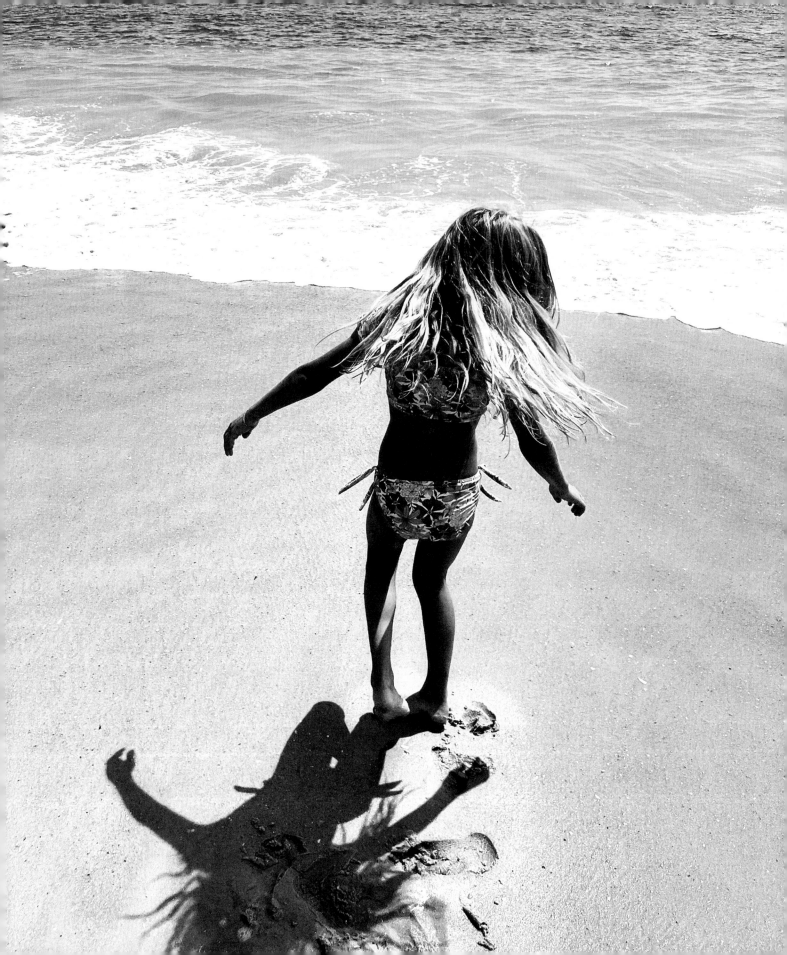

There are times when I've felt young and times when I've felt old, and not necessarily in that order. I remember being nine years old, taking a walk in the schoolyard with a friend, hands in my coat pockets, eyes scanning the dull winter grass below our shuffling feet, and saying, "I want to be carefree again." Feeling the rising pressure of schoolwork, and fourth-grade-girl drama, I'd realized that life felt different than it had when I was "younger . . . ," when I didn't think about those things, when there weren't big projects with deadlines, and when there were double recesses. I yearned to lift up my arms and spin to feel free like I once had. I was old enough to understand that something had shifted and I was entering into new, more serious territory with higher stakes.

The last day of school that very same year, I twirled around my bedroom, singing at the top of my lungs to Cyndi Lauper's "Girls Just Want to Have Fun" and Wilson Phillips's "Hold On" into the finial from the top of my canopy bedpost in celebration of summer. I stopped abruptly as one of the bedposts I was swinging on snapped off and I was left holding my "microphone" in one hand and a broken bedpost in the other. (Sorry, Mom!) But it was okay because it was the first official day of summer vacation and I had the entire season ahead of me. No projects, no deadlines, no drama. I was carefree again. I had my summer spirit!

Sometimes summer spirit is carried in with a warm breeze. If we listen, it whispers to us with the first scent of spring. It bubbles up when we laugh or when we dance or sing with abandon. It's there in that moment of walking over the dunes and first laying eyes on the ocean. It soars when we dive into a wave and burst back up through the surface of the water. It flutters in our

OPPOSITE Our daughter Gisele, feeling her summer spirit

chest with the right kind of kiss. Summer spirit thrives on purely present moments and adventure . . . on true human experiences. It's the stirring of our soul.

I've also heard my daughter declare, "I *am* a summer spirit," as if it's actually something she's become, and I know this is true too. Somehow, feeling our summer spirit has the power to change us. The more we focus on it, the stronger it becomes until its essence fuses with our own.

My grandmother, who is ninety years old, has confided in me on multiple occasions. "Do you want to know a secret?" she'll say with a little smile. "I still feel like I'm twenty years old. I know I'm an old lady but I don't feel like one." Since I was a little girl, I've been inspired by my grandmother's optimistic, industrious ways and I admire that she hasn't let her age or her outer appearance change who she is inside. She's never been an age, she's always just been herself. She has always made time in her life for creative pursuits like painting, telling stories, flower arranging, and daily walks in nature.

As I watch my kids run free on the beach, barefoot and winded, I see their summer spirits fully alive. I see them existing purely in the moment, without a care. I know they have the rest of their lives to adult and I'm grateful that, for now, they have only the ocean, the sand, and the sky to contend with.

If I close my eyes and breathe deeply, I know that's really all I have to deal with in this moment too. I know that the emails, the deadlines, the workloads will come and go, and at times I will feel older and at times I will feel younger, but my summer spirit will always be there waiting inside me, even when I'm ninety. ✦

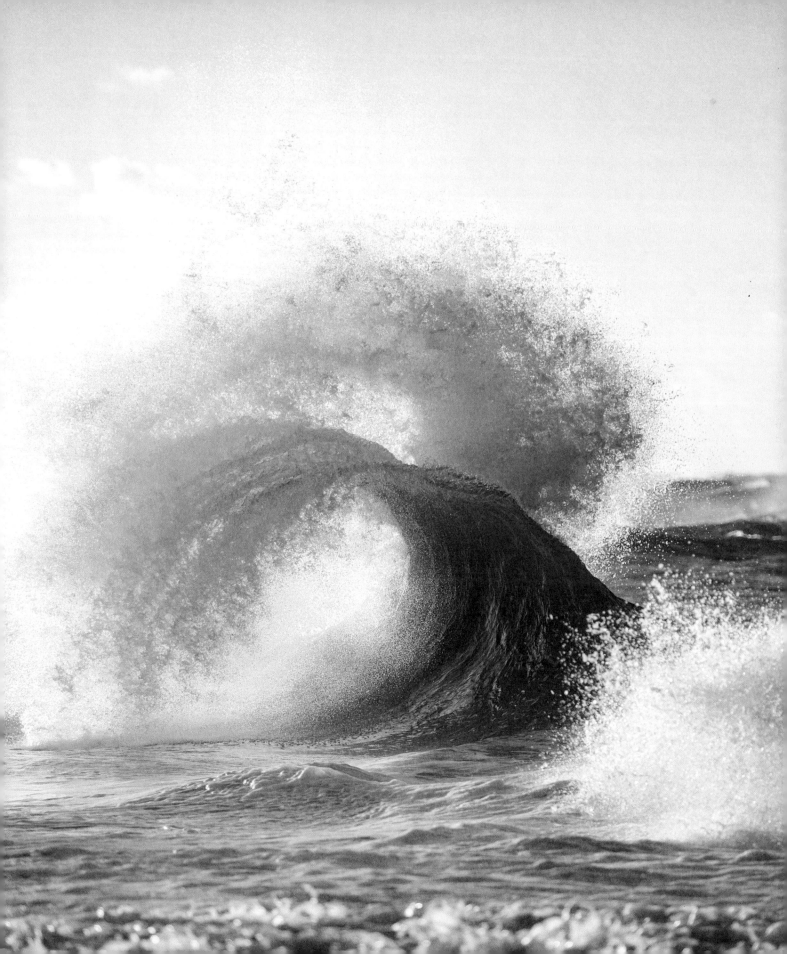

"My soul is full of longing for the secrets of the sea, and the heart of the great ocean sends a thrilling pulse through me."

HENRY WADSWORTH LONGFELLOW

thalassophilic design

THALASSOPHILE [tha-las-so-phile] *noun* A lover of the sea, someone who loves and is magnetically attracted to the sea, ocean

If you've got this book in your hands, odds are you're a thalassophile, or ocean lover. Many of us miss the seaside when we're away from it for too long, though the definition of how long is "too long" varies from person to person. We feel that little spark of summer spirit and we, quite simply, need to get to the ocean. Longing for the ocean is just a part of life for a thalassophile who's away from it.

One way we can ease those pangs is by bringing a bit of the seaside home with us. The houses in this chapter are not all by the sea, but some of them belong to thalassophiles who feel the lure of the ocean and wanted to incorporate their love for it into the design of their homes. A common request at our design firm comes from clients who once lived by the ocean but for some reason or another had to move away. They want to be reminded of the seaside and their own personal history with it. They want their homes to bring the feeling of being by the water without feeling overtly "nautical" or kitschy.

Thalassophilic design features key elements, and I think of it as a subset of the overall design philosophy of "down to earth" in which the specific part of nature being referenced is the seaside.

key elements of thalassophilic design

NATURAL MATERIALS

The use of natural materials, such as raw woods that are reminiscent of weathered cedar and driftwood, or woven materials like rope and seagrass is a hallmark of thalassophilic design. We go to the beach to experience raw nature in a big way, and bringing natural objects and materials into the home

OPPOSITE The restored old Life Savings Station in Corolla Village

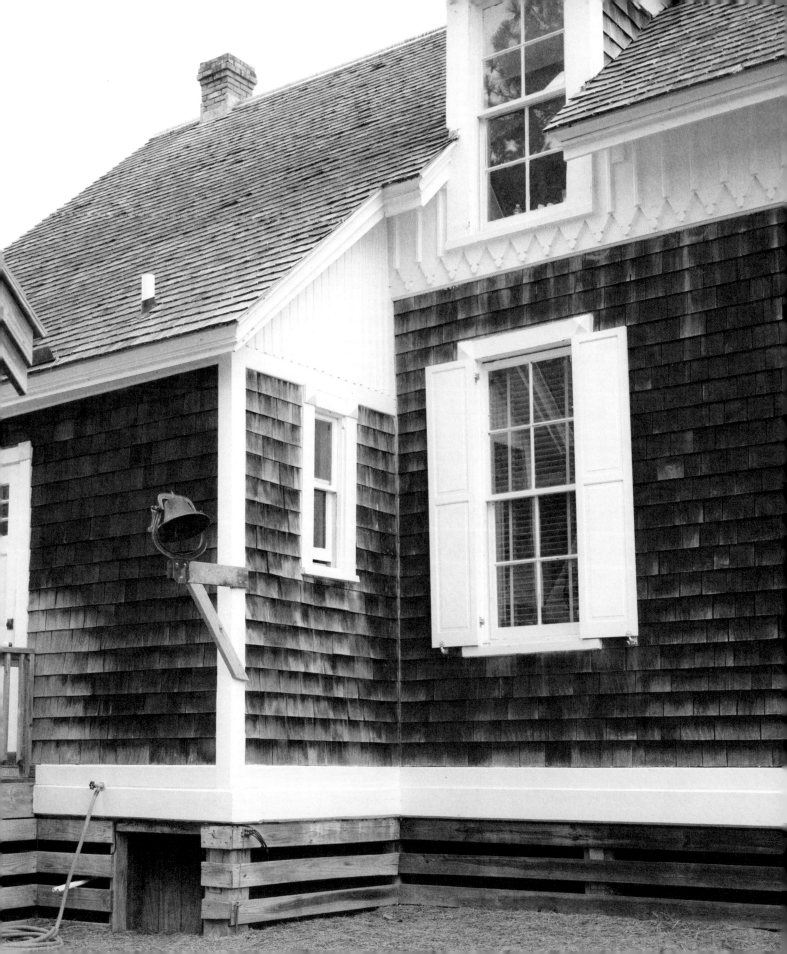

reminds us of these awe-inducing experiences. These elements not only bring texture and depth to a home, but also call to mind the feeling of awe and peace we have when experiencing life by the ocean.

A COASTAL PALETTE

A coastal palette consists of colors taken right from nature on the seaside: often soft neutrals, sand tones, blues, and grays. But I like to get really specific here and look closely at tones in the sand, sky, or water from the exact locale being referenced, which can have a surprising array of color. Some sand is black while other sand is pink. Some water skews aqua while other water goes silver gray, and of course that can vary day by day. A coastal palette is traditionally thought of as blue and white, but as you really start to observe the colors of your own beach town, you might notice more than initially meets the eye. Each of the homes featured in the remaining chapters of this book has a unique palette derived from the land and sea right near where the houses sit.

EASY-BREEZY VIBE

Homes evocative of the water often have an effortless, down-to-earth vibe. Simplicity reigns in functional beach houses where all who enter are invited to kick off their shoes and relax without fear of "messing up" anything. Material selection affects moods. Think pure and light in terms of both vibe and materials: linen, cotton, sailcloth, and anything that will blow in with a breeze. Nothing should be overdone or "fancy." Include hard-wearing materials that can stand up to salt, sand, and lots of wear and tear and that make everyone feel at home.

LOCAL NODS

Art, objects, and collections that reflect the sea, coastal lands, nature, and history of an area begin to tell a story of someone who loves the sea. Seascapes, nautical charts, maps, nature studies, historical bookplates, and natural objects found on the coast are among the many treasures we can display to evoke the sights, sounds, smells, and feel of being by the ocean. Whether we are actually in a beach house or simply want to think of a place we love, local touches remind us what it feels like to be by the water. ✦

a hint of coastal

Although landlocked at the moment, our clients grew up in Newburyport on the North Shore of Massachusetts and wanted their home to reflect their history and love for the water. We created a palette of blues and grays to call to mind coastal environments and warmed it up with rope-like natural textures and driftwood tones.

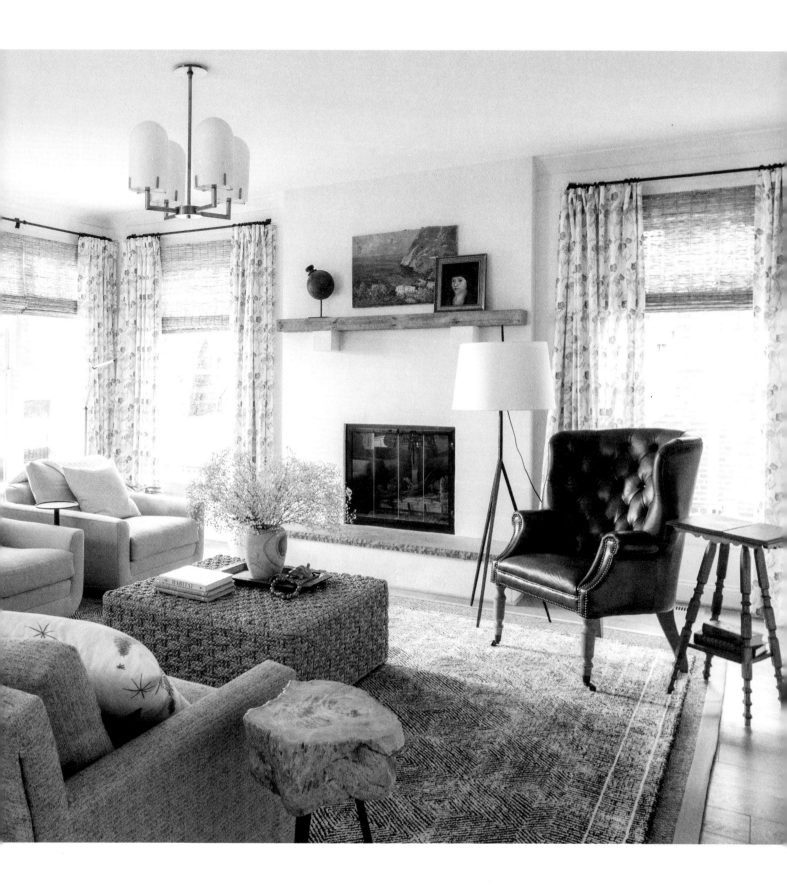

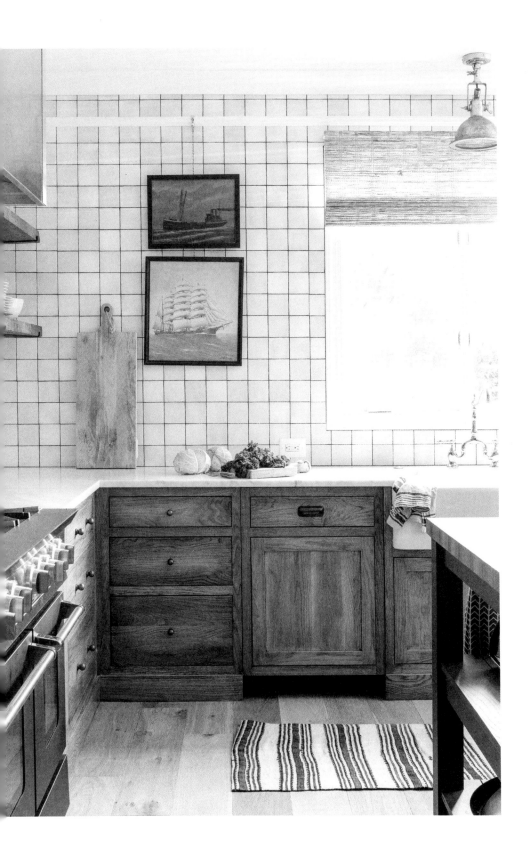

thoughtful accents

The palette continues in the kitchen. Antique paintings hang over the tile from picture molding and a mix of patterned pillows in the breakfast nook bring a seaside charm into what is tyicially a more utilitarian space.

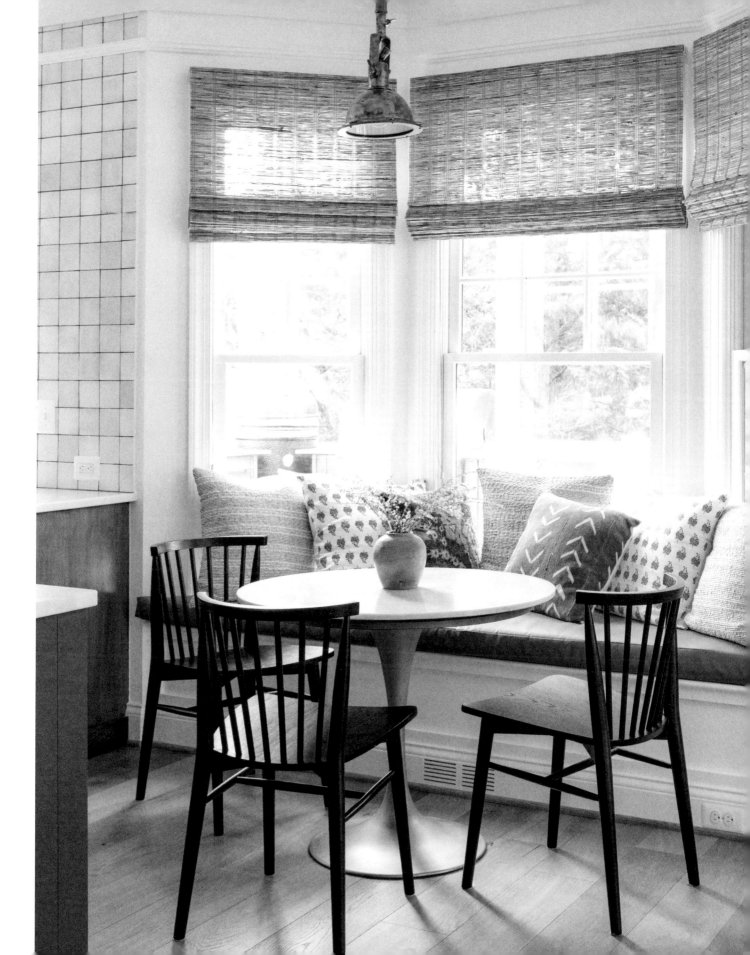

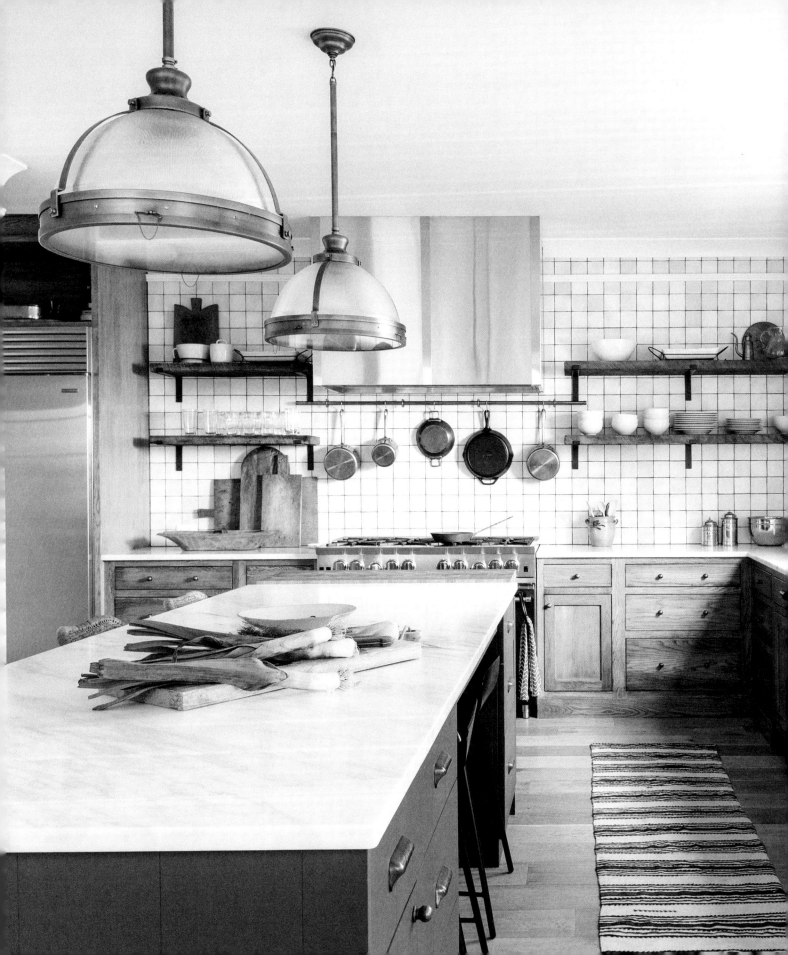

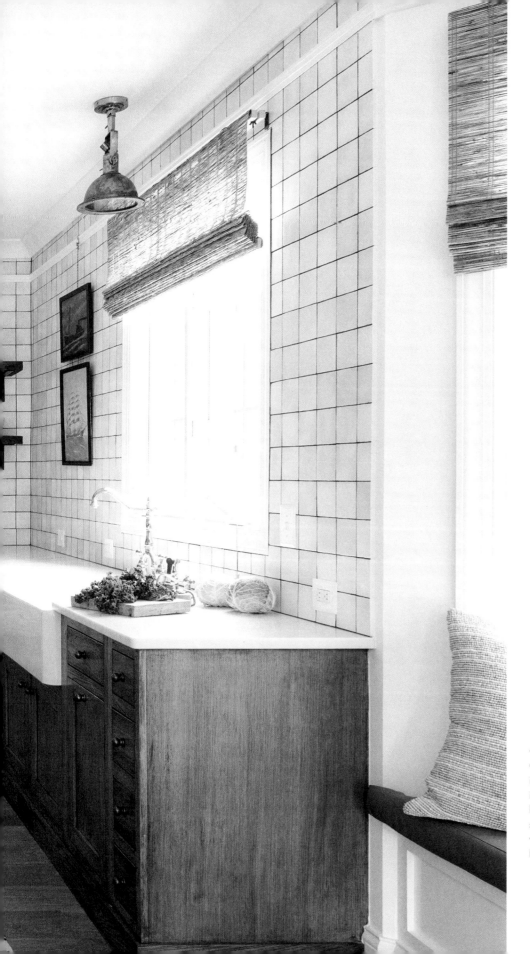

mix it up

Oak cabinets mix with a black island, and a variety of metals were incorporated to add "color" to the kitchen—brass, copper, iron, and stainless steel. Warm elements like wood and woven materials make the kitchen feel charming and cozy.

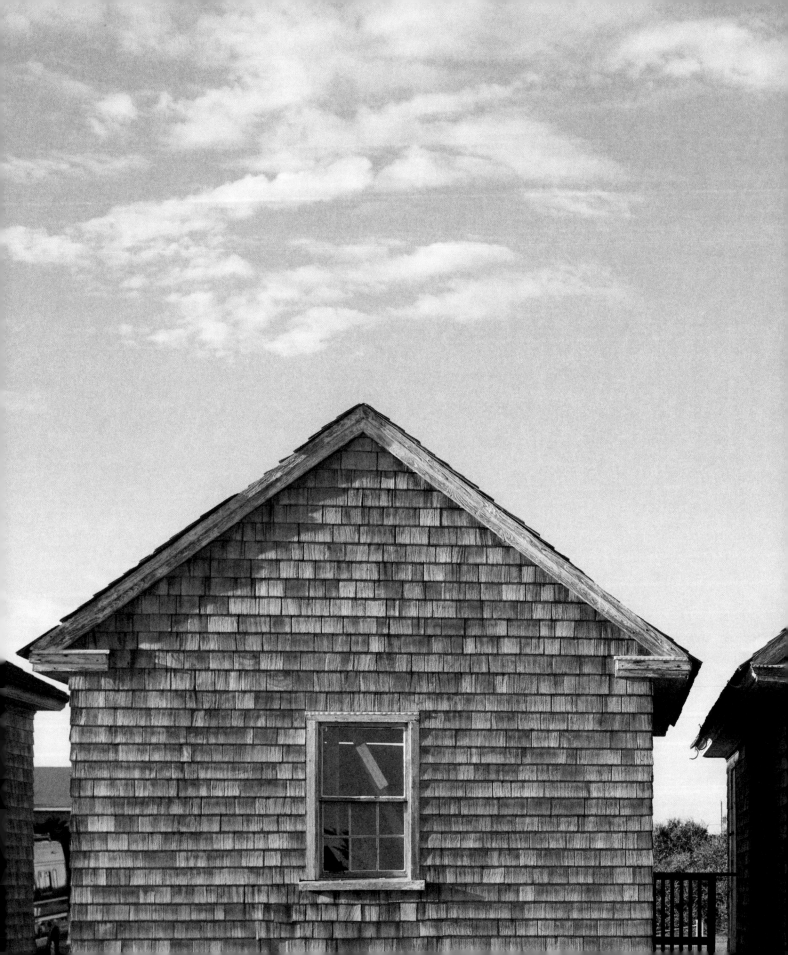

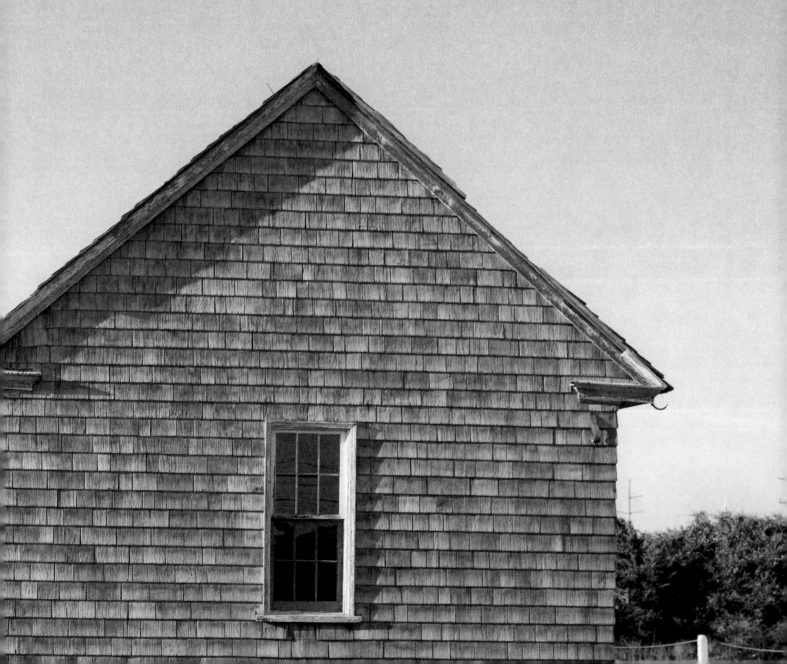

"The sea, once it casts its spell, holds one in its net of wonder forever." —JACQUES COUSTEAU

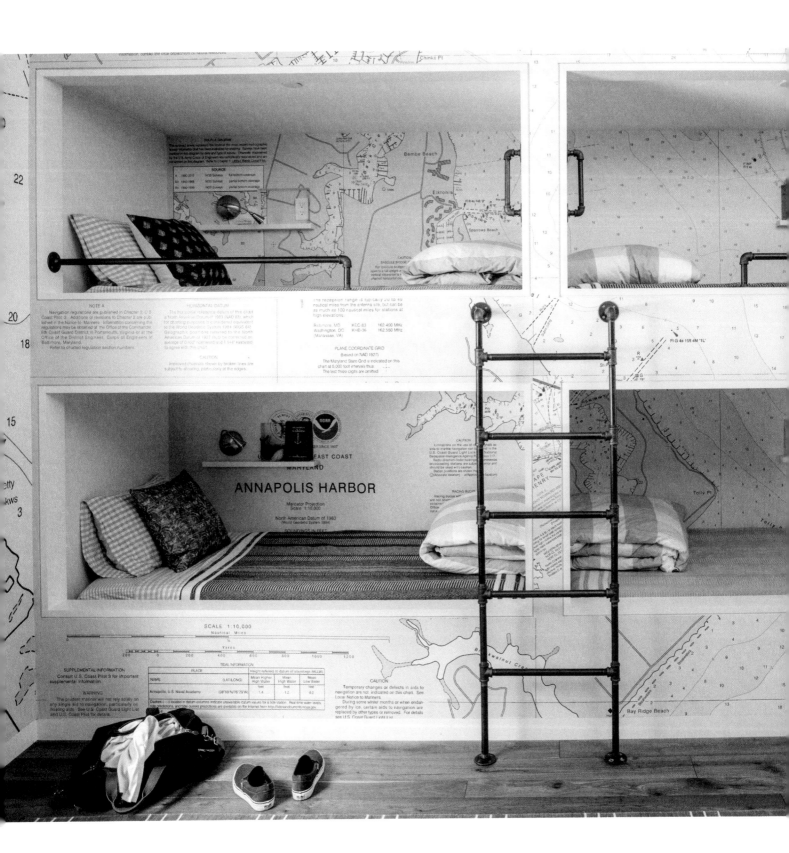

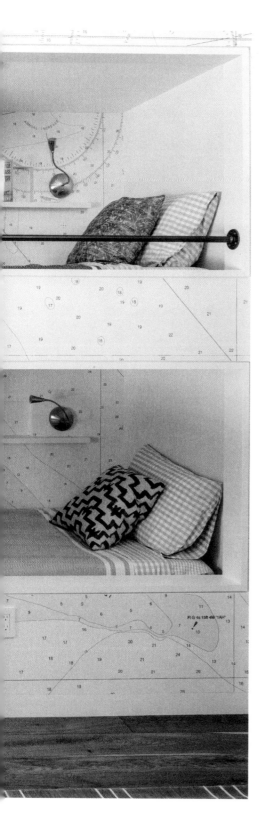

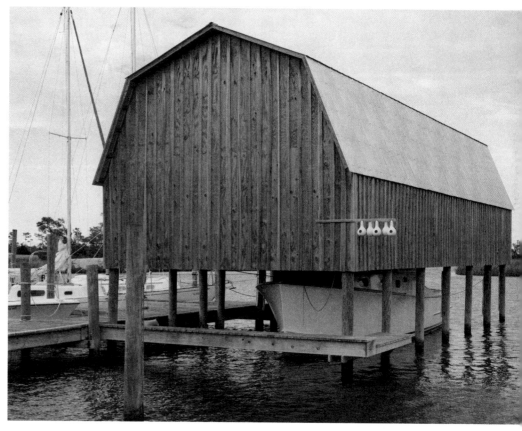

local flavor

Streamlined bunk beds—with mismatched blankets for a little bit of quirk—help sleep a crowd when needed. We had the custom nautical chart by the late "Skipper" Steve Morris in this Gibson Island home papered all over the walls and ceiling, so the kids could enjoy learning about the bodies of water around them. Architecture by Hutker Architects.

stark simplicity

I love the stark, charming simplicity of many of the old boathouses in the Outer Banks. Thinking about the exterior architectural elements can help guide thalassophilic interior design.

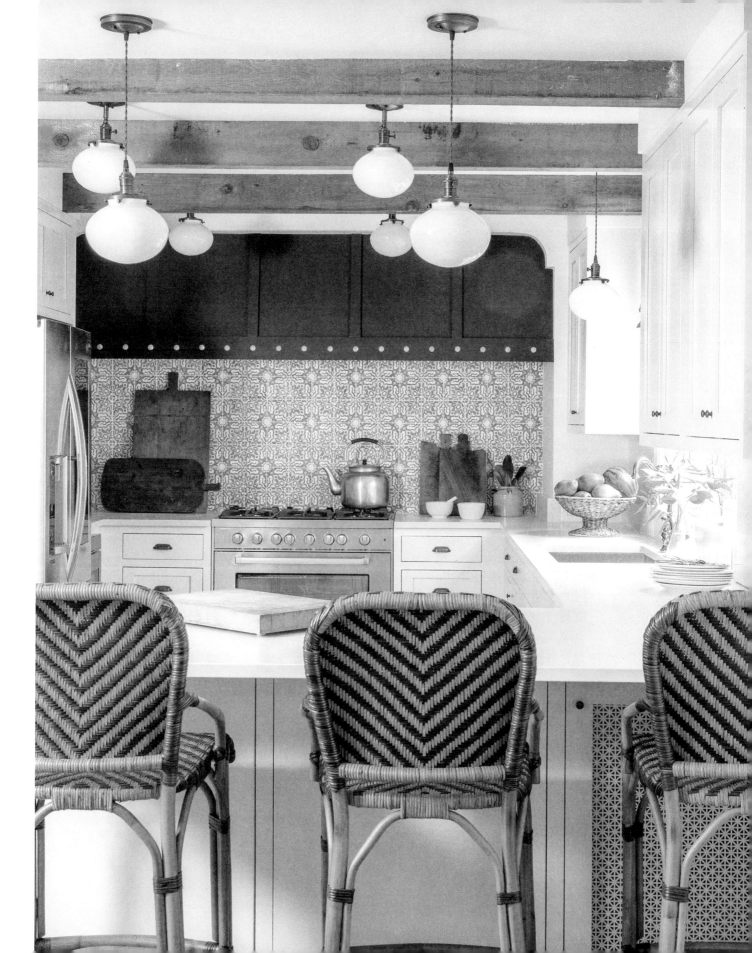

PREVIOUS LEFT
Aged cedar is a coastal staple.

PREVIOUS RIGHT
Rattan chairs and watery blue tiles offset each other in a classic beach palette.

RIGHT A painted striped "rug" under the dining table makes cleanup a breeze.

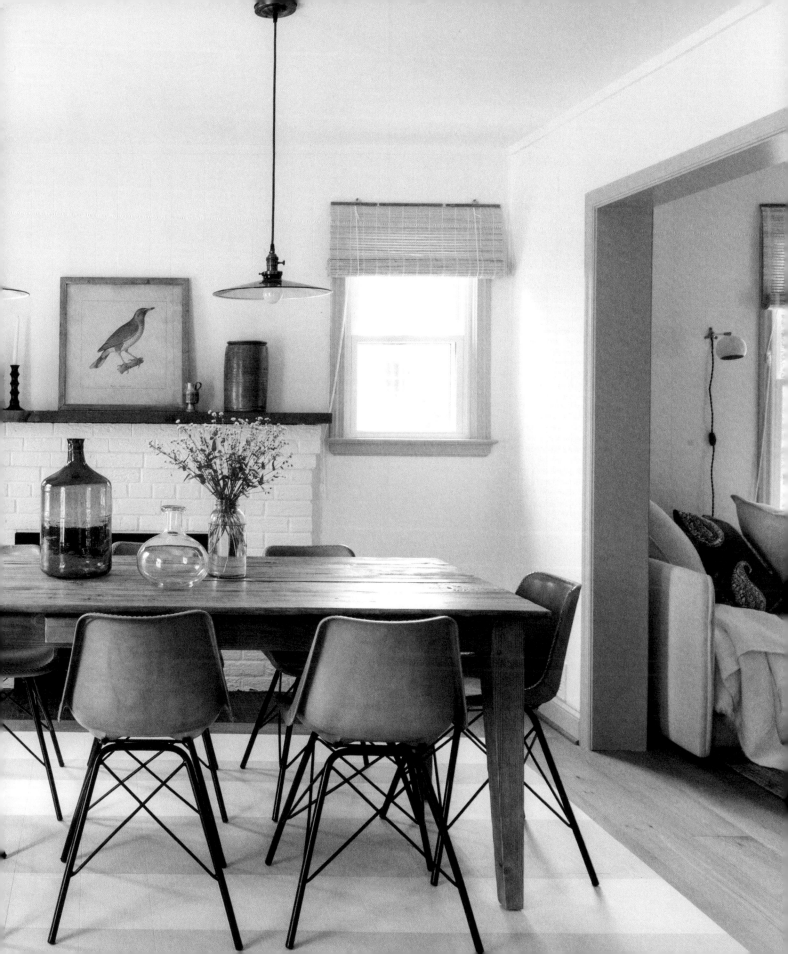

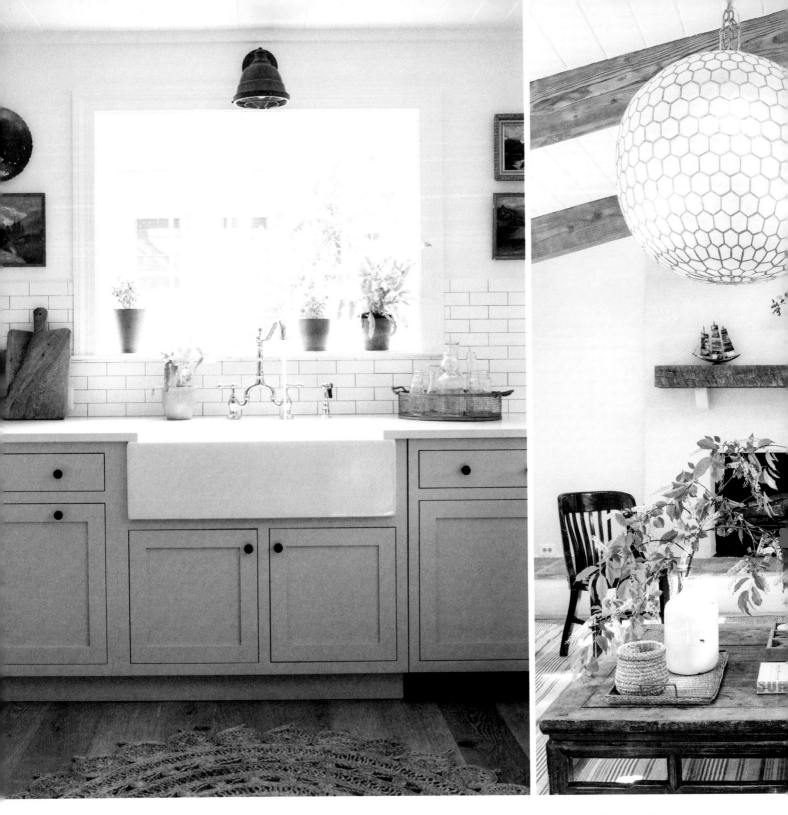

ABOVE LEFT Nautical lighting mixes with the timeless shaker cabinetry in this classic kitchen.

ABOVE RIGHT Relaxed branches, stripes, and natural woven elements help create an "easy-breezy" vibe.

OPPOSITE Casual materials like linen, cotton, and rattan give this bedroom a light and airy feel.

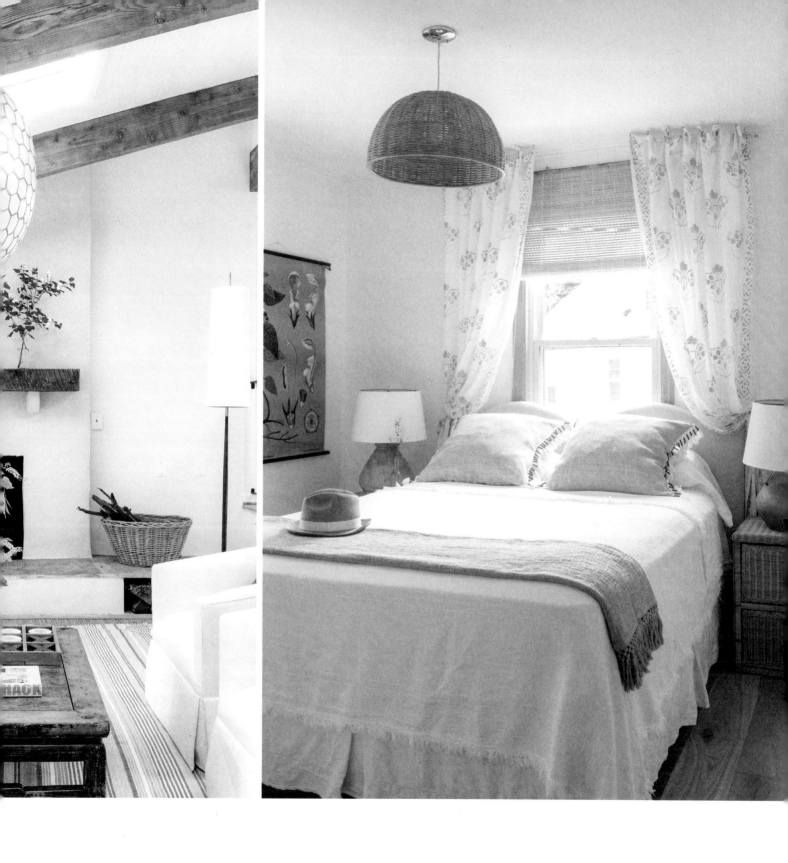

"Everything good, everything magical happens between the months of June and August." —JENNY HAN

chapter 3
lost and found

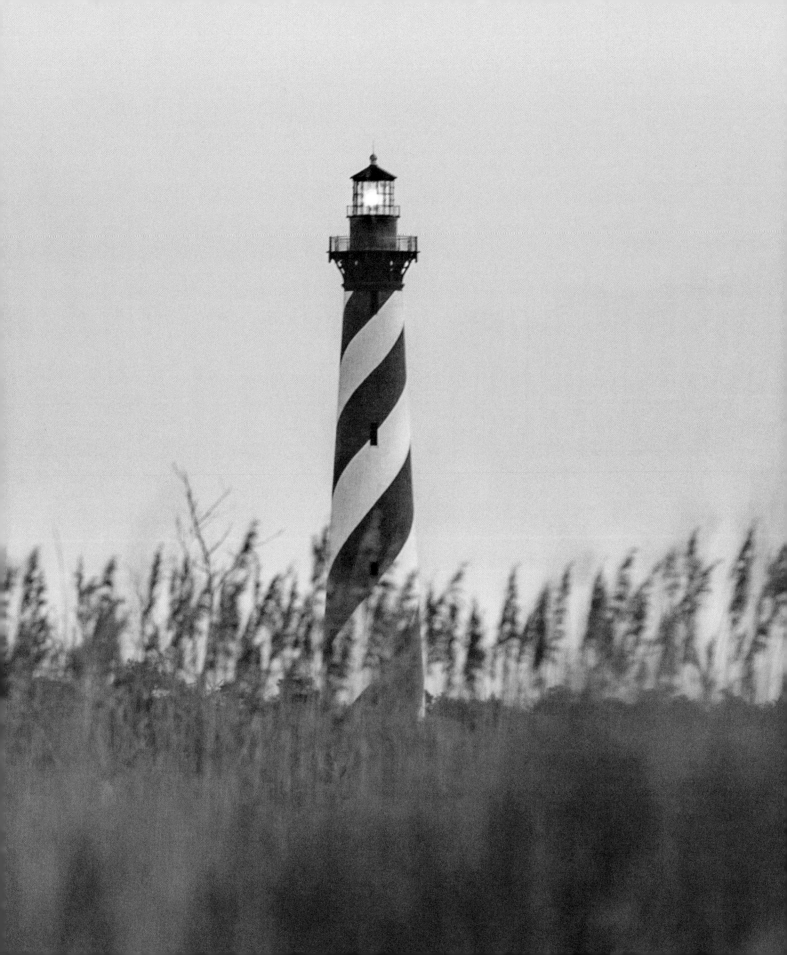

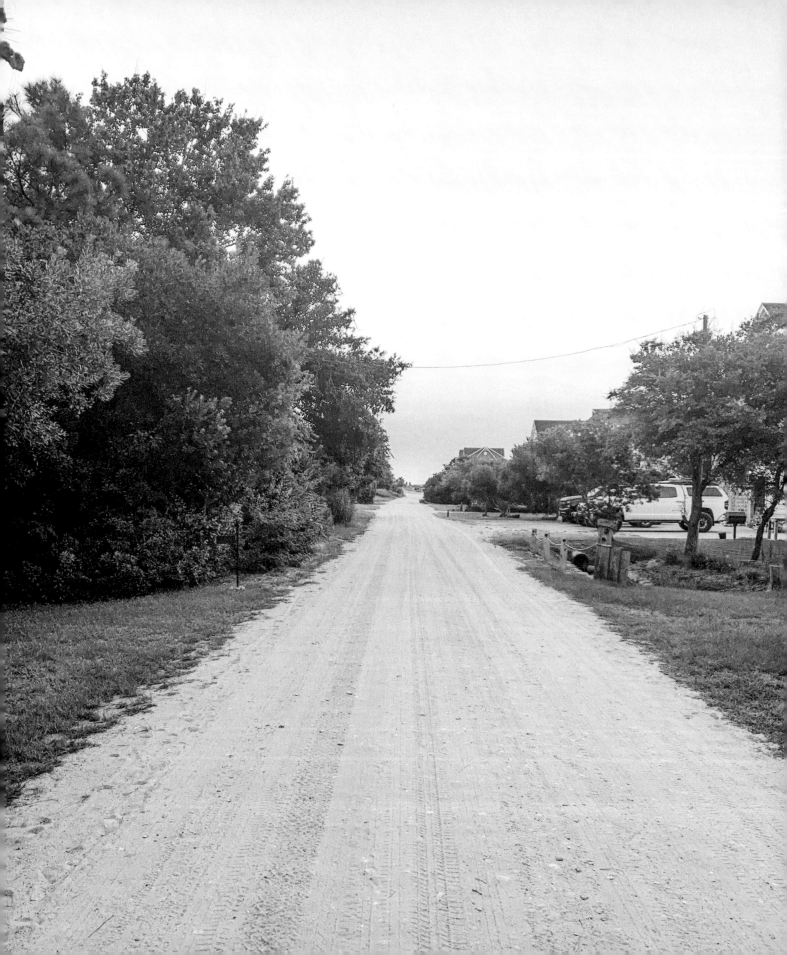

By the time the sun rose on that Saturday morning in June, Dave and I had pulled up the real estate listings we'd been scouring for years. We had no plans for the weekend, so we booked an Airbnb, packed our bags and the kids, and headed down to the Outer Banks in our jam-packed minivan to play-hunt for houses.

I didn't think anything would come of it. We'd been talking about finding a beach house for so many years, but perusing real estate listings online was just a fun exercise we'd regularly take part in and never really do anything about. Although, we had never actually gone down to look before, so I should have been prepared for what was about to happen.

When we got there, we decided to look at two houses. The first stop was a four-bedroom with a wraparound porch that would make the perfect rental property: close to the beach, walking distance to fun things, enough bedrooms for kids and guests, a charming exterior, and in need of a simple, straightforward interior redo. We spent an hour or so there while I thought about how we could update the house to get the rental price we'd need to cover the mortgage. The expenses would be considerable though, and in the end we realized we couldn't afford it.

I figured we'd save up and come back years later to see what we could find, but Dave still wanted to go see the two-bedroom, eight-hundred-square-foot "surf shack." It was only a street or two over and was less than half the price of the other house. (In fact, it was the least expensive house in town by hundreds of thousands of dollars!) I didn't take it seriously due to its small size and our family's large size, but Dave insisted we check it out.

OPPOSITE One of the last remaining sand streets in Corolla

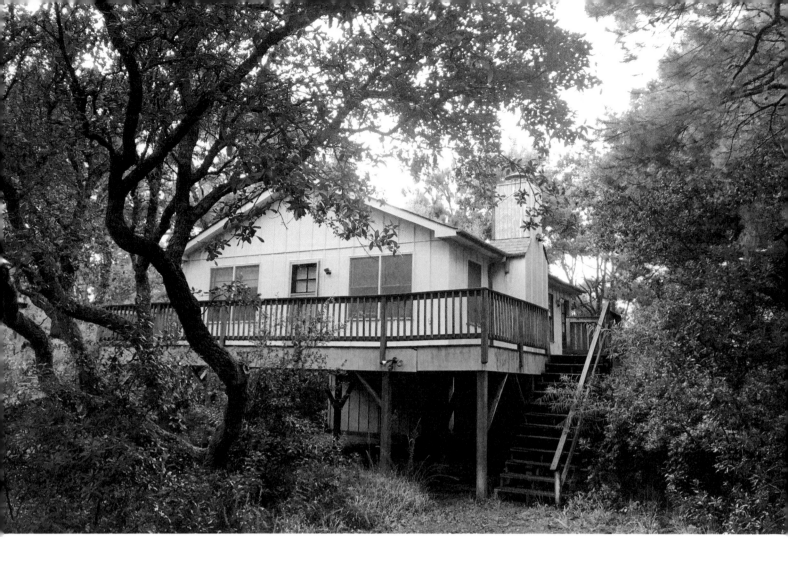

"This street feels good," I said as we drove down the sand street. It was wide enough so that the brush wouldn't graze the cars as they drove by, but narrow enough that it still felt like an old-fashioned side street. It was smattered with divots filled in with oyster shells someone had laid down in an attempt to flatten out the potholes. Charming cedar cottages lined the way to the surf shack and I fell a little in love with the nostalgia of the place. When I saw the house—hidden by pine trees, Russian olives, and poison ivy gone wild—with a massive live oak tree in the front yard, a crooked deck, and what looked like water damage underneath the house, my heart started beating in the way it beats when it feels like my life is about to be upended because we're going to do something crazy. Though it was hot out, I shivered.

We climbed up the rickety stairs to the deck, holding on to the little ones' hands. The interior was light and cheerful. Pale peach cabinet doors with little brass vintage knobs greeted us in the kitchen. I loved it!

The little cottage was hidden among the live oaks and Russian olives.

"My surf shack!" Dave said giddily. I couldn't join him in his excitement. I was busy designing the house in my head and worrying about the fact that this situation seemed doable.

Wall-to-wall carpeting and linoleum floors could easily be replaced with hardwood. A wall of windows in front would give us a view of the live oak tree . . . That would mean needing to move the front door. Can we raise the ceilings? Can we get another bedroom somehow?

I walked quietly from room to room (there were only three; four if you counted the bathroom) reworking the floor plan in my head, trying to figure out how to get five beds—one for each of the kids—into one of the two ten-by-twelve bedrooms. I thought about going up, but the roof wasn't high enough for a second floor and we didn't have the budget for changing that. I considered going down, which I knew was dicey being so close to the water and I wasn't sure the lower level would have the headroom. (Turns out, it

didn't.) I decided I'd steal space from the bathroom and closets to get the kids enough room for five beds.

We went out to the small side deck and found a jungle of a backyard teeming with live oaks and pines completely overgrown with thorny vines. I pictured a big deck with an extra-long picnic table overlooking the trees in the backyard. The back bedroom would be ours and a big glass sliding door would lead from our bedroom to the imaginary future deck.

We wandered down the deck stairs and under the house—which was mostly open as it was on pilings—and found an old bathroom coated in mud from flooding. Just as I had suspected, the entire underpinning of the house was soggy and rotten.

Well, we told the Realtor, we would most likely make an offer. We decided to speak with a contractor first, to get some sort of ballpark estimate for what we were in for. We met with one the next day. "If you were my daughter, I'd tell you to run," he said. "It's a teardown." No matter how much we explained we understood that we would potentially be putting more dollars into the home than it was worth, he wouldn't even quote the job for us.

Dave and I sat with that for a bit and eventually made an offer anyway. We estimated it would cost "a lot" more than we wanted it to, but believed we'd never see a house as close to the beach, as charming, and as inexpensive as this one ever again. The best part was that, because of the low price, we wouldn't need to rent it out and so would be able to visit whenever we wanted.

We called it "the Lost Cottage" in our conversations, a nod to the unsolved mystery of the Lost Colony and the fact that it was so hidden it was almost "lost" in the trees. It turned out though that there were three other parties (as we heard years later, one was the contractor we had met with) interested in the Lost Cottage and our offer was not accepted. My heart fell and I had to remind myself that's just how real estate is sometimes. You set your eyes on a house and it feels like "the one" but you don't always get it. For as many stories as I have about special houses we've bought and fixed up, I must have three or four times that number of stories for ones we missed out on or passed up. We decided not to bid on anything else because (a), the Lost Cottage was actually the one we wanted and we weren't going to settle and (b), we couldn't afford anything else. We chuckled about the fact that it—ironically and sadly—was truly our "lost" cottage.

But a few weeks later, we got a call. The buyers of the cottage had gotten cold feet because they met with a contractor and were told it was a teardown. Did we still want it? We had one last chance to bid against the other remaining

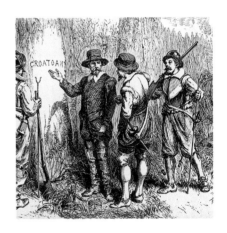

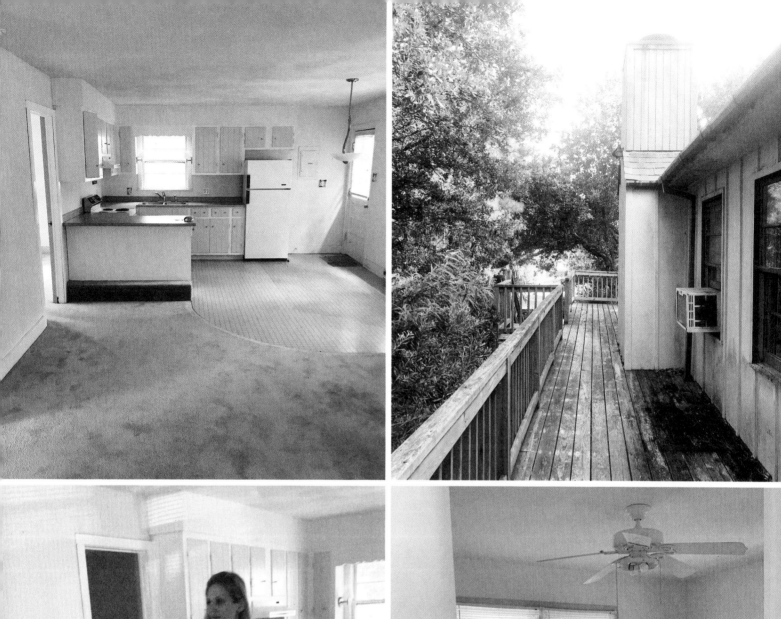

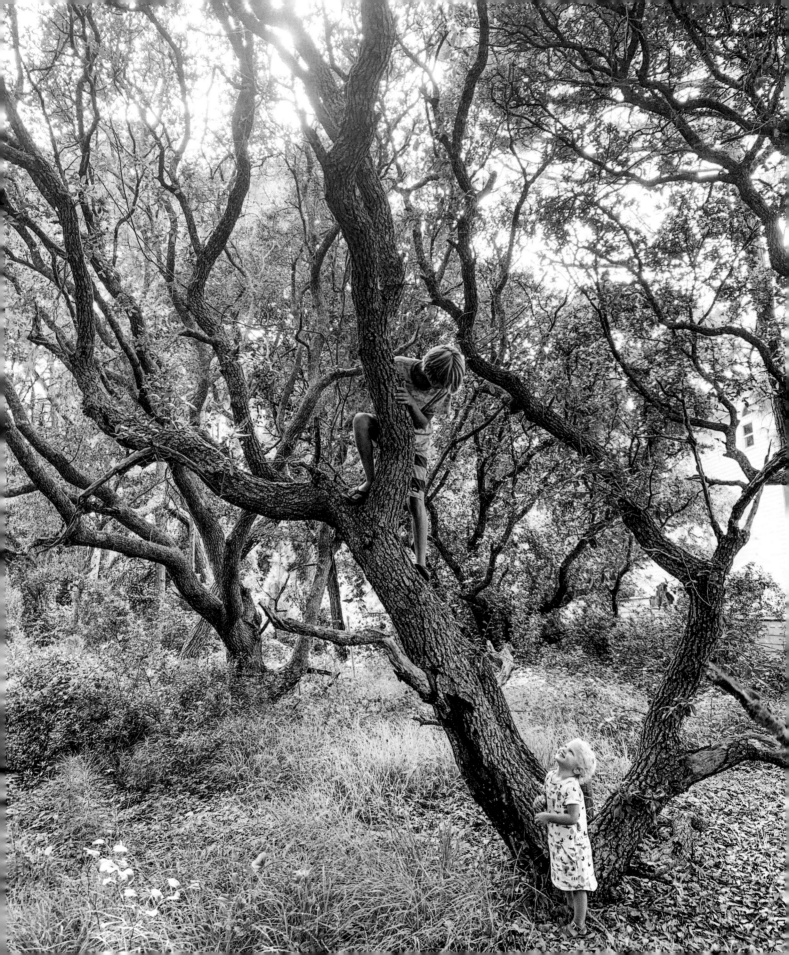

buyers who were still in. After much deliberation, we wrote our best and final offer and it was accepted. The Lost Cottage was ours!

We couldn't believe it. What had started out as a pipe dream was now a reality. We were so grateful to be able to make this little place for our family, this tiny surf shack that would shape our kids' lives for years to come. We spent the next year or so heading to and from the Outer Banks with the kids to plan the project and check on work at the cottage with our (new) contractor, Travis. We had to explain that our instructions wouldn't always be typical and that we would be retrofitting, repurposing, and specifying design details that needed to be followed to a T even though they might sound nonsensical, like telling the team, "Don't hang any of the boards perfectly straight. Mess up a little and make them crooked."

As it turned out, an old friend from my summer of working at the beach during college lived in the cottage next door to us with his wonderful wife, so we had unknowingly moved next door to people who would go on to become some of our closest friends. I have laughed harder and danced more than I had in years thanks to all our amazing friends down there.

a good climbing tree

Live oaks make the best climbing trees. My son Louie recently told me that he thinks the oaks like having kids in them. I think he's right. Like old friends, they're always there waiting for us. Christian looks down at Aurora from the tree.

RIGHT Dave and I celebrated closing day on the old front deck at the Lost Cottage. We loved visiting the house when it was under construction. We'd often make sandwiches from the grocery store or order pizzas to eat on the beach, since we didn't yet have a house or even a kitchen.

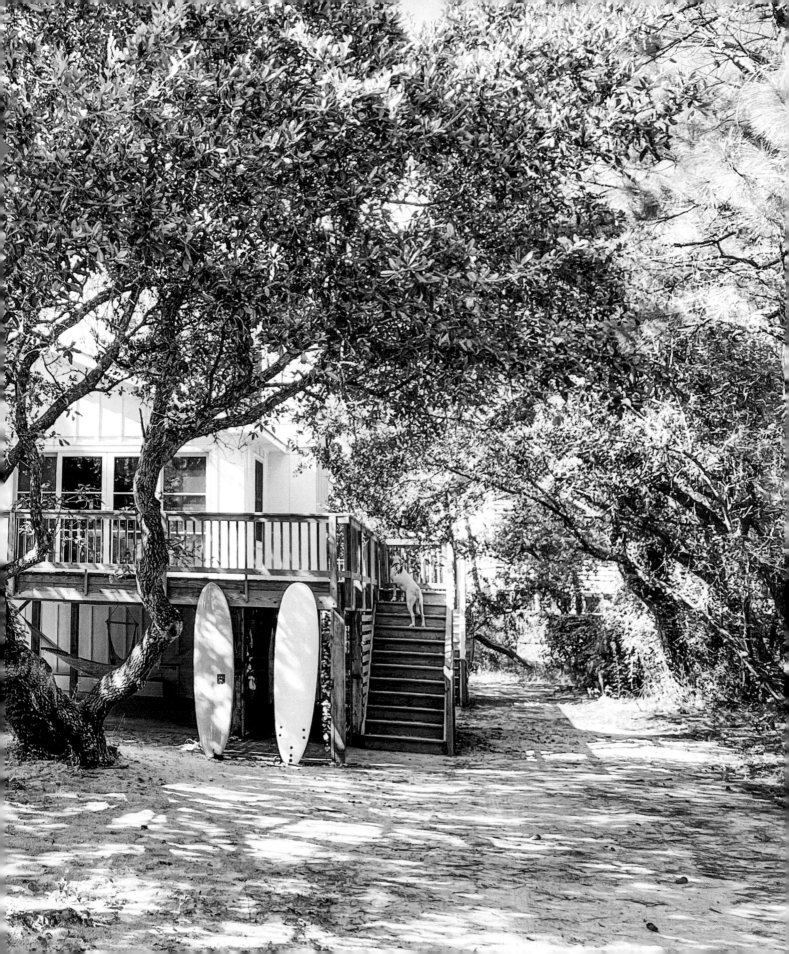

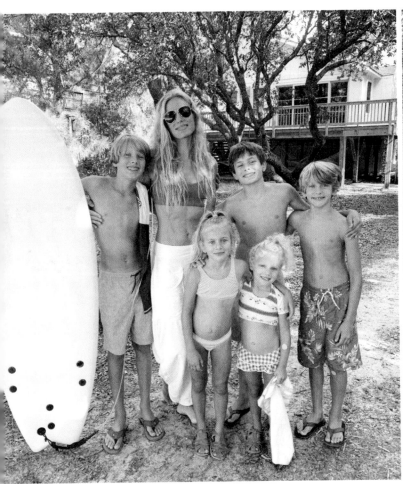

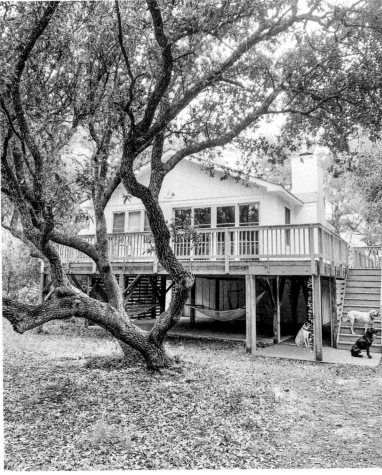

The rest of our sweet little street welcomed us and the kids with open arms and I sometimes think about how different things would be for us if we had chosen another house on another street.

The next summer, we moved in and unpacked in what felt like a day (major perk of a tiny house!) and got right to beaching!

We had no idea how much we would be in the Outer Banks, spending as many days as we can there, even in the off-season. Some of our kids have summer jobs down there and—thanks to virtual meetings—Dave and I are able to work from there almost the entire summer. I love our cozy little cottage in the winter, when the town is empty and we light all the candles and cuddle up on the sofa to read and watch movies. I love it when we get together with friends around a fire in the fall or are given a day that feels like summer in the early spring. In so many ways this little place has set my summer spirit free.

LEFT Me with our five kids

RIGHT Our five dogs in front of the house one fall

OPPOSITE Gisele loves skating on the decks at the cottage.

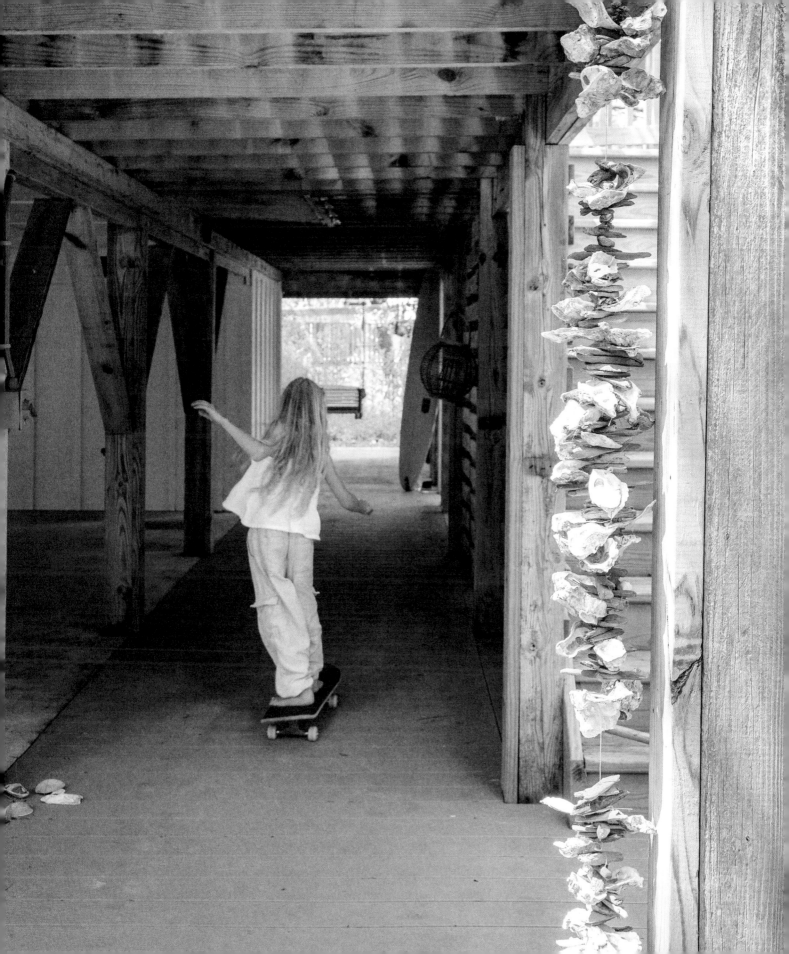

living small

Inside our eight-hundred-square-foot cottage, I find stuff inevitably begins to collect: natural objects, dirty clothes, books, shopping finds, extra food on the countertop, more sunscreen and chapstick, supplies for future projects, and garbage the kids are currently playing with, etc. (And by "garbage," I mean actual garbage because they don't have many toys, so they love a good bottle or cardboard-box craft project!) If we don't constantly edit and stay on top of what's in the house, we are quickly overrun with clutter. We try not to buy much, but despite my desire to be a minimalist, we'll inevitably come home with pirate gear and other such quality purchases that we felt the need to make room for.

Minimalism comes easier to some of us than others, but I think it's about finding the form of minimalism you can subscribe to, the level of minimalism you can realistically handle. The older I get, the less I seem to want around me (with the exception of books . . . I do have a book problem.) What was once an okay amount of stuff to deal with is no longer manageable for me.

When designing the house and hunting for all the furniture, I adopted a more minimalist mindset than I was used to. I bought nothing accidentally or because it was convenient. There are only thirteen different pieces of furniture (plus mattresses) inside our house so each and every piece had to be just right and perform a specific function.

We have one open living/kitchen space, two bedrooms, and a bathroom on the main level and everything in the cottage just barely fits. Outside, under the house, the laundry room and a second bathroom can be accessed. There is also a large outdoor shower and hammock space down there. Our decks are oversize and function as outdoor rooms, so we do a lot of our living outside. The kids' domain is the pirate ship playground in the backyard which has bought Dave and me hours of quiet in the house. We sat four Adirondack chairs in a circle in the sand in the back under the live oaks and it's one of my favorite spots to listen to music and have a drink at in the afternoon.

We rearranged the bathroom, giving up the closets to steal space for a fifth bed in the bunk room. We took space from the bunk room for a shower. I am not exaggerating when I say that fitting five beds in one of the tiny bedrooms came down to the literal inch.

mission control

Honey Bear, one of our three dogs, matches the house palette. A galvanized-steel bench with an upholstered top by the recycled original entry door is a godsend for housing all our shoes and a bin of sunscreen. A simple wooden peg rail is a catchall for drying towels, hats, beach bags, and coats (in the off-season). The hanging fish-trap lantern gets used all the time, providing cozy ambiance in the evenings or during storms and does double duty as outdoor lighting when we have dinner or drinks on the decks.

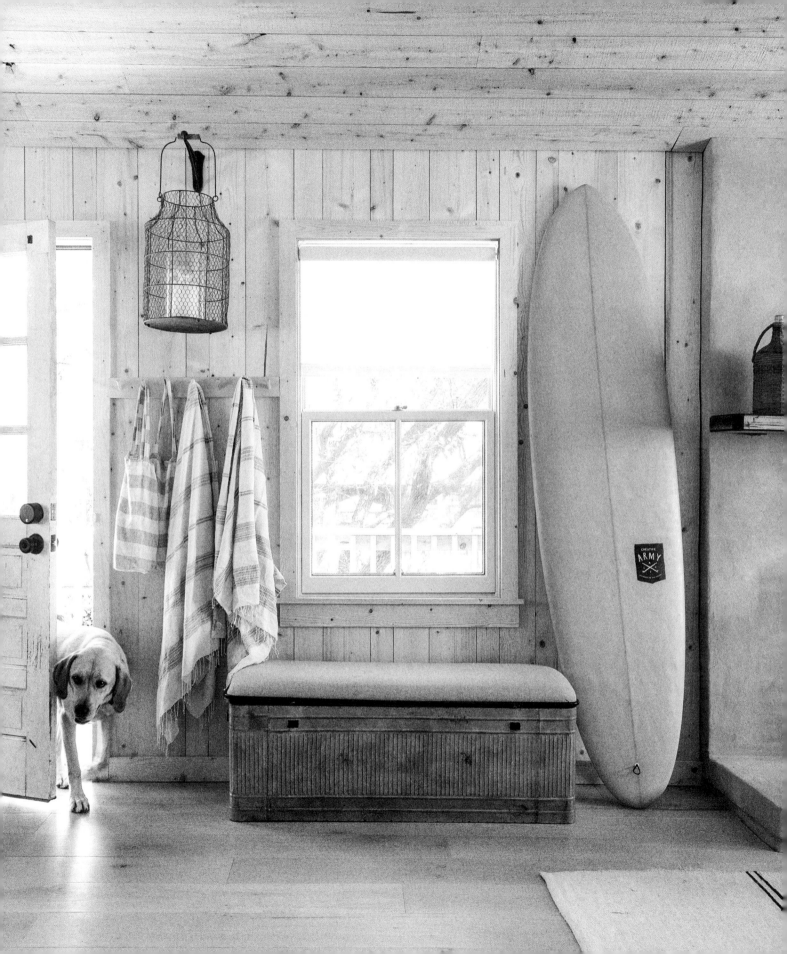

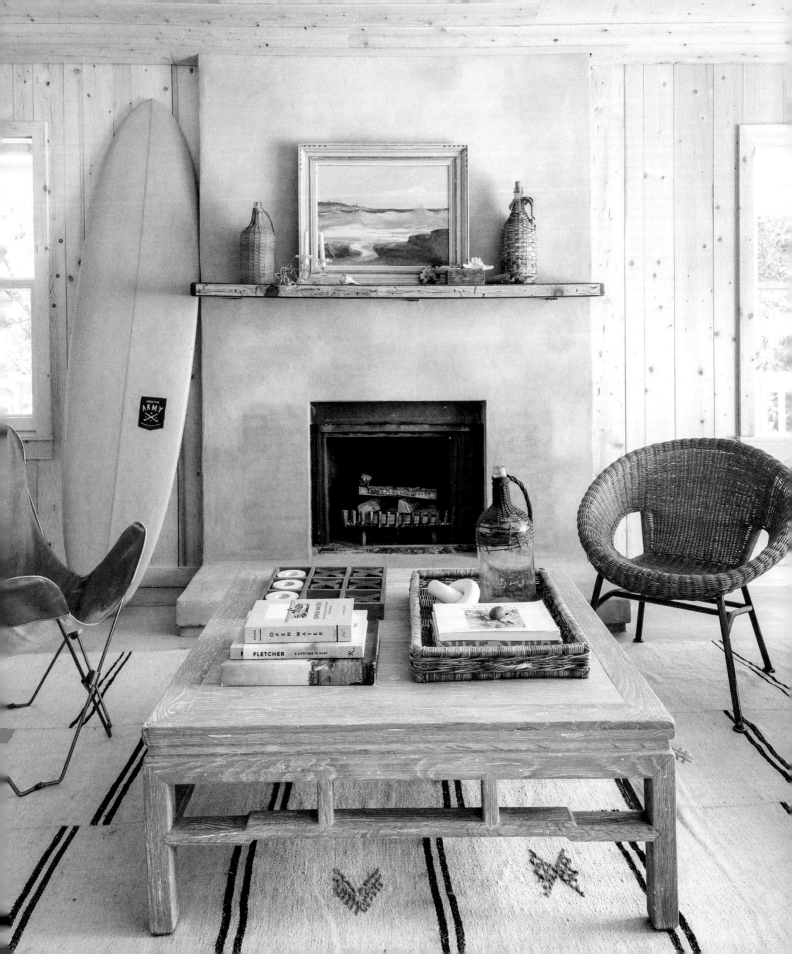

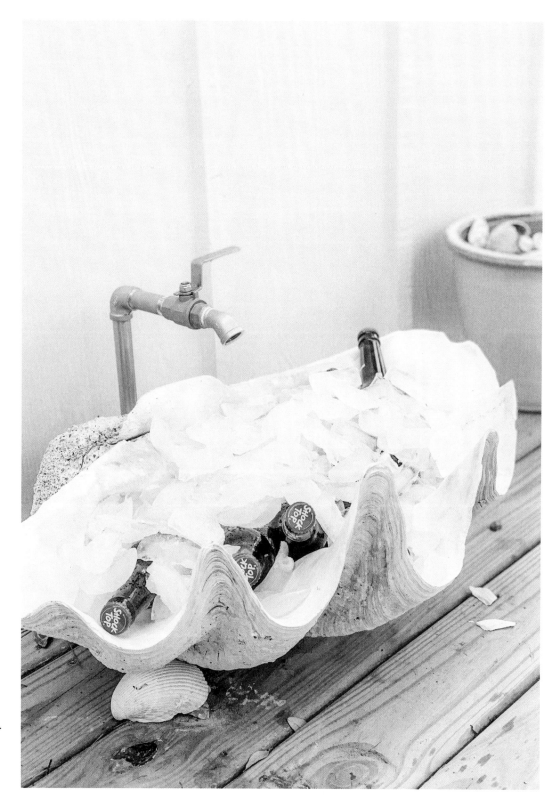

creating cozy

The fireplace grounds the living room and provides a focal point for gathering around. We coated the original bricks in fireproof plain concrete.

shell footbath

A big old shell I found years ago at an antique sale serves as a sink for rinsing off sand before going inside. We fill it with ice and beer during parties, as seen here.

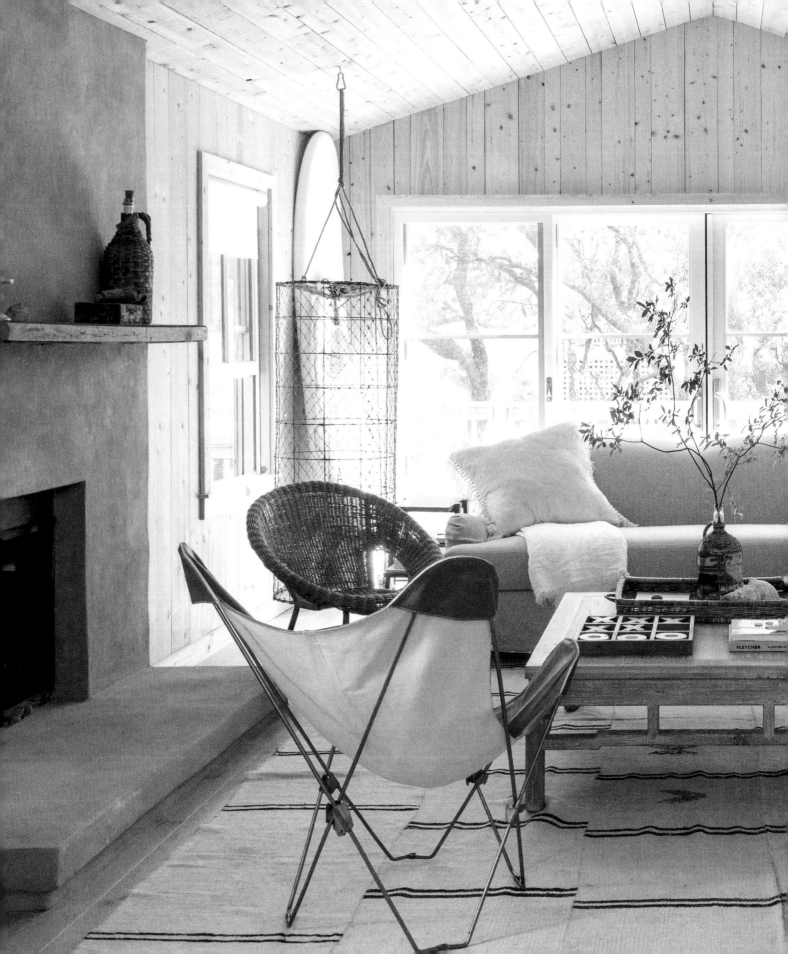

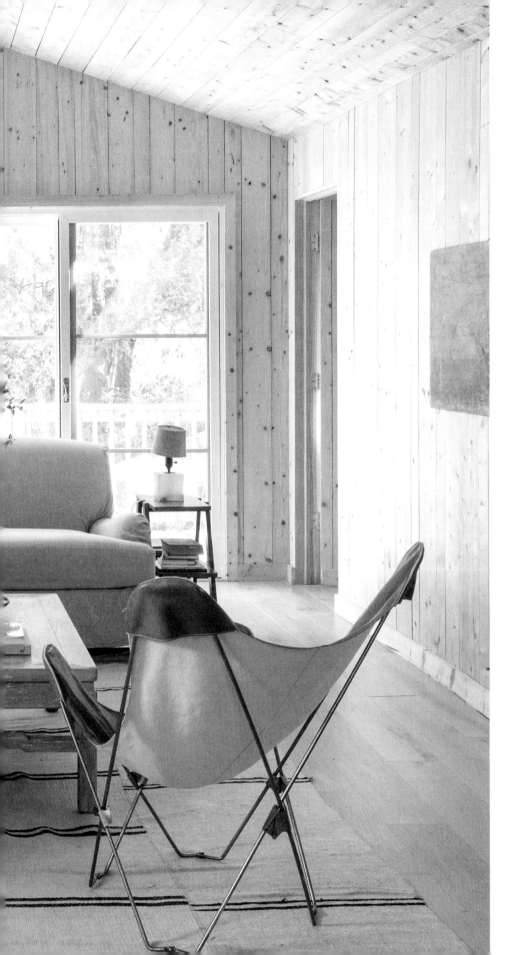

the illusion of space

The biggest (and best) decision we made at Lost Cottage was to vault the ceiling in the main room. At one point in the project we scrapped the idea due to budget, but thankfully Dave pushed me on it and asked if I'd regret not doing it. I knew that with seven of us, plus the three dogs, every square inch in the house—even if those inches were vertical—would matter and that if the ceiling stayed low, the house would feel much smaller and more chaotic when we were all in it, filling it up, so we bit the bullet and raised the ceiling.

We have an extra-large coffee table for easy game playing (a room feels bigger when you're not struggling to fit a bunch of things on a tiny surface) and because even though the room is small, the large coffee table helps to visually expand the space.

We decided to forgo a dining table in lieu of a larger (though not very large at all) kitchen with seating for seven at the peninsula. We had always eaten most dinners outside at the beach and thought that the picnic table on the back deck would be our main dining table but as it's turned out, we eat as many meals at the peninsula as we do outside. Had we tried to cram both a dining area and a kitchen into the space, neither would have been fully functional and the entire room would have felt chopped up and pinched.

double duty

In small spaces, things have to do double duty. Our leather butterfly chairs from the living room often find themselves shifting around the house— maybe brought into a bedroom for extra seating when movie-watching or outside on the back deck around the coffee table or under the house for dance parties. We specifically picked light, foldable chairs so they'd be easy to move and use in other places.

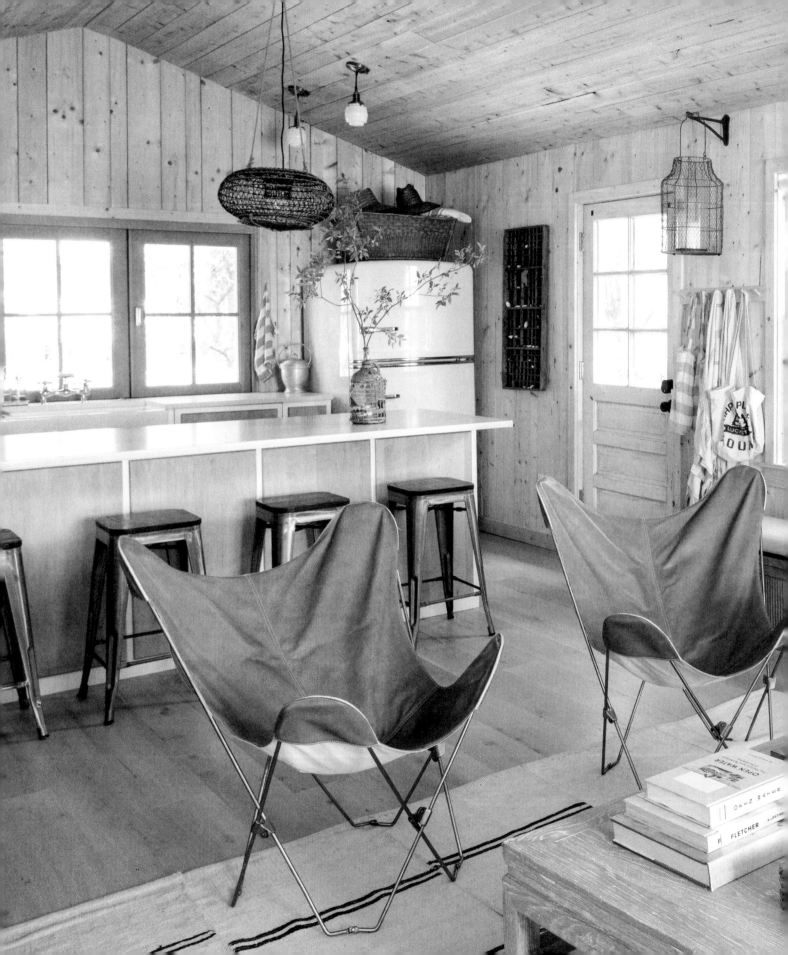

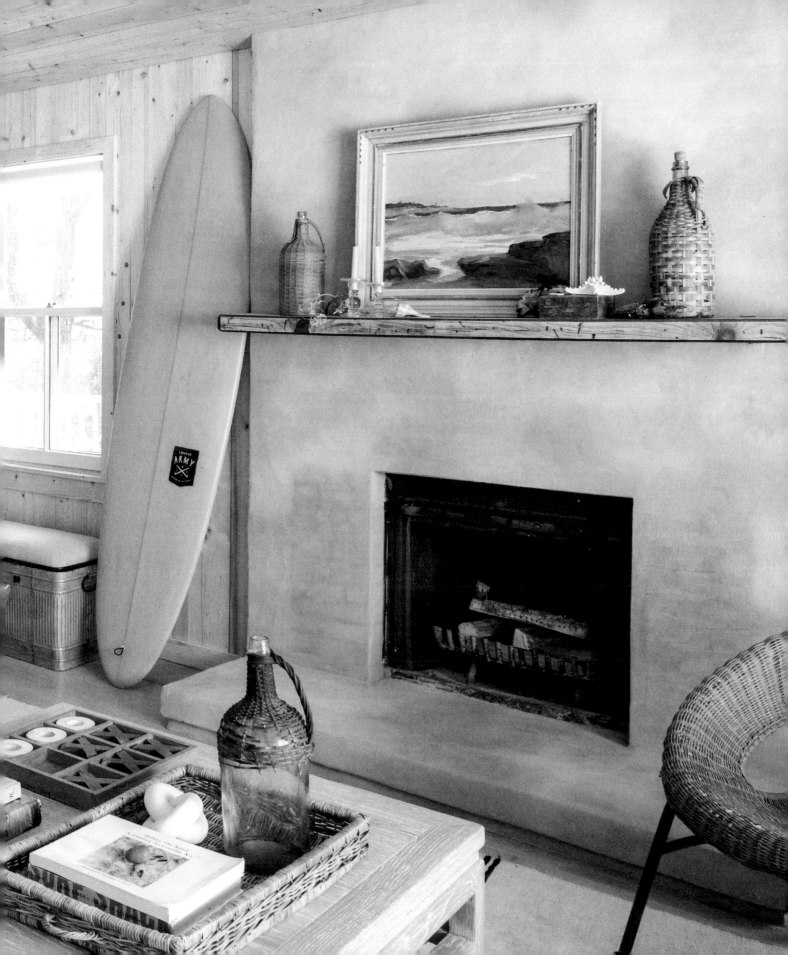

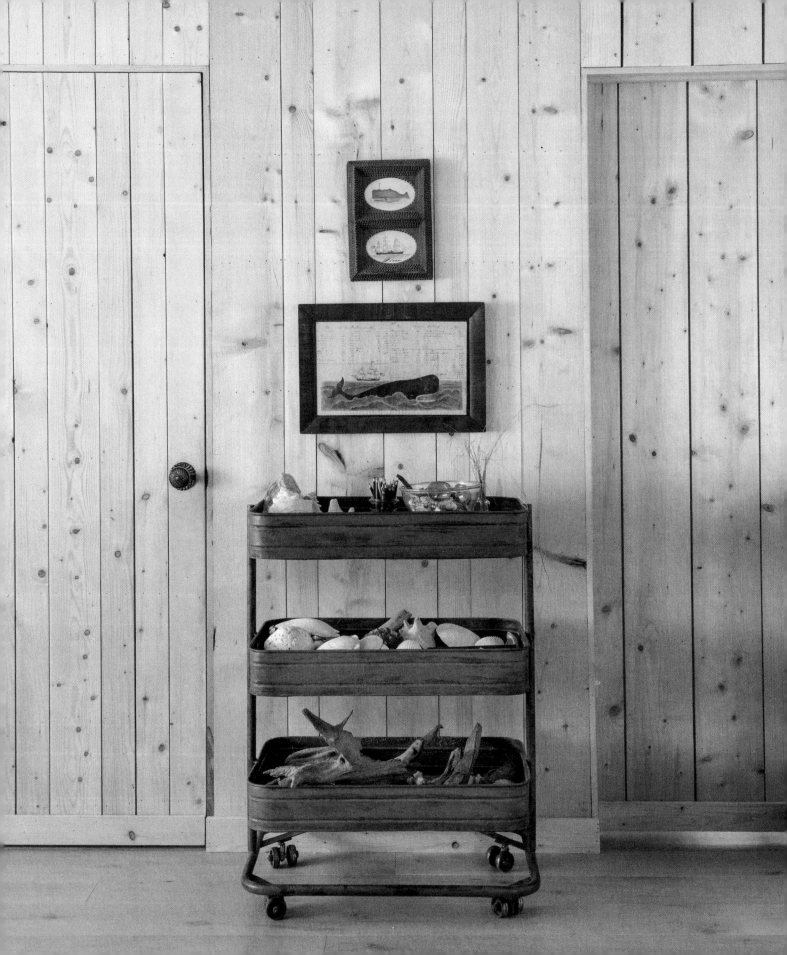

functional decor

In a tiny home, there isn't any room for "extras." Almost everything we bring into our small cottage needs to perform a function. We've been careful to make sure each item we bring into our little house fits with the vibe of the cottage, essentially turning our functional items into decorative objects that enhance the environment. (Sidenote: I recommend taking this approach to normal-size homes too!) Surfboards lean in various corners of the house, and go in and out as needed adding to the "surf shack" vibe Dave had envisioned. I even selected our linen dishrags with the house in mind, knowing that in such a small space, everything has a bigger effect.

An old factory cart corrals our seemingly endless collection of nature finds—driftwood, shells, sea glass, and fulgurite (the gray stones found all over the beach, made by the fusion of sand by lightning), among other things—along with acting as a storage console for things like keys, sunglasses, lip balm, cards, colored pencils, and hair ties. This thing helps me keep my sanity as I just toss anything and everything in it.

An antique French market basket on top of the refrigerator (next page) holds a routine supply of beach blankets, towels, and straw hats. Each and every one of these items is something we need in the house but was selected for an aesthetic purpose as well.

BELOW LEFT Towels are a functional necessity, and I knew they would be getting left out all the time, so I picked towels from my shop that matched the décor of the house.

BELOW RIGHT We made friends with a tiny ghost crab on the beach one day.

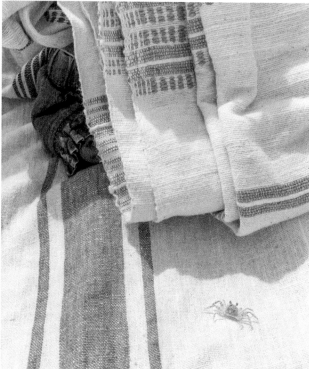

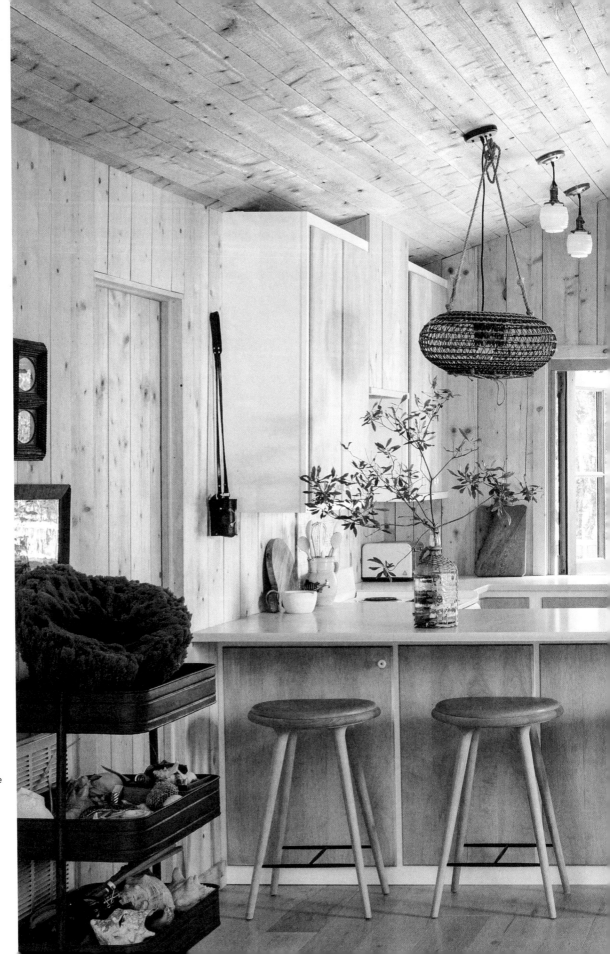

simple and sweet

I kept the kitchen intentionally spare, choosing a large pass-through window in lieu of cabinetry to bring in the views of the backyard trees. There are five counter stools on one side of the peninsula and two "secret stools" on the back side to accommodate all seven of us for meals. The kitchen is tiny but functions beautifully.

yesteryear

I designed the cabinets for my collection with Unique Kitchens and Baths to look very close to originals.

pattern play

Seen on the next page, I hand-drew the original pattern for our tile and named it "folk bouquet" for my collection for Architessa. Our retro white twenty-four-inch-wide range goes a long way in instilling quirk and charm onto our wood-dominated space.

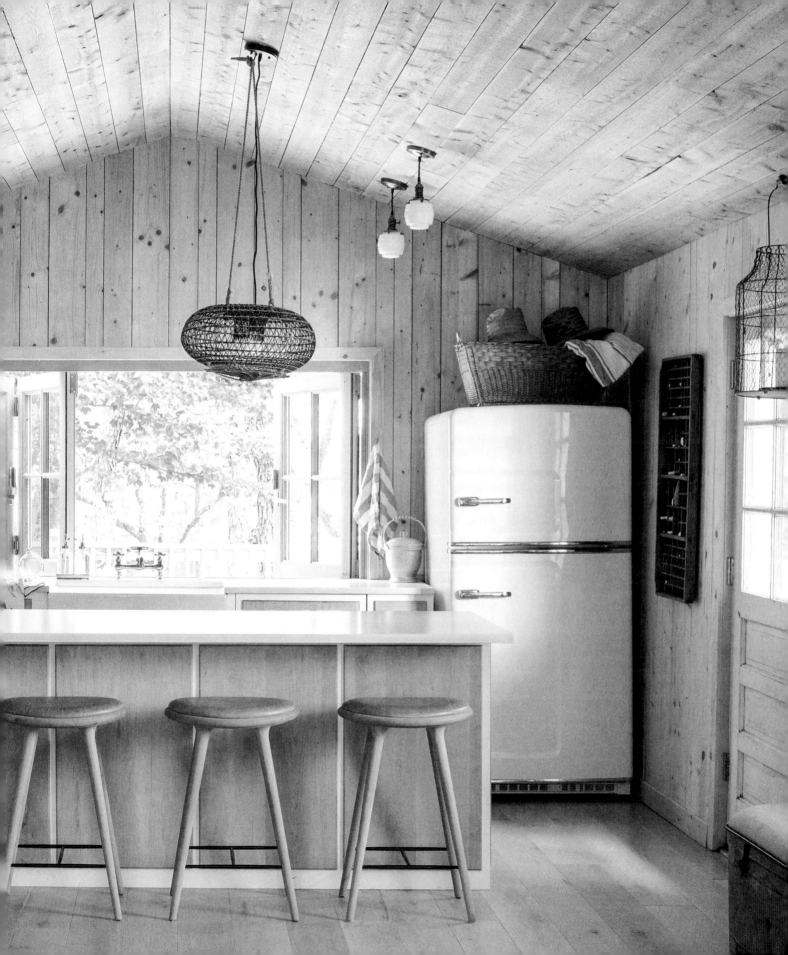

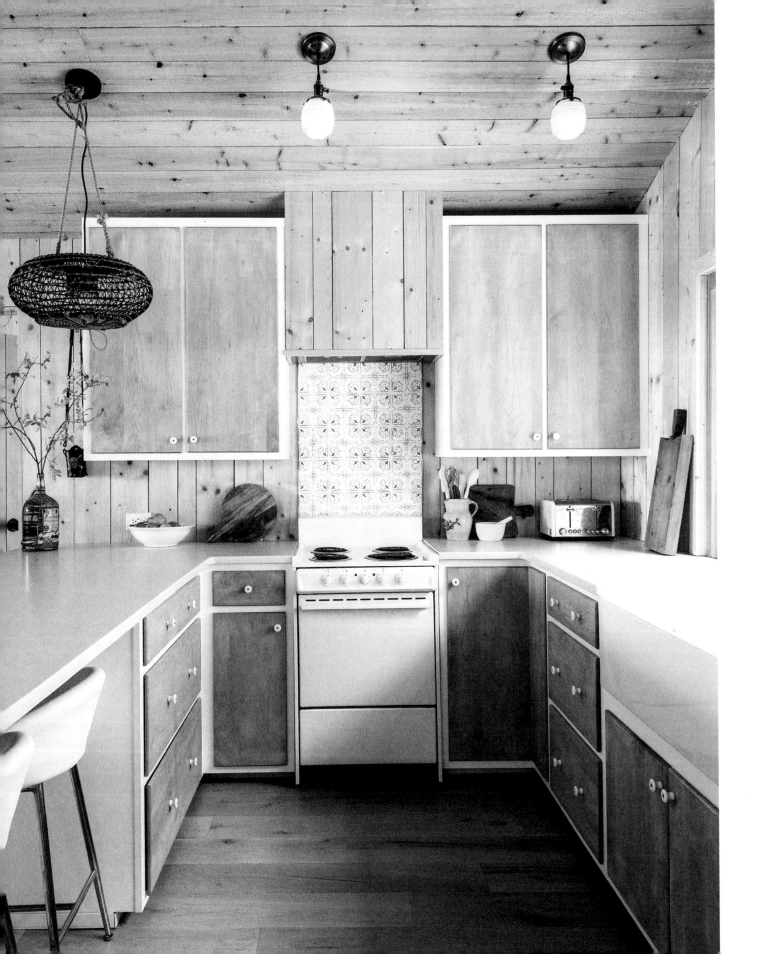

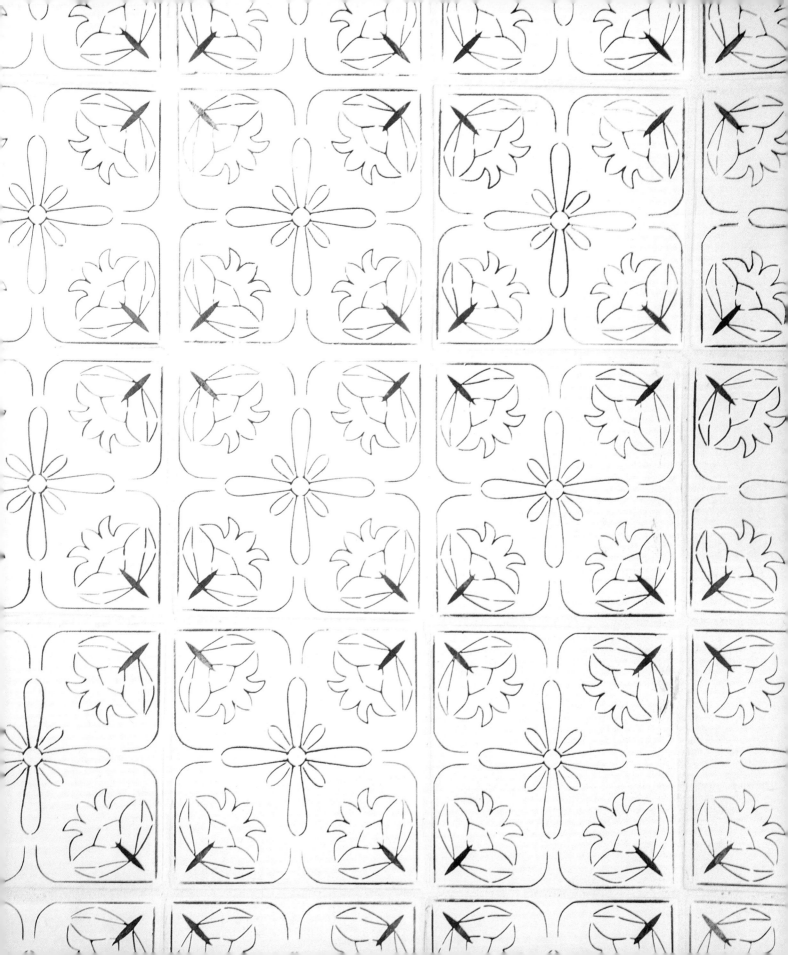

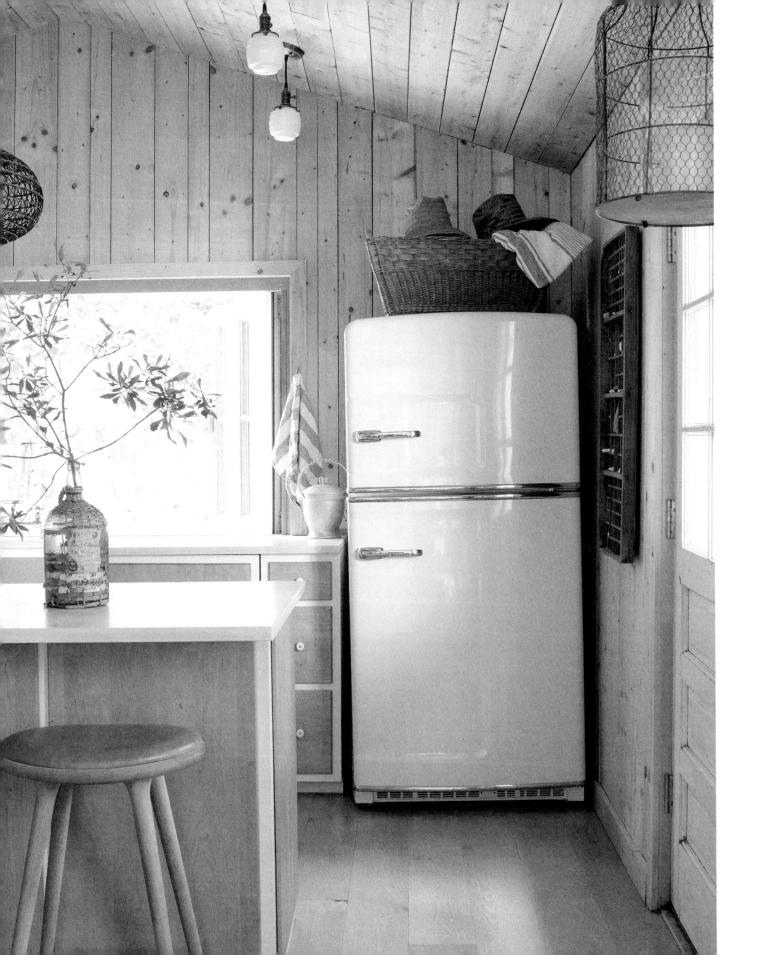

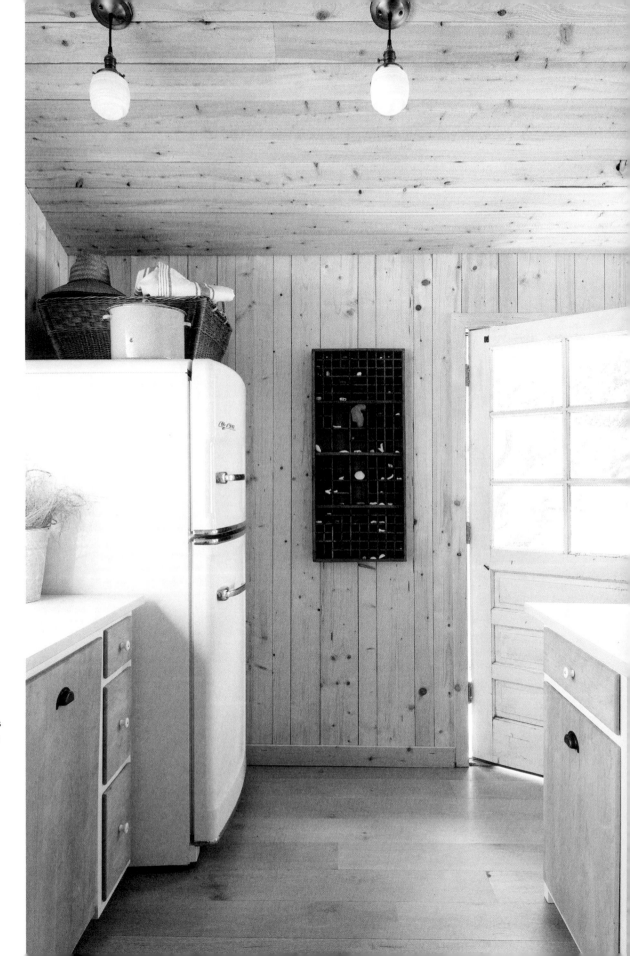

chill time
Our "Big Chill" refrigerator makes the entire cottage feel like an old beach box.

nature box
I often use old printer's trays to collect the kids' nature finds.

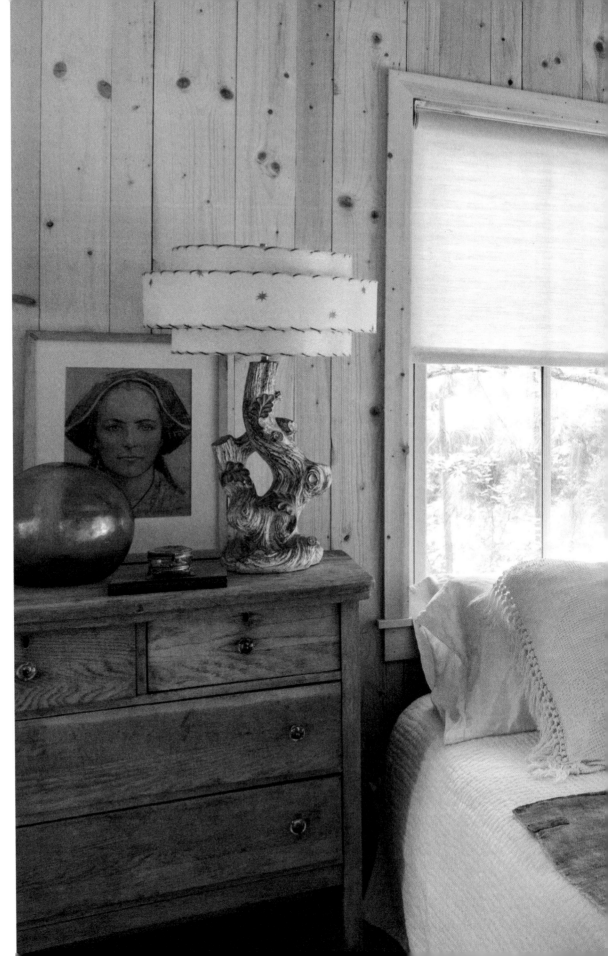

easy breezy

Sea breezes easily
catch the unlined
white linen curtains
in our bedroom.
I often purposely
close the curtains to
enjoy the romance
of it. Our bedroom
is tiny and is
furnished sparsely.
Our bed has no
headboard to allow
more room to walk
around and it is
dressed simply with
a white quilt and an
indigo-dyed throw.

collected objects

Everything on our
dresser means
something to me,
and I've had it all for
years. The vintage
oil pastel portrait
is a Belgian piece I
had in my shop that
never sold. (Perhaps
it was because I
loved her so much
I overpriced her?) I
happened to have
an antique pine
dresser that fit
perfectly next to
our bed and I set a
favorite vintage faux
bois lamp of mine
on top for color and
quirk. An antique
Japanese fishing
float that's been
in almost all our
houses has finally
found its home at
the Lost Cottage.

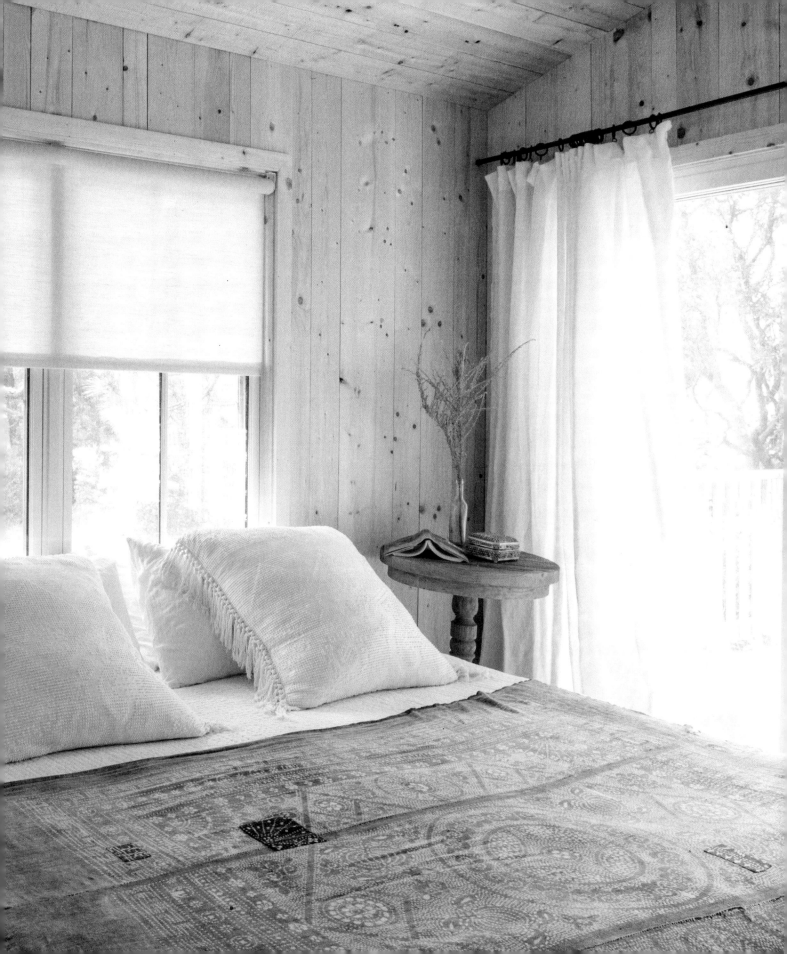

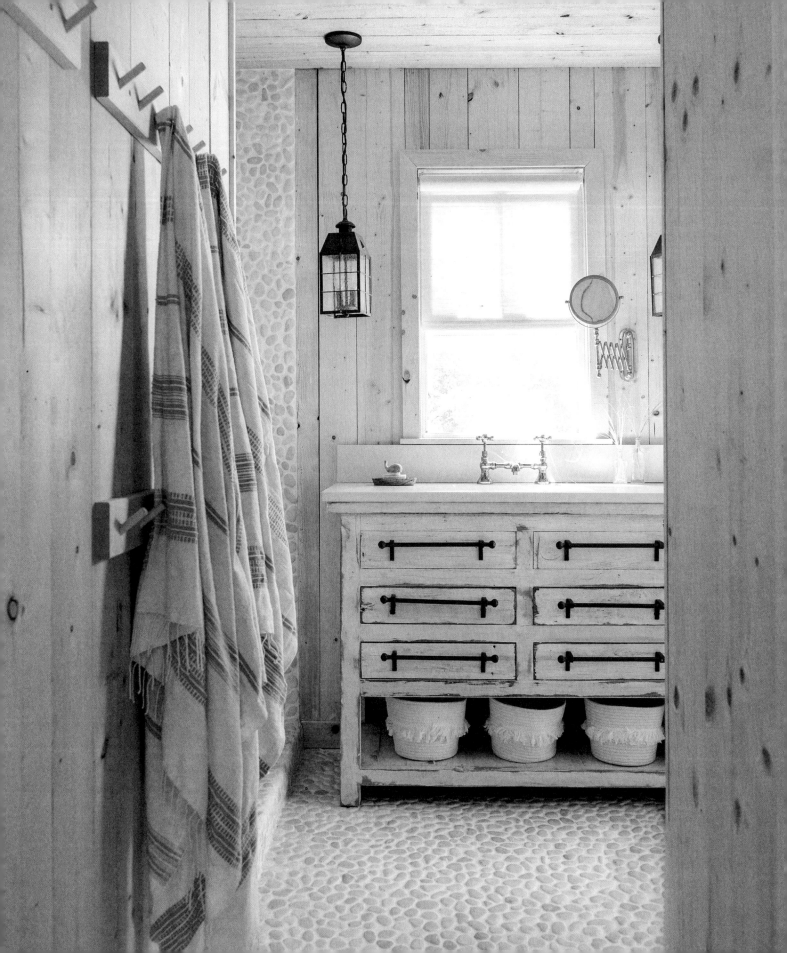

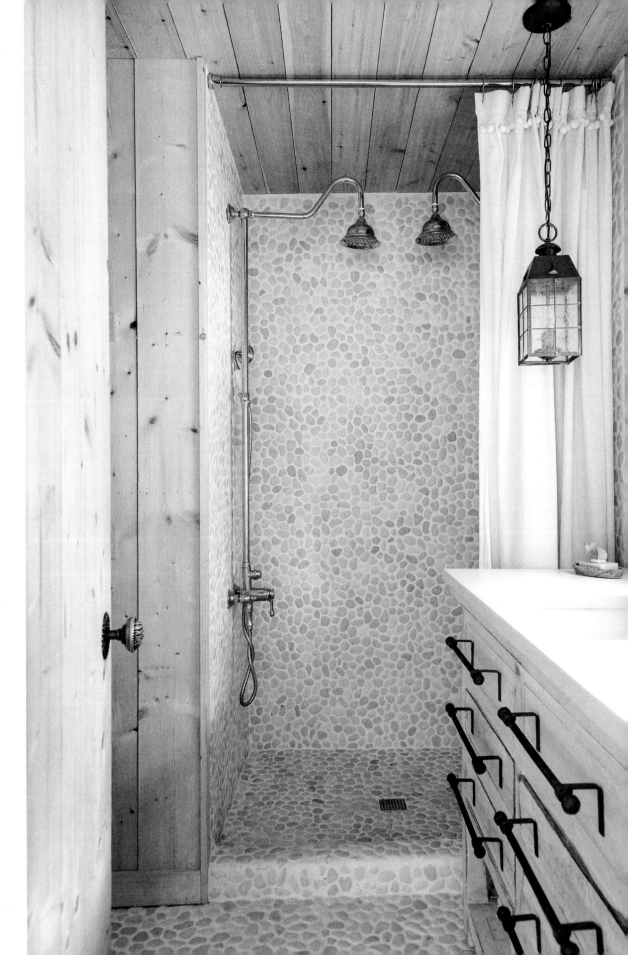

wood and stone

Pebble tiles and pine paneling play against each other in the bathroom to create a textural, nature-inspired mini spa.

Thin Turkish towels hung on the pegs take up less space than traditional plush towels, opening up the walkway in the tiny space.

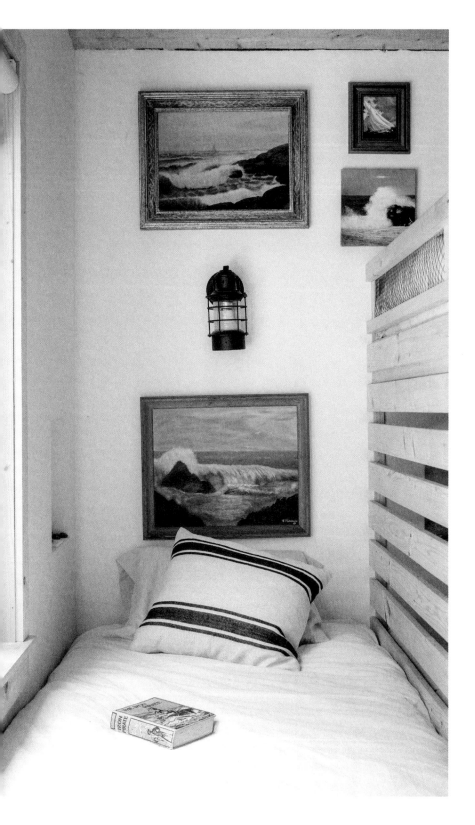

shipshape

Like a ship's interior, every inch is utilized in the bunk room. The beds just barely fit, and each child has his or her own light and shelf for books and objects. They each have a single drawer under the bed for their clothes. The safety rails are made from fish nets.

more can be more

I figured that most of the time the bunk room would be a mess of unmade beds, kids, and dogs. (It is.) I was tempted to keep it simple and spare but also wanted a spot to display the collection of seascapes we'd amassed throughout the years and thought they would add a cheerful cadence to the room and ground it a bit when it was messy. I am now so thankful for those paintings because often they are truly the only orderly thing in the entire room!

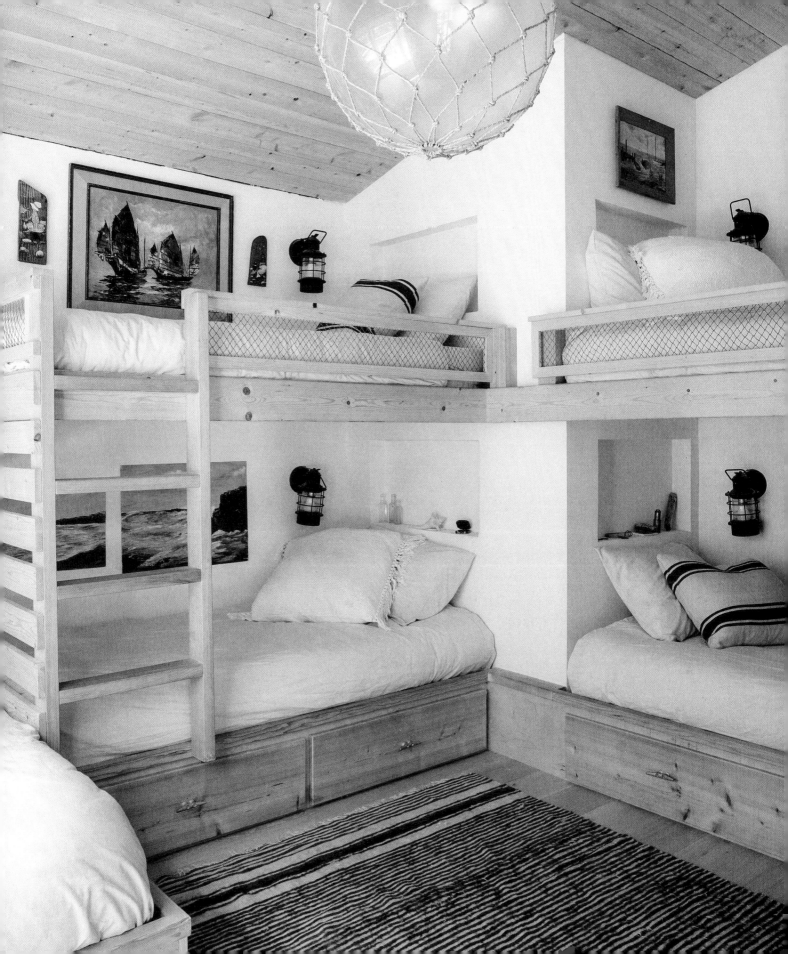

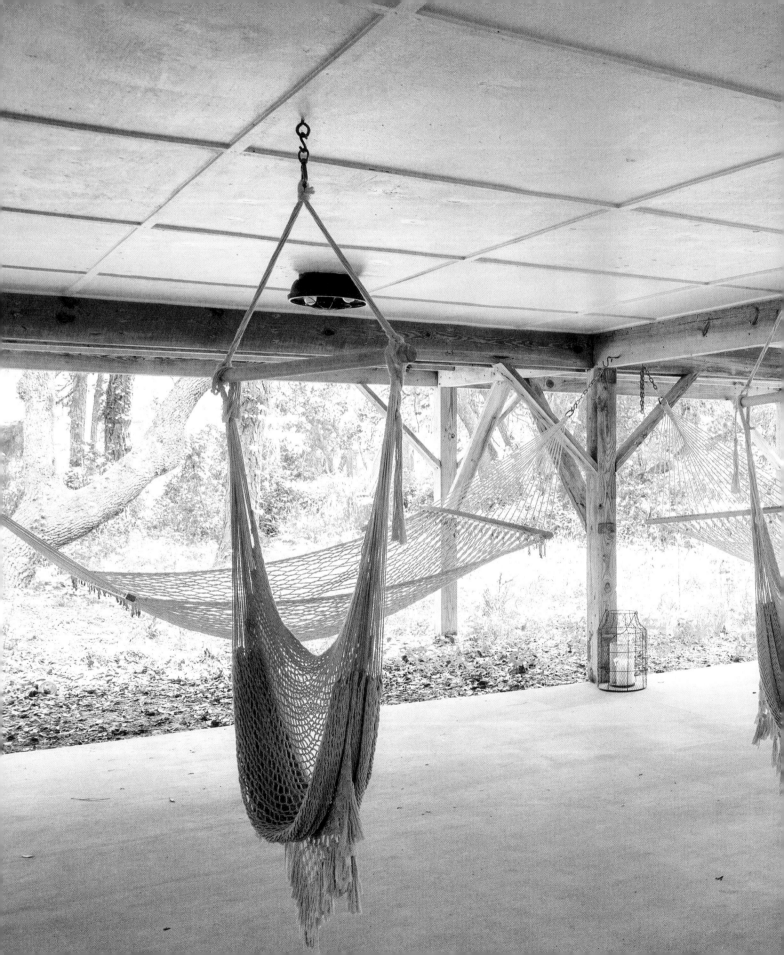

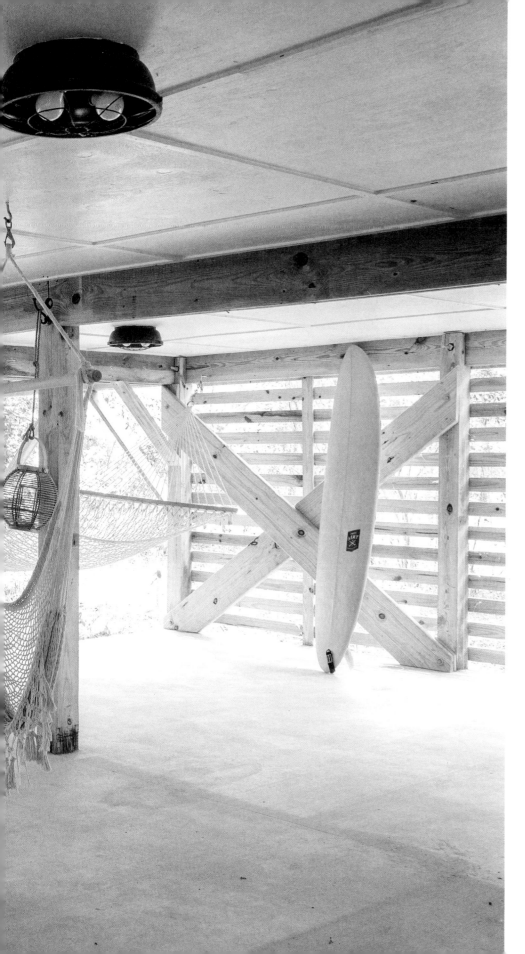

a slow place

If we're hanging out under the house, it means we're really relaxing. Hammocks have a way of slowing us down, taking time to nap, read, or be with one another. We love being here when it's raining or having parties with friends down here.

movies on the house

I didn't want to clog up our living room with a TV, but we love watching movies together as a family so we went with a projector instead. We hang up a sheet and watch movies on the living room wall when it's rainy or cold out. In the first half of the summer, before the mosquitoes are biting, we have movie nights under the house in the hammocks.

FOLLOWING The back deck functions as an additional living space for us. Coal, seen on the chaise, likes to make himself at home out there. The butterfly chairs from the living room do double-duty out here during get togethers.

PAGE 120 The backyard is another hangout with a circle of Adirondack chairs and solar lanterns hanging in the oaks. The kids love their pirate ship play set (not shown), so Dave and I often end up having good, long conversations in the chairs as they play.

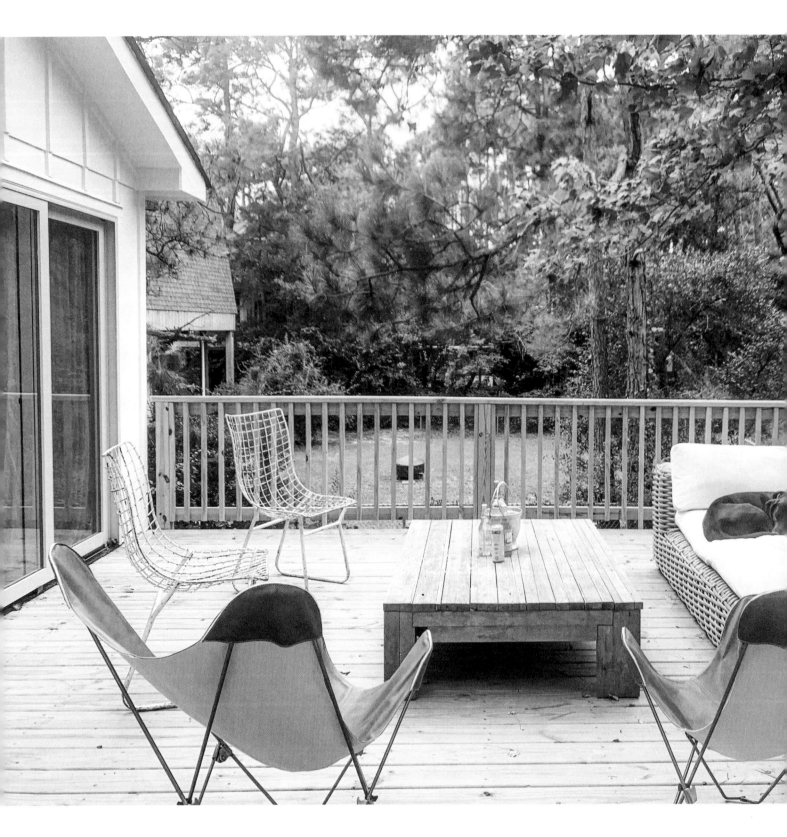

intentional living

The very best part about having less than 115 square feet per person in the house is that we spend our time doing what we love to do instead of managing the house and its contents. We can speed-clean the entire house in record time. Because we're not spending our time managing things (for example, it's easy to decide what to wear because I only have a couple of options, and toy cleanup is a breeze because there are only a few toys in the entire house), I feel my mind is less on *things* and is freed up to be more fully present. We also spend more time outside than I think we would if we had a larger house.

space-savers

We have very limited storage space in the kitchen but it's surprisingly functional. In the cabinets, tin cups stack right into each other, taking up much less space than conventional glasses. Nesting bowls and extra shelving in the cabinets allow us to fit much more than one would imagine in our two upper cabinets.

Books are always an issue for us. We love reading and collecting them. We've amassed a little library of children's beach reads and some of my favorite moments at the beach are spent on the sofa reading with the kids. To combat our addiction, I used small shelved end tables in the living room that hold a surprisingly large number of books. We also had three large bookcases recessed into the upper wall of the kids' bunk room. They're not the most accessible (we have to stand on a chair to reach them) but they're great for long-term storage. I also transport books from the side tables to the shelves and back to our house in Virginia.

using scent to elicit emotion

I wanted us to be transported and taken out of "normal" mode into "beach" mode every time we arrived at the Lost Cottage and I know that smell is the sense with the greatest tie to our memories and emotions. I wanted to be flooded with a scent that was strong and pure every time we arrived at the cottage so it would sort of wake me up and let me know where I was. We had the walls paneled in cypress and the ceilings paneled in cedar. We left both untreated and the smell is one of the sweetest in the world to me. I was originally undecided about painting the cypress walls white, but once they were in and I visited, I was smitten with the natural cypress and threw all ideas about painting it out the window. For the walls we used varying widths of three, four, and five inches and asked the carpenters to leave imperfect gaps and make sure they weren't perfectly straight. I wanted it to feel a bit like the oyster shack the Walrus and the Carpenter built in *Alice in Wonderland*.

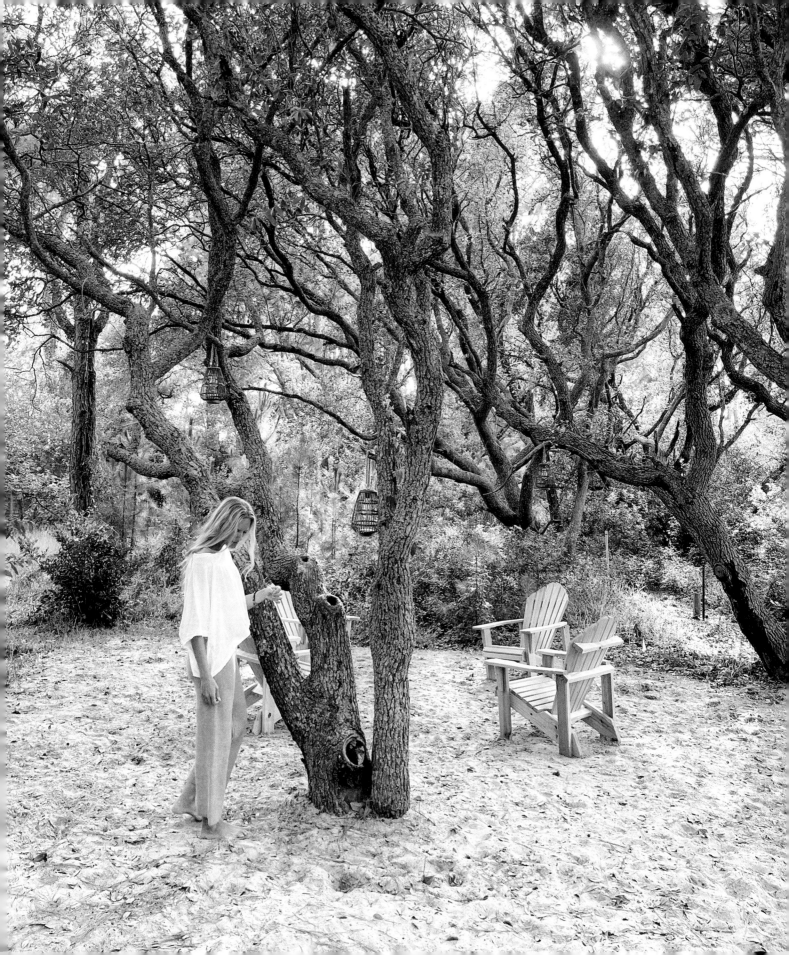

"We leave a world of busy schedules and commitments for a little bit of land by the beach, dripping with live oaks and Russian olives."

apparel and "the palette"

Our closet has less than six inches of hanging space in it (I had to give up most of it for an HVAC trunk line) and to be honest, it's more than enough for both of us. Dave and I have two dressers—one for each of us—and I keep off-season bins under the bed. Each of our kids has a bunk bed and a single, extra deep drawer under the bed for all their clothes. The kids' extra sheets, swimsuits, and rash guards live in a single dresser in their bedroom.

What I'm about to tell you next should be a joke—and my friends make a lot of fun of me for it—but I am not kidding when I tell you that we have a "palette" for clothing down at the Lost Cottage. It started off by accident when we decided we would be keeping a very small wardrobe down at the beach so we didn't have to pack every time we visited. I went online and ordered all the kids' clothes at one time, sticking to blues, neutrals, and soft pastels.

Dave and I brought down the things from our closet that felt "beachy" to us, which tended to also be lighter, softer colors, neutrals, and blues. When we got down there and unpacked we realized that we had assembled a family wardrobe with a distinct beach-colored "palette." When we go out we look like we're about to take a family photo. It's been years and the palette is still a thing.

Most of our friends in town have picked up on the palette by now. It was probably pretty obvious when, the first year we were down on the Fourth of July, my oldest son went to his job at a nearby restaurant without a red, white, and blue outfit. When asked about it he told everyone, "My mom doesn't let us wear primary colors." Not exactly, but close enough.

That first summer at the beach, I realized how much I actually loved having a palette. First of all, it hurts my eyes less when I see clothes on the floor or a pile of laundry in the living room that needs to be folded. The hues blend in and don't jump out the way bright colors would in such a small space. When we're out and about or on the beach, the colors look pretty with the nature around them, and that makes my decorator heart happy. It's easy to spot the kids when we're out because I never have to remember what they're wearing—it's always in the palette!

Since that first year, I've had to buy more clothes as the kids grew out of things and I now religiously stick to the palette. As much as everyone thinks this is all my doing, Dave recently told me that he wished we had a palette at home. I just about died laughing. Though I realize how obsessive having a palette sounds (and is), we've both noticed how calming it is when managing all the clothes we seem to be destined to deal with in every part of our life.

OPPOSITE My daughters walking around town in matching outfits

ABOVE I'm in the palette too!

FOLLOWING, CLOCKWISE FROM TOP LEFT The dunes at the end of our street; Dave and Aurora share a moment; Aurora and Gisele love eating breakfast at the bar; a typical deck dinner; Gisele and Aurora enjoying a cheese board literally on the table; Louie and Justin love the live oak trees; a wild horse in Carova

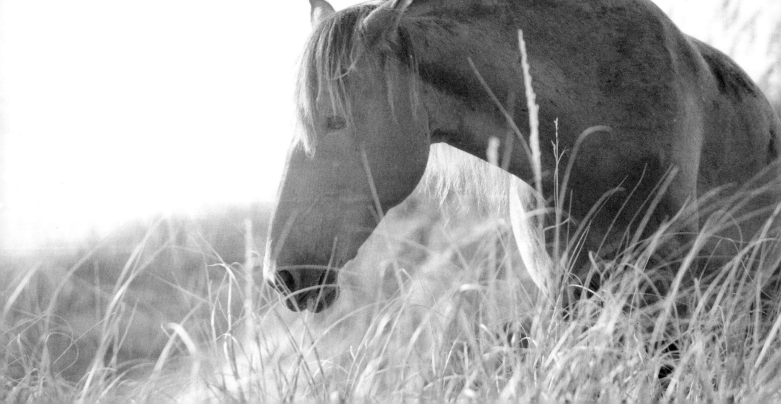

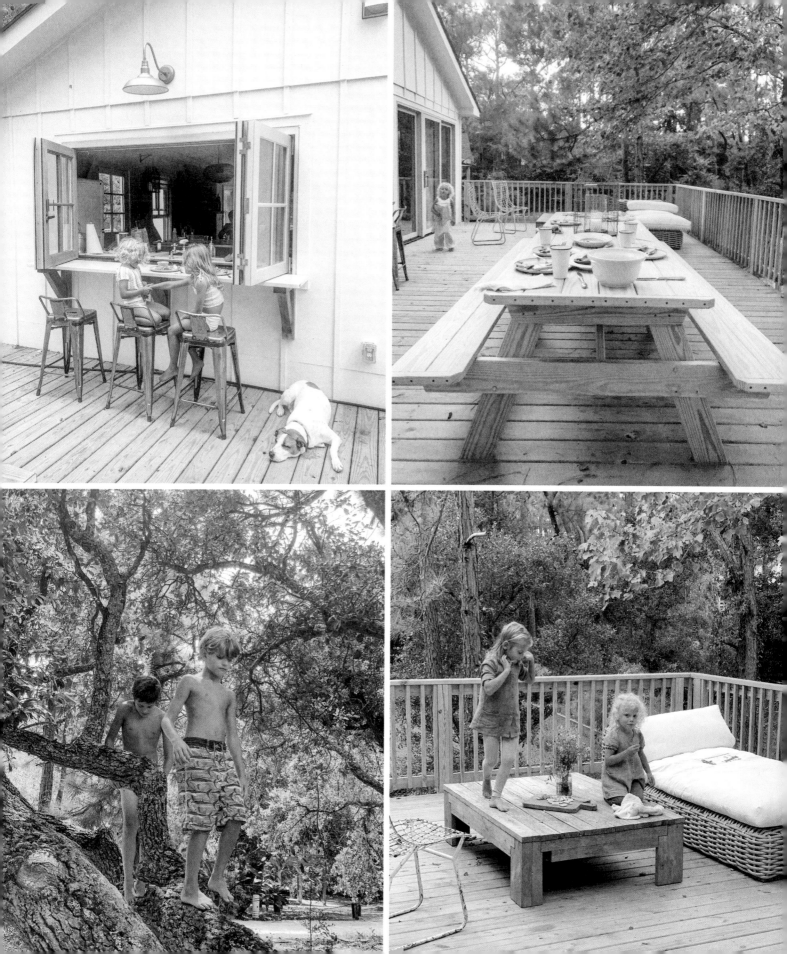

7 people, 3 dogs, 800 square feet

I didn't originally know how we could comfortably fit seven people into eight hundred square feet, but we did and it's been incredibly freeing. For most of my life we'd stayed in fairly spacious beach houses that I found visually distracting—filled with bright colors, trendy patterns, and tchotchkes that took my attention away from the ocean and put it square on the decor around me. I had always dreamed about designing a beach house that would let nature do most of the talking. I imagined natural wood with minimal decoration, bringing in only what was necessary. With the cottage's small square footage, too much decor would crowd the place. Every inch counted.

how to beach like a minimalist

I don't think any book of mine would be complete without an impassioned treatise about minimalism—both my love for it and my personal struggles with attempting to stick to it—and this book is no exception. I believe that if we actually want to get "down to earth" and enjoy the innate simplicity of beach life, we need to slow down on the consumerism and sheer amount of *stuff* in our lives. We simply cannot focus on the people and environment around us when we are stuck managing our possessions. It's one of the quickest, surest ways out of the present moment and into *work*.

Every summer morning on our beach—between 7:30 and 9:30 or so—you can watch the early morning "March of the gear." It's an intermittent coming-and-going of people (it's almost always dads) overloaded with stuff, saving spots on the empty beach, making multiple trips to and from their houses or cars and back again to retrieve every last imaginable thing that could be needed for a day at the beach. On the first Sunday of the week there's a nice pep in their step as they carefully and joyfully set about making camp, but it seems to wane a bit by Wednesday or so as they continue to deliver wagonfuls of toys, coolers, tents, and gear onto the once-pristine beach. The dads turn back for home—probably to have breakfast with the family—before returning hours later to the camp they so carefully erected. The beach is now littered in every direction with a mishmash of brightly colored gear.

When friends or family with kids come to visit us at the beach, I find myself strapped with beach bags on each arm, pulling a wagonful of stuff through the sand. (Let me be super clear here: I'm *always* happy to do it because I love my people and am thrilled when they come to see us, but it always leaves me thinking about why this practice seems to be so standard . . . it's like we don't know there's any other way.) When we arrive on the beach, the setup takes a good ten or twenty minutes. What for?

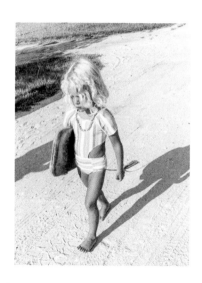

OPPOSITE A very typical scene in our bedroom with me and a few of our "creatures" when we first moved in. I hadn't yet found a nightstand, so we used the window instead.

I have five kids. Trust me, I get it. We want them entertained and shaded and fed. That takes supplies, I know. And it absolutely takes preparation, but do we have to make it this hard on ourselves? Would it hurt our kids if they had to play with sticks and shells on the beach or go make friends with another kid and pool some toys together? I'd say it's just the opposite, that they grow when they have to get creative with the natural objects strewn about on the beach by the ocean and when they have to push themselves outside their comfort zone to make new friends. I crave the feeling of walking down our sandy little beach street all year without a care in the world and refuse to be saddled with *stuff*. I want that for my kids too. I love seeing them swing their arms freely or run down the street with abandon because they're not hindered by loads of gear. If we are intentional about it, we can be almost as carefree and empty-handed as our kids.

We experience a lightness of being when we are without baggage—be it physical or emotional. At the beach we are given the perfect opportunity to have neither.

I take a die-hard approach to what comes into our beach house and what leaves it to go to the beach each day. Fairly firm rules are the kids have to carry their own gear, (this has been enforced since my youngest, Aurora, was two years old, and before that her stuff had to fit in her stroller) and if anyone is leaving the beach, they have to bring their stuff back. (We all know how it is when someone says they're coming back and then doesn't and you're stuck with more than you can carry home.) There are of course days when the rules get ignored, but most days the rules are followed and our stuff isn't a distraction from the ocean views or the ones we love.

what's in our beach bag?

I keep a couple of small washable linen totes hanging by the door for handy beach use and have extras cycling through the laundry so we always have clean ones. One of them has sunscreen in it, ready to take to the beach. (I try to keep sunscreen to one for face, one for body, and one spray lotion for my sweet husband's bald head.) I usually drop books for myself and Dave in there along with some water and maybe a mint hydrosol if I'm extra-prepared.

We have a beach sheet or blanket for the family (we realized the kids weren't using the towels we brought them) and an umbrella. Sometimes we bring small, light beach chairs. We have a cross-body cooler bag that's easy to carry when needed. The kids bring boards, balls, lacrosse sticks, or a bucket with a few toys some days and other days they don't bring anything. After experiencing the situation shared in the epilogue of this book, I highly recommend bringing at least one board or flotation device with you if anyone is planning on swimming.

OPPOSITE The peg rail catch-all by our entry door

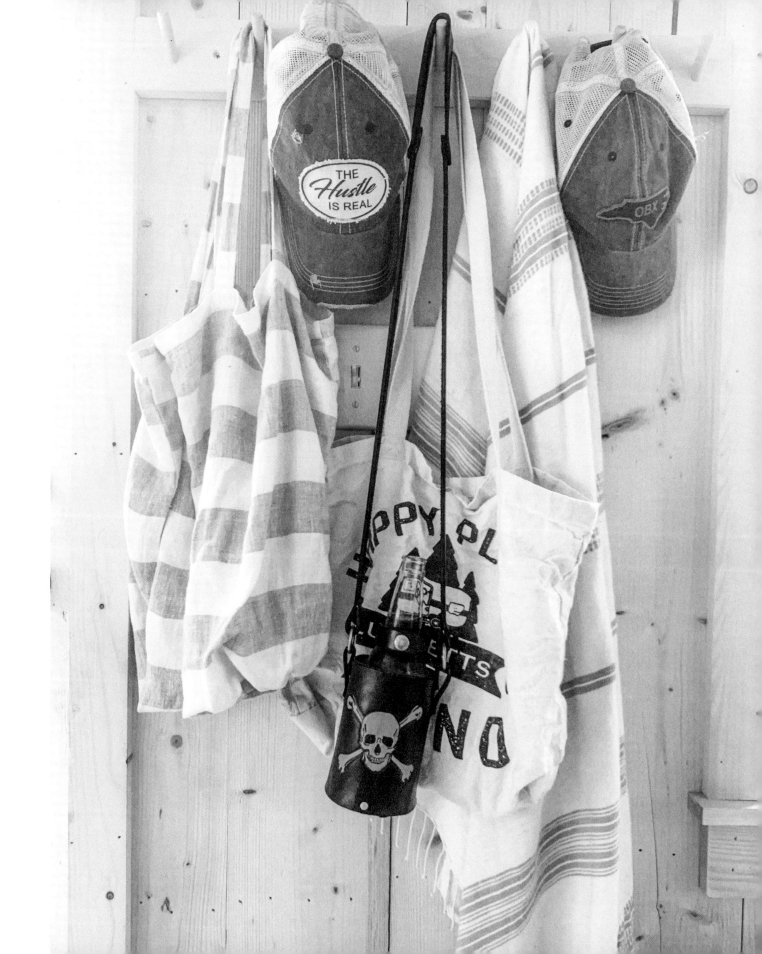

think light

Lightweight aluminum lawn chairs make for easy carrying at the beach.

nature play

The kids are entertained: playing in the sand, in the water, with shells, seafoam, driftwood, tidal pools—whatever abundance nature has seen fit to provide that day.

We have everything needed for a day at the beach—shade, a place to sit, and entertainment—without having to burden ourselves with a gross amount of stuff.

being found

It's easy to get swept up in the fast-paced world of work, world news, events, social media, and being all things to all people . . . to be "lost," in a sense.

But beach life is waking up naturally, without an alarm. The typical work-school-life race is exchanged for a mosey. There is freedom in not having set plans for the day. Without clear schedules, we let life unfold. We unplug. We take the time to do the things that we're often too busy to do. We walk most places instead of driving, adding extra hours of exercise to our days and reconnecting with our minds and bodies. We remember how it feels to be carefree.

We're barefoot most of the time, hardening the soles of our feet that were shod all winter. We enjoy the sun, the sea spray, and the fresh air. We focus on the people and the relationships that matter most. How often do we get this sort of downtime anymore?

I often walk to the beach with Dave in the early morning. My best days seem to begin this way. Silent, we let the ocean and the seagulls sing without interruption as we pray, breathing deeply. I feel the sun as it rises higher in the sky and I attempt to let my thoughts go and just be. Some days it's easier than others. When I open my eyes, I look at the birds and the water and sit for a bit.

Sometimes we take an early-morning swim, when no one's really arrived yet—except maybe the dads setting up—and the beach is all ours. Dave will sneak back home for his surfboard if the waves are good. Most days I try to get in a quick workout before eating breakfast.

Mornings at the beach are a time of prayer and meditation for me. I leave feeling completely at ease and at home in my body. Morning by morning, day by day, my work self melts away as my summer spirit takes over.

As lost as I feel in the rat race, in a way, I also get lost at the beach—lost in my prayers, thoughts, and in the ocean—in order to be found. That's how being down there in general feels to me. We leave a world of busy schedules and commitments for a little bit of land by the beach dripping with live oaks and Russian olives. The phones turn off and we hide away in days steeped in nature. Barefoot and free, we are both lost and found.

OPPOSITE I adore our little beach walk-up. Throughout this book you'll see photos of it that I've taken throughout all the seasons and at different times of the day. It's here I feel my heart wake up to the ocean.

The ocean rolled on, the same yet different, watching the same couple, who were also the same yet different.

Sometime that first summer, soon after the construction was completed at the Lost Cottage, Dave and I went out to the beach alone one evening after dinner. We headed north and sat by the edge of a dune, taking in the pink sky. I'm not sure how it took us that long to realize we'd moved so close to it, but we got to talking about that night we'd fallen asleep under the stars all those years ago. We realized that we were sitting in almost the very same spot beside that very same dune. The ocean rolled on, the same yet different, watching the same couple, who were also the same yet different. I felt such a palpable welling of gratitude in that moment, sitting in the cool sand, leaning against him. I smiled at all the angst I'd once felt and wished I could have sent lost, lovesick me a message that it would all be okay.

And that's how it is, isn't it? We feel like it's not going to be okay, but somehow, we always get through it. On the other side, we are given perspective and hindsight and we see it would have been easier if we hadn't worried so much… if we had simply ridden the wave and enjoyed the ride. With time, we're often able to look back without pain at something that once cut so deeply in the moment. We realize that being lost was simply a part of the journey of being found.

Like time, the ocean is perspective's friend, opening us up with its vastness. The ocean shows us how much bigger everything is than our own little world. Time slows in front of the waves. Deep breaths filled with sea breeze soothe the soul, helping to shake off our worries and making us grateful for what we're experiencing, for what we have. We are made stronger and clearer by the sea and we find our true selves when we strip away all the excess.

Well past sunset, as Dave and I tiptoed back into the house, careful not to wake the kids, I thought about how this beat sneaking back into the house in the wee hours of the morning that one summer in college. After kissing the little ones, I got into bed and fell asleep to the sound of the crashing waves drifting in through our bedroom door, grateful.

There was no life-changing event that happened to me that night, but rather a mere moment of time in front of the ocean in which I saw my life as if from afar, where I was given the gift of perspective. I felt an appreciation for the journey of this life in which we sometimes feel lost and sometimes feel found, but are always just as we are meant to be. ✦

OPPOSITE Sunrise on the beach

"Like time, the ocean is perspective's friend, opening us up with its vastness."

chapter 4
beach quiet

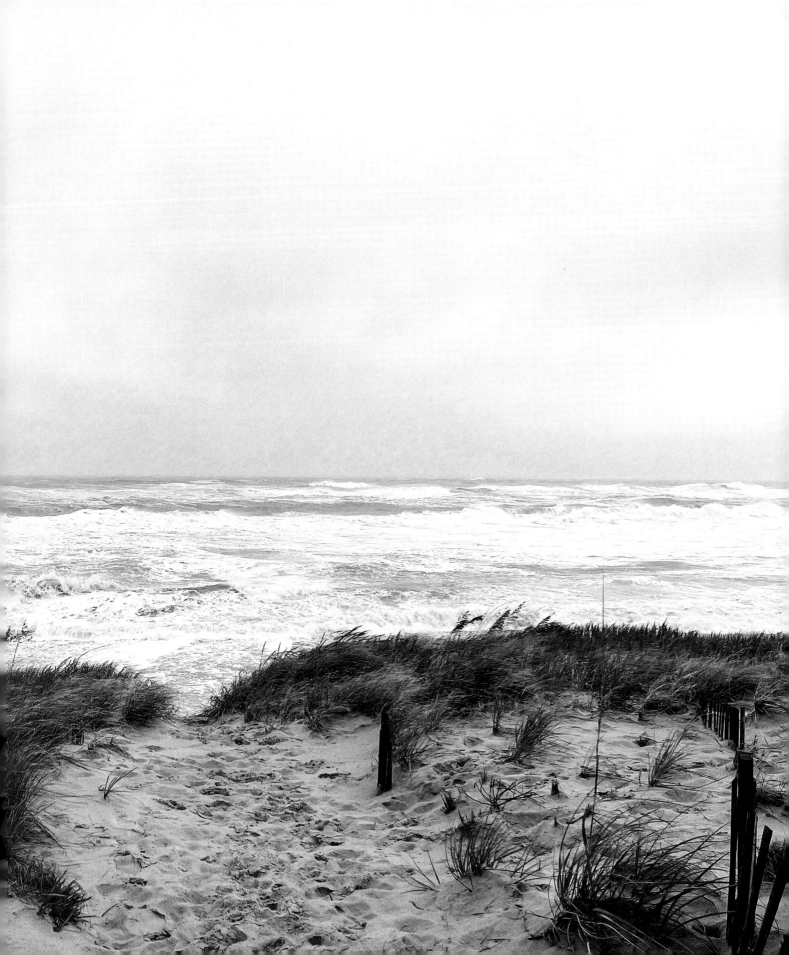

I love the energy in the air when the clouds gather low over the beach and we have to pack up and run home to escape a storm. Taking down the umbrella and tossing our things haphazardly into bags, I grab my girls' hands as the cold breeze blows in and the raindrops start—as they always do because we tend to wait until the last possible moment to leave. I've made sure to toss our flip-flops in my bag because we can run faster barefoot, and the girls squeal in excitement as we race back up the dunes. We've already told the older boys to go ahead because they're much faster than I am with the littler ones dragging behind me. By the time we're rounding the driveway into the Lost Cottage, the downpour is usually torrential and we're soaked to the bone. We take hot showers and the kids put on sweats or pajamas and we light candles around the dark house. Picking out books, everyone finds a cozy spot to curl up. If it's warm enough, I'm sure to find a kid or two in the hammocks under the house.

I've always treasured that first stormy day at the beach, after I've spent too many days in the sun and surf and finally get a good excuse to chill. Quiet days slow down beach weeks, pacing them with variety, giving us space to exhale alone with our thoughts. Beach quiet feels like an expansion of time, where life is slowed down so that it can be fully appreciated. But even without storm clouds, quiet can be found in abundance at the beach: in a sunrise or sunset or in activities like prayer, yoga, meditation, stargazing, cloud-watching, nature walks, and even fishing, surfing, or reading.

In real life, which is a blur of activity, it can be difficult to find the time to stop and slow down. With to-do lists often miles long, quiet is a gift many of us get very little of. Once we leave the frenzy behind in the quiet moments of the beach, our minds are free to wander. Free of noise, our brains shift into high gear, repairing and reenergizing themselves.

PREVIOUS I snapped this photo just before the skies emptied on us one summer day.

OPPOSITE An "angry ocean" day one fall

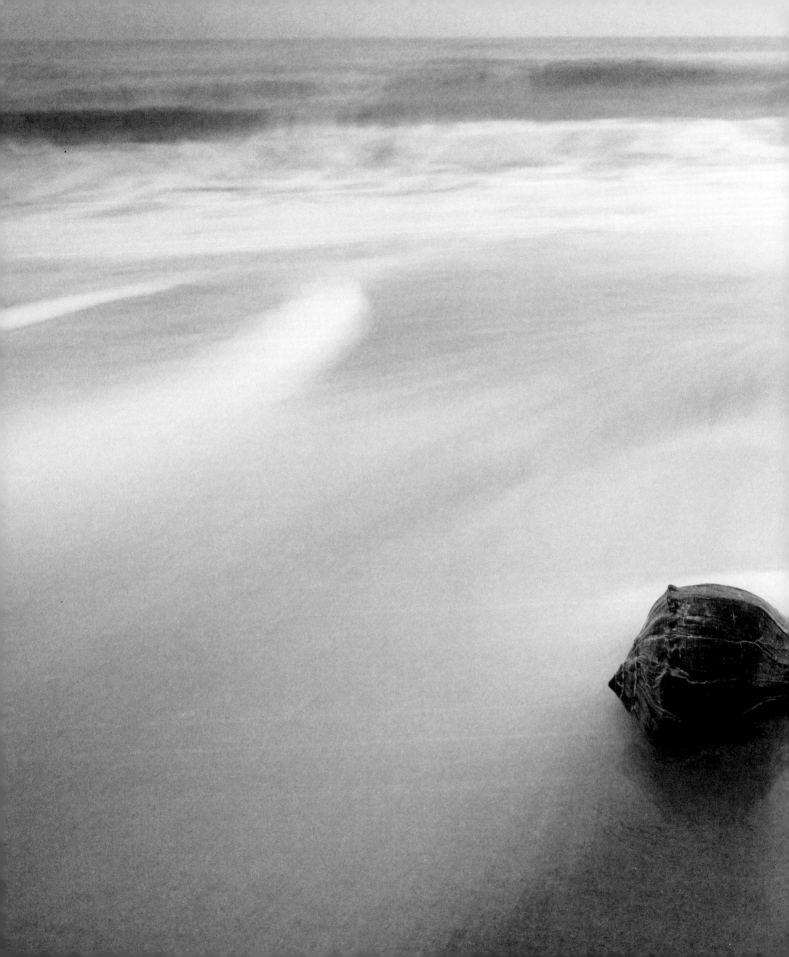

"Why do we love the sea?
It is because it has some
potent power to make us think
things we like to think."

—ROBERT HENRI

Quiet time is calm and healing. If we're lucky, we may drift into boredom—a state that breeds creativity. In the quiet, our minds process and problem-solve, sometimes without our even knowing it. During this time of growth we are given the space to cultivate intention. Without it, it's all too easy to function on autopilot: saying yes to too many commitments, spending too much time indoors, scrolling on social media, bingeing mind-numbing TV shows, or participating in unintentional consumerism. Quiet protects us from the very noisy world that would consume every last moment of our time.

While good times with friends and family fill us up on so many levels, it's time alone that completes our "soul cup," so to speak. Whether we are introverts or extroverts (or extroverted introverts, anyone?!) we all need quiet in our lives. It teaches us to fully accept ourselves just as we are, to be

Whether we find it in the low-hanging clouds of a stormy day, in the pages of a good book, or within the refuge of our very own minds, quiet opens us up to our true intentions.

Trips to the bookstore have always been a beach tradition. Perusing the possibilities is often just as enjoyable as settling down to actually read. On days when it looks like rain, we sometimes head to the bookstore with the kids and let them each get a book to take back to our home library. It's interesting that when we think of books we've read, we can often remember where we were when we read them.

Silence improves blood circulation and reduces blood pressure, making us less stressed. After five minutes of silence, the body reduces its stress and starts producing good-feeling chemicals like serotonin, endorphins, and oxytocin.[10]

okay alone with our thoughts . . . Eventually, maybe we can even let those go too, experiencing the profound emptiness of a quiet mind.

As the rain lets up a little, we wander down under the house with snacks, drinks, and music. The tips of my toes push the hammock in rhythm. Games typically ensue, neighbors stop by making plans to meet up later that evening, and the quiet moment has passed like the storm that came upon us so quickly. But we're refreshed, restored, and filled up from our quiet time, ready to go back out with more than we had. Everything is new again and we're energized and excited about what's next. ✦

Quiet your mind and listen for

whispers of truth in the waves

hill cottage

Our friends Maura and Daan—also the cofounders of our real estate brokerage, Property Collective—were in search of the perfect beach house and found Hill Cottage, named by the original builder and architect. The exterior of the cottage was understated and beautifully proportioned, with elements reminiscent of the old Nags Head cottages of a bygone era: weathered cedar shingles, wraparound porches, dormers, and a steep-pitched green roof. The inside, however, was more reminiscent of the era it was built in: the 1990s. Our goal was to create a sense of modern timelessness and improve usability and function throughout the interior of the house.

We knew the cottage would be filled up with family, friends, and lots of little kids, so a calm, quiet, open-feeling house with lots of room to relax felt right. The cottage would need to have a pared-down, simple, and graceful vibe with a Belgian nod (Daan is Belgian and Maura and Daan are both drawn to simple Belgian design) that would help slow down the days for my friends who live a very busy, fast-paced life at home.

The beach house would be a rental property for some time and so we made decisions with durability and practicality at the forefront. New paint, flooring, and woodwork did wonders for the house and we were able to revamp the space without majorly changing the floor plan or reworking doors and windows, which are typically quite costly.

The original kitchen was small and relegated to a corner of the great room, but Maura and Daan needed a large workspace with lots of storage where groups of people could easily cook together so a large kitchen redesign was paramount. The ceiling on the upper level had a unique shape to it because of the dormers, so we worked on making it feel symmetrical and pulled down walls to create much-needed storage closets.

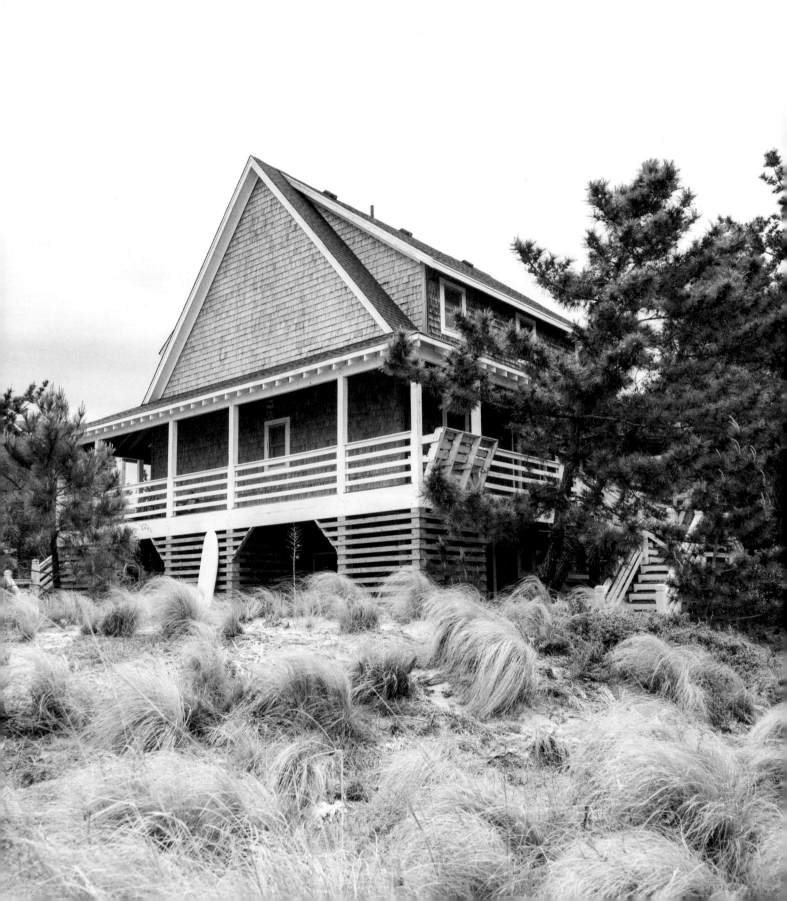

Maura and Daan have a cool, calm, restrained style and I wanted the house to reflect both their personal style and that of classic Nags Head beach house architecture. In the mid-1800s, when the thirteen original Nags Head cottages (also known as "the Unpainted Aristocracy") were being cobbled together, the interior walls and ceilings were typically planked in unfinished reclaimed wood, often salvaged from shipwrecks or other houses because fresh lumber wasn't readily available. Paint, plaster, and wallpaper were almost impossible to obtain and were considered too precious for beach cottages that might be taken by a storm in an instant. Ironically, today reclaimed wood is typically more costly than fresh lumber, which in turn is more expensive than drywall. We decided to use fresh cedar lumber sparingly for a nod to the old classic cottages without breaking the bank. We removed outdated wainscoting treatments throughout areas of the house, replacing them with white-painted drywall, and then planked the ceilings of the top floor of the house in raw cedar. The result is a house that feels fresh yet classic, with a calm, natural palette that lets you breathe easily and clear your mind.

I take a light, natural approach to decorating by the ocean. There is often a strong sense of place surrounding beach houses—whether by the ocean, in between rows of charming cottages, or tucked in a maritime forest—and I like for that outer landscape to seep inside a home so we really feel where we are. I use natural materials and colors that are quiet enough to not overwhelm an environment so the focus is on the nature and people around us rather than on things. Incorporating natural materials that are found by the water— grasses, seashells, stones, and wood such as pine, cypress, and oak—connects a home with the coastal environment that surrounds it. ✦

OPPOSITE Maura and Daan have the cutest beach cruisers in town.

the quintessential beach porch

Wraparound porches surround the house and provide various quiet areas where people can go to get away from the group for alone time. We were fortunate enough to get to stay at Hill Cottage and I loved sneaking away with my daughters to snuggle in the hammock and read when things got loud in the house. I have such fond memories of the beach moments that have made me slow down and be present with the people I love. Porches were made for slow living: naps, storytelling, guitar-strumming, reading, swinging, and watching the world. Simple, low-maintenance hammocks, Adirondack chairs, and picnic tables are classic and comfortable beach porch staples. Soundside sunsets can be viewed from some of the decks at Hill Cottage and are a sight to behold. Fast-drying lightweight Turkish-cotton towels look at home hanging on the clothesline, billowing in the sea breeze.

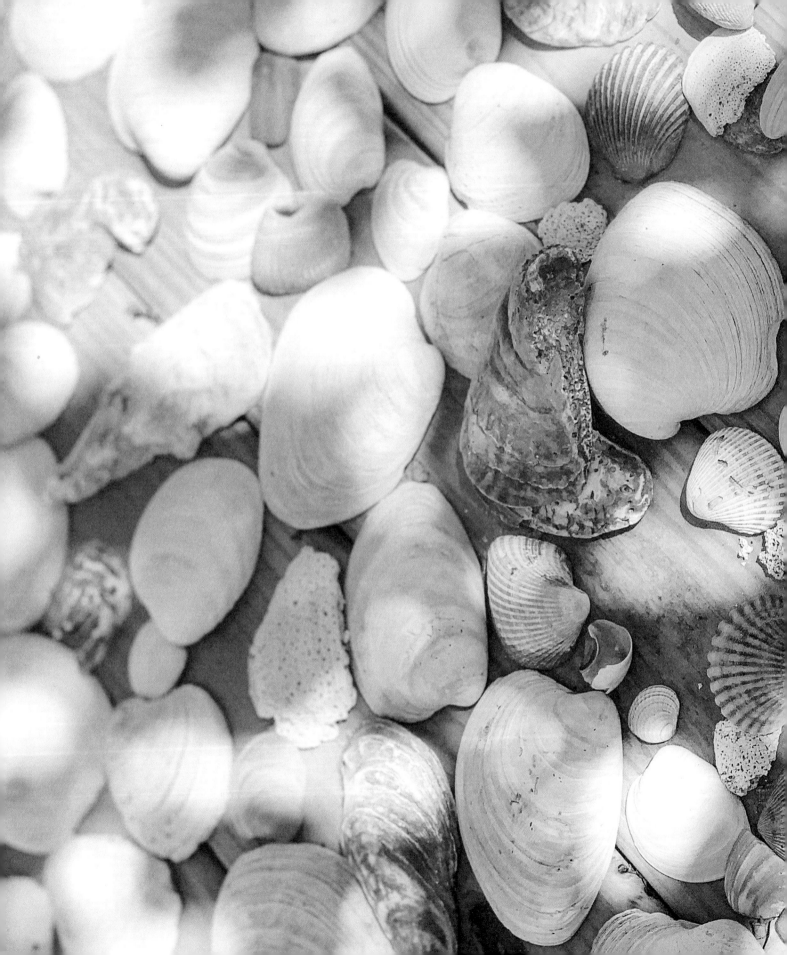

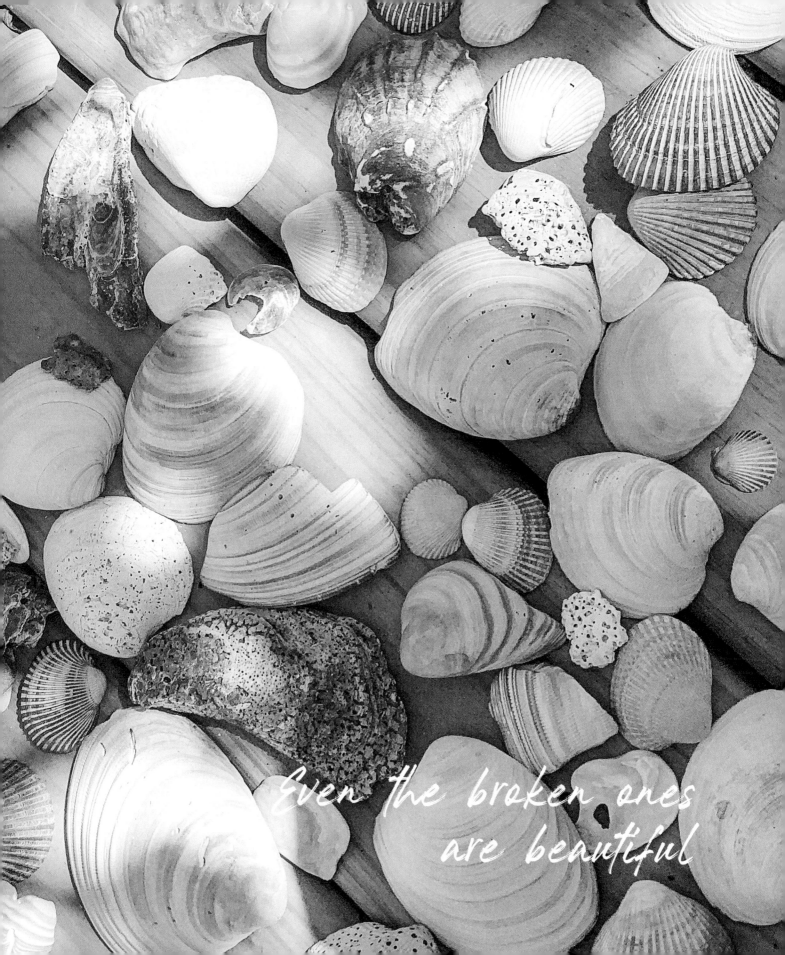

Even the broken ones are beautiful

a simple welcome

Hill Cottage is in one of the last stops before 4x4 country and the wild horses. A stallion painted on canvas by artist Lauren Rose Jackson greets guests in the entryway. Bleached oak floors run throughout the house, creating a sense of peace and calm throughout.

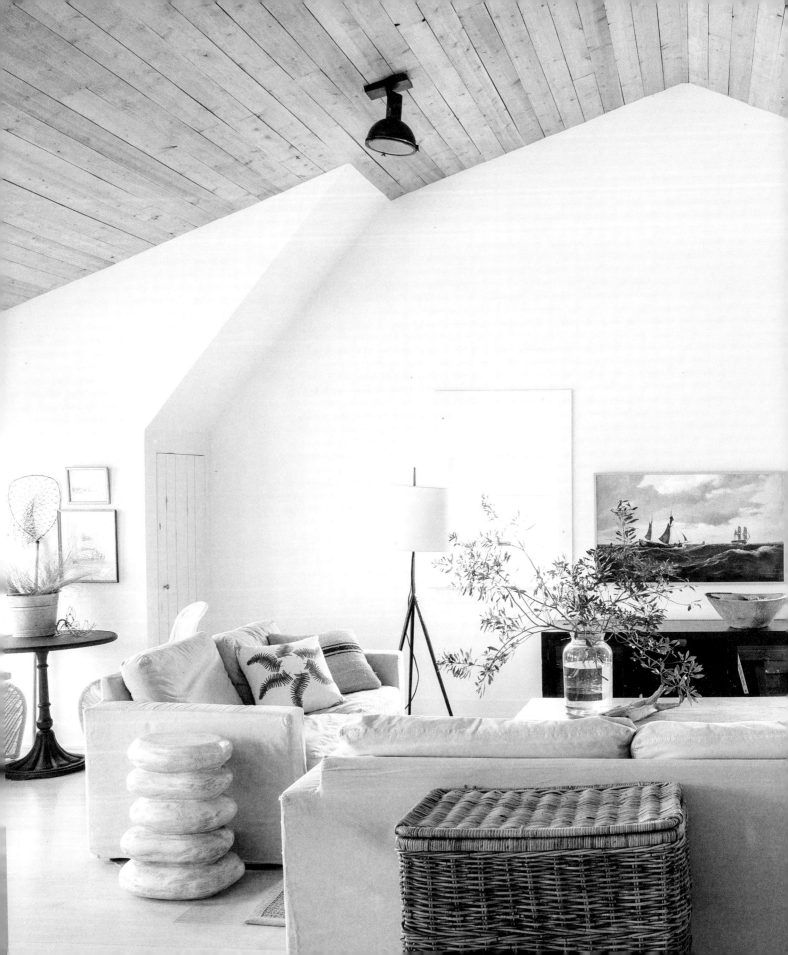

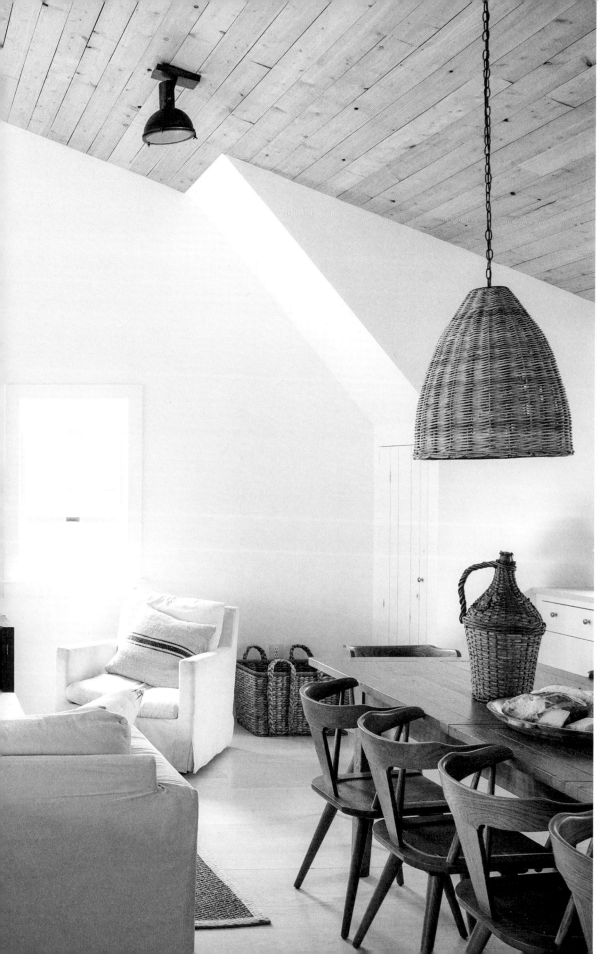

a sense of peace

To create a feeling of calm expansiveness, we kept the palette at Hill Cottage soft and neutral, pulling colors from winter dune grass, white sand, and cloudy skies. Forms are pure and simple and woven baskets add texture to the quiet house.

"Sit quietly and listen . . .
the answer will come." —ANONYMOUS

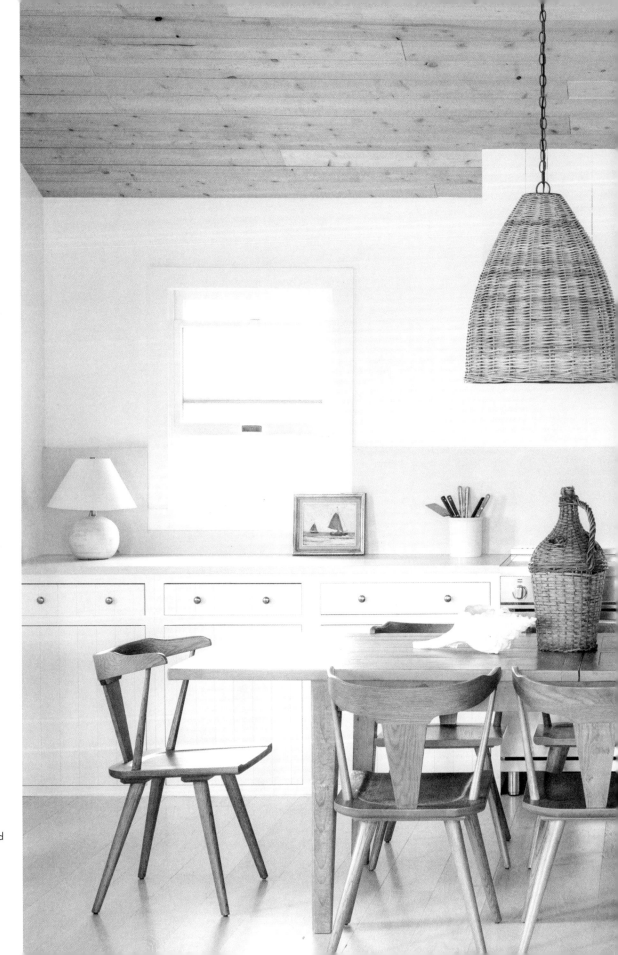

imperfect symmetry

I like to create strong focal points in rooms and decided that—though we couldn't achieve perfect symmetry due to window location—the range wall could serve as a beautiful backdrop to a central dining table. With two large rattan pendants over it to help ground the furniture grouping, we were able to create a sense of balance and informal symmetry. White-painted planked cabinets are from my "Cottage" cabinet collection with Unique Kitchens and Baths. Countertops and twelve-inch-high backsplash are in maintenance-free quartz made to look like concrete.

wood work

Raw cedar planks on the ceiling of the top floor bring the house warmth, texture, nature, and a historical nod.

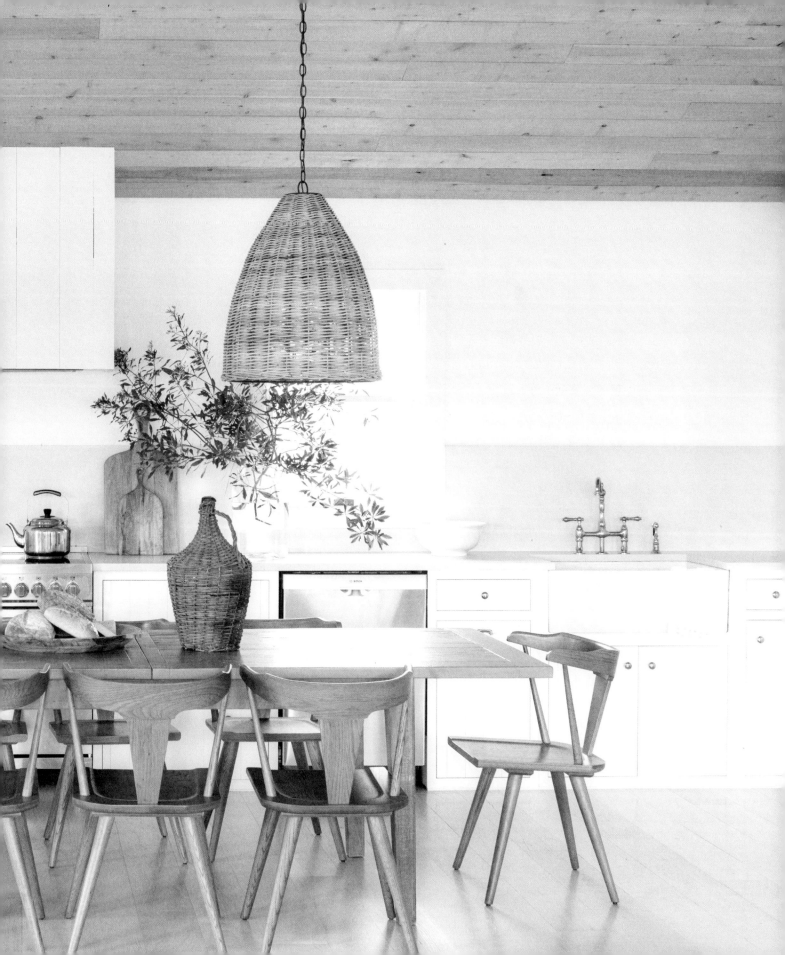

lean in to art
Maura has an
eye for art and
displays it casually
throughout the
house, even on
kitchen counters.

hidden storage
A countertop
pantry was
designed to store
and hide a host of
essentials in the
well-appointed
kitchen.

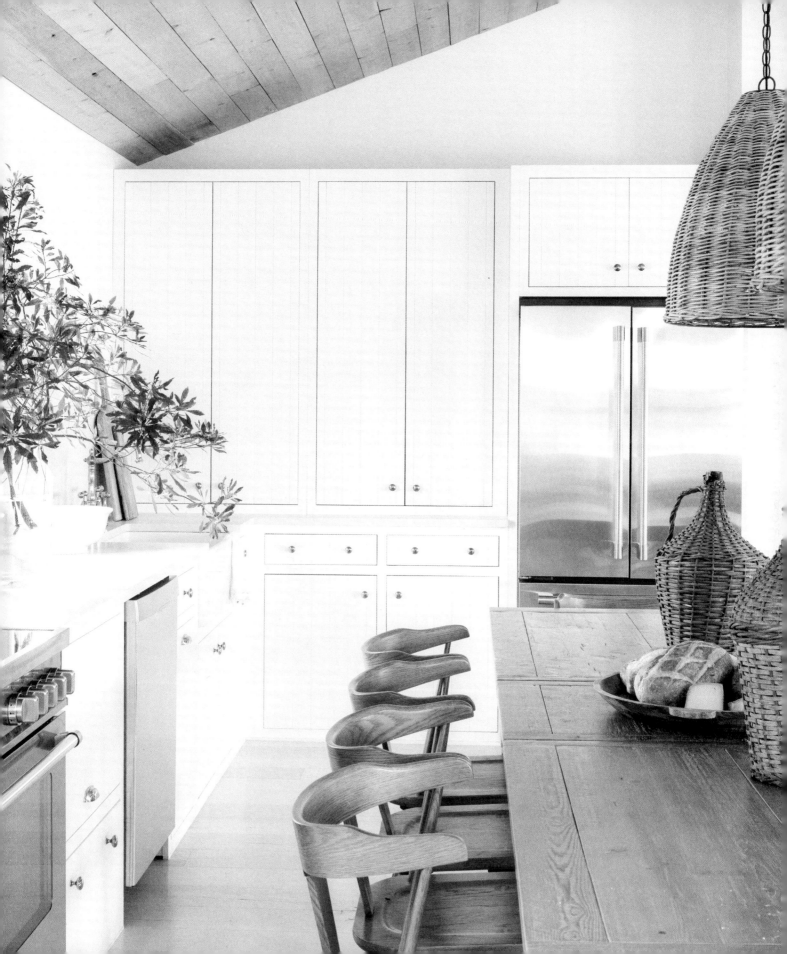

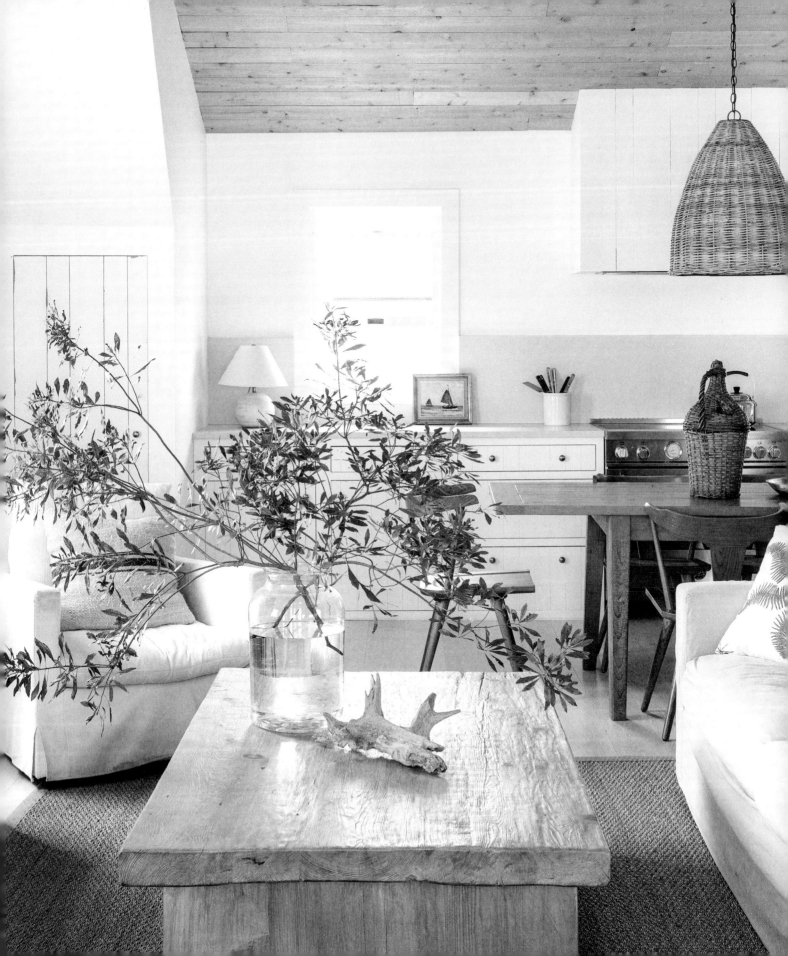

branch in

I've never met a branch I didn't love, and the branches in the maritime forests at the beach are no exception. I like to go out and forage on the first day of a beach week so my arrangements can be enjoyed the whole trip. The "branch vase" from Lauren Liess and Co. is my favorite vessel for branch styling.

table for two

A bistro table and chairs is a worthy addition to squeeze into a room when there is space. It provides a little getaway spot for game playing or working. Dry grasses in a plain galvanized bucket from the local hardware store make a lovely all-season arrangement. At the beach there are even beautiful things to forage in the winter.

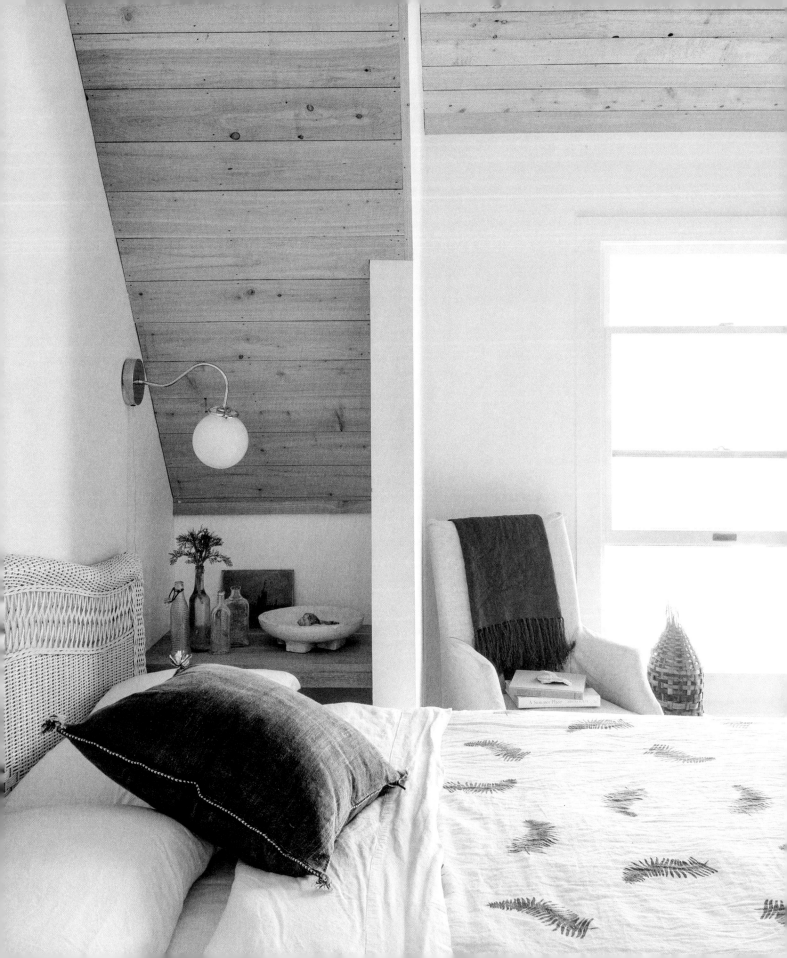

work the angles

Odd angles in top stories of houses can be turned into useful spaces. In the primary bedroom there wasn't much room for a nightstand in the corner so we added a functional niched shelf instead. A sconce in the niche for nighttime reading makes the space feel intentional and cozy.

pattern where it counts

We used very few patterns in Hill Cottage but I wanted to add a sense of charm and patina to the primary bathroom, so I paired a distressed patterned tile with a simple painted vanity from my collection with Unique Kitchens and Baths. A duvet in my Lauren Liess textiles fern star pattern adds an organic vibe to the primary bedroom.

simple beauty
Old bottles and
nature finds lined up
along a windowsill

*paneled for
privacy*
The powder room
is fully planked
and painted in the
same white as the
walls throughout
the house for a
sense of privacy
and architectural
integrity. I often
panel powder rooms
because it aids in
soundproofing,
which helps make
guests feel more
comfortable.

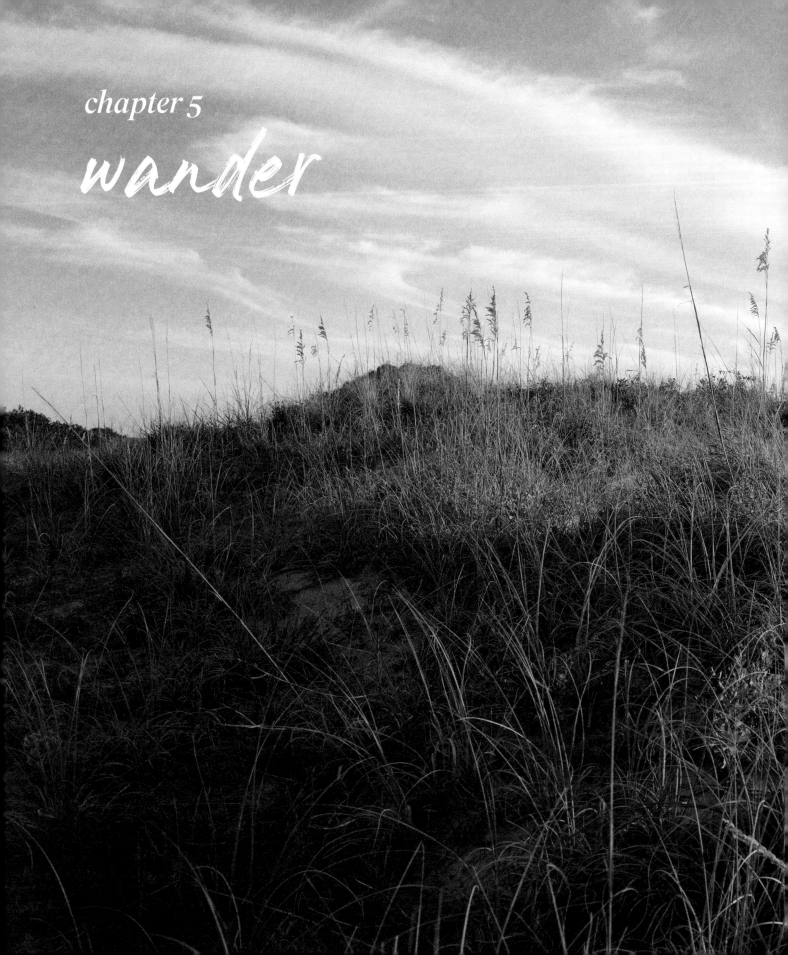

chapter 5

wander

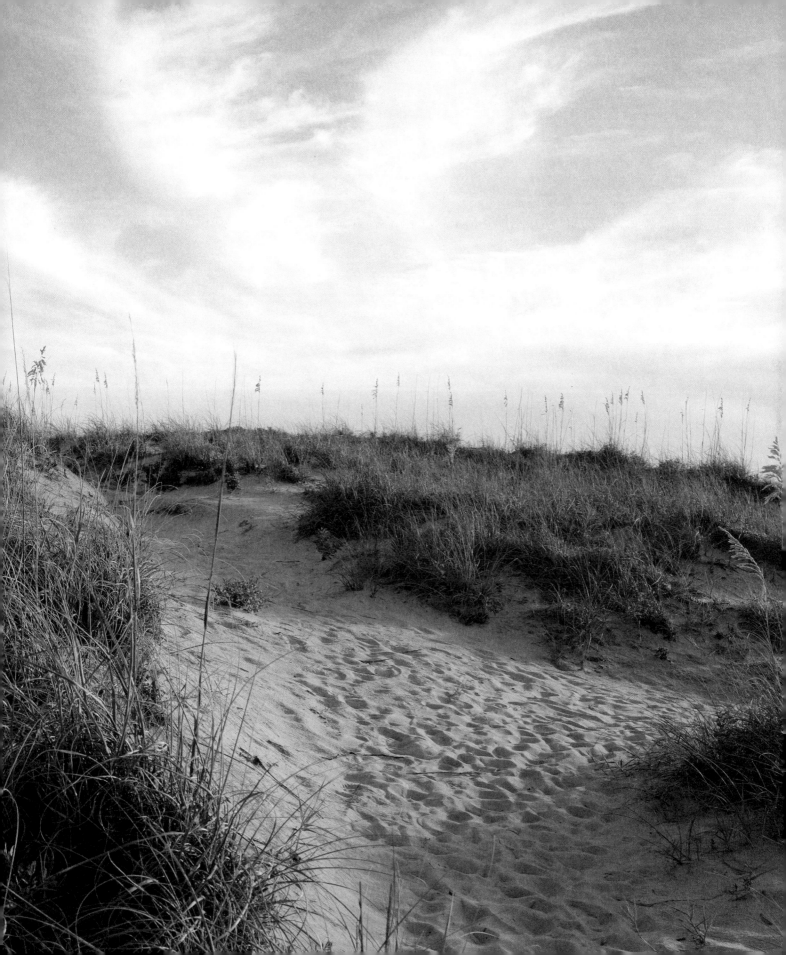

Like most people, I have more on my to-do list than I can ever accomplish in any given day. (And if I'm being honest, some items stay on my to-do lists for years at a time, having been pushed to the bottom as more pressing to-dos come up.) In order to accomplish all that I need to get done in any given day I often feel the need for speed and efficiency. I typically run up the stairs, taking them two at a time, and I will sometimes take bounding skips, jumping as high as I can to get from point A to point B around my house. If I am waiting for something on the printer, I do squats. I do calf raises when I'm filling up water from the fridge or waiting for the shower water to warm up. I power-walk through the grocery store. (I'll be honest, sometimes I do lunges down the aisles with the cart if I'm shopping with other family members who are being slow, which is doubly gratifying in that it also embarrasses my teenager.) Moving faster between tasks allows me to get more done and gets my heart rate going, giving me mini-workouts throughout the day. I do this so I can relax later and do one of my favorite things: nothing.

Dave says I have only two modes—on and off. There is no in between. But I have another mode: it's a mosey, a wander. I often find it when I'm cooking on the weekends, gardening, taking a walk, or reading a book. And it can always be found in nature . . . Especially big nature that is so all-encompassing you absolutely cannot race through it.

Wandering is a slower way of being in which point As and Bs don't exist. We may set out to do one thing, but then end up doing another. With no set destination and nothing to accomplish, we let life unfold. There is such freedom in a wander, going where your curiosity takes you.

OPPOSITE Live oaks are lit with golden light from the evening sunset at Jockey's Ridge.

being barefoot

It was a sunny spring day with temperatures in the mid-seventies and my parents had recently joined us down in the Outer Banks.

"Hey Mom, take off your shoes," I said as we headed from the Lost Cottage to the beach.

"Why?" she asked.

"Because it's good for you."

"I'll take off my shoes when I *get* to the beach," she argued.

"The *walking barefoot part* is what's good for you."

"Why? Do I really need to do this?"

"Yes. You'll work out tiny little muscles in your feet and legs that make you stronger. It's better for your feet and knees and hips because you spread out your weight more evenly when you walk barefoot than you do with shoes on. Please."

My mom is used to these sorts of requests from me (or at least she should be by now) and knows I'm a dog with a bone, so she sighed and removed her navy canvas deck shoes, leaving them by the door. "All right."

"And you're going to get a bunch of grounding ions from the earth as you walk." She looked up at me with a mixture of bemused resignation and skepticism. (I am a free-spirited earth child but I certainly didn't get it from either of my parents.)

"Uh-huh, okay."

"And you need to walk barefoot as much as possible, Mom. It's going to be really important for your stability as you get older."

"Okay." I knew she wasn't convinced but I also knew that she would try as she often does when I ask her to make life changes based on my latest reading and research.

"You too, Tom," I said pointedly to my stepdad who was slinking off with shoes on. "Do it as much as possible, guys."

"Yeah, Grammy and Pop Pop, it's good for you!" our daughter piped up.

Our kids already know the drill: If the ground isn't too hot or too cold, and is soft enough, we're going barefoot. It's one of the reasons I love living on a sand street. Barefoot, we feel everything underneath us, being exposed to it all by an additional sense—touch. Each step is different and considered as opposed

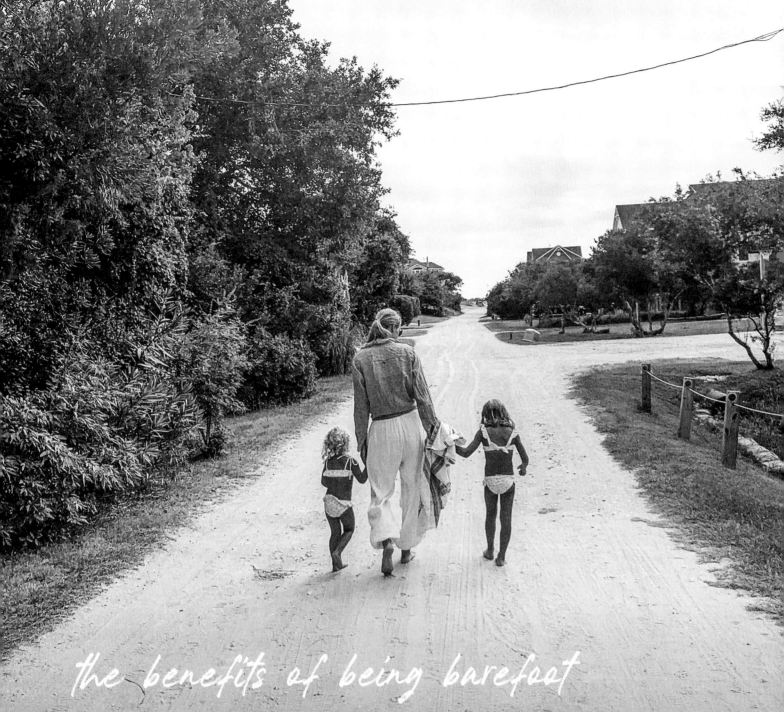

the benefits of being barefoot

- Walking barefoot restores a natural walking pattern.
- Shoes can prevent people from using all the muscle groups in their feet, legs, and hips.
- Better control of foot position when it strikes the ground.
- Improvements in balance, proprioception, and body awareness, which can help with pain relief.
- Better foot mechanics, which can lead to improved mechanics of the hips, knees, and core.
- Maintaining appropriate range of motion in your foot and ankle joints as well as adequate strength and stability within your muscles and ligaments.
- Stronger leg muscles, which support the lower back region.[14]

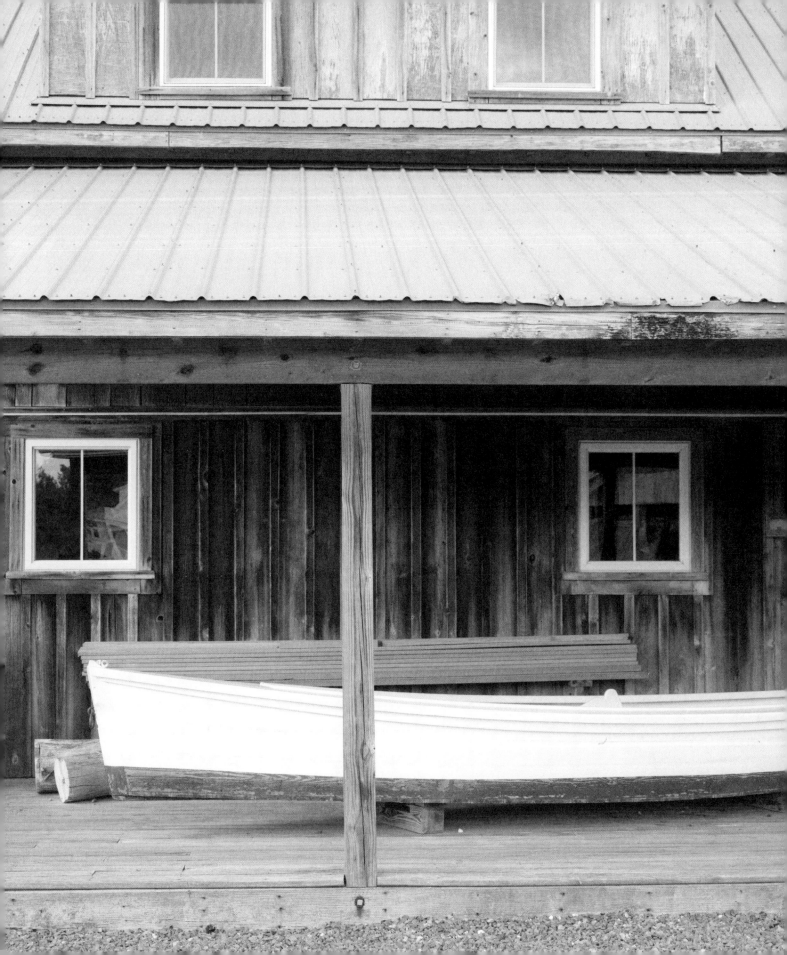

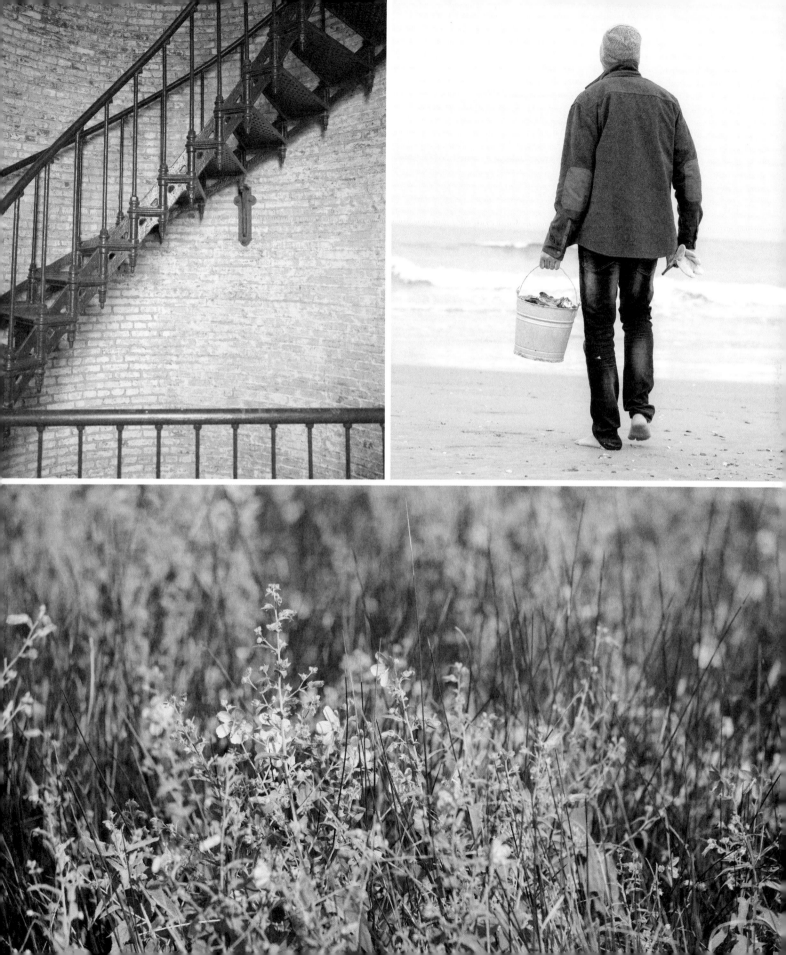

to the monotony and automaticity of being in shoes. Being barefoot makes us stronger and tougher, yet more sensitive and open to observation of the natural world around us.

Along with all the muscular and skeletal benefits of walking barefoot I bombarded my mom with, we also come into direct contact with all those amazing negative ions mentioned in chapter 2, "Summer Spirit," and receive their benefits: pain relief, improved immune system function, greater oxygen absorption, and stress reduction, to name a few. Knowing this, I want the people I love exposed to as much barefoot walking as possible.

present-moment focus

When designing a home, I set out to create an environment where people are focused on each other, rather than on things like clutter or technology that might be a distraction from having the most meaningful experiences. Nature is already the perfect environment for bonding and focus. Free of messes, phones, and technology, out in nature our attention is on the people and the world around us, the here and now. If we think back on our best core memories, they are typically when we are fully living in the moment. Present-moment focus is a true gift and our environments can either aid or hinder us in finding it.

natural wonder

With the many awe-inspiring natural coastal landscapes there are to explore—the ocean, maritime forests, caves, cliffs, dunes, and more—the seaside is a wander-inducing place. Beach mode *is* wander mode. Meandering down sand roads, paths, or along the beach, not knowing how far we'll go, we are free from having to *do*. Each wander is a discovery of natural curiosities, of flora and fauna, stones, and animals that captivate us on a primal level, and connect us with this planet and its wonders.

uncommon nature

Today, walking barefoot is referred to as "earthing" or "grounding," and we call walking in the forest "forest bathing." Each of these practices is known to have positive effects on our general well-being, but think about the fact that we now have special names for what were once commonplace experiences vital to daily living. It underscores that, as a society, we have lost touch with these experiences, that they are no longer commonplace. How often do most of us walk barefoot outside or wander through the forest?

the wandering mind

Not only do we physically wander in nature, but when we're walking, our minds often begin to wander too. Light-bulb moments and increased creativity are a common side effect of walking that even lasts for a short while after, when we sit down to do creative work.[11] When we are thinking, we will often get up and pace because walking at a low speed aids in creative problem-solving. "When we go for a walk, the heart pumps faster, circulating more blood and oxygen not just to the muscles but to all the organs—including the brain. Many experiments have shown that after or during exercise, even very mild exertion, people perform better on tests of memory and attention. Walking on a regular basis also promotes new connections between brain cells, staves off the usual withering of brain tissue that comes with age, increases the volume of the hippocampus (a brain region crucial for memory), and elevates levels of molecules that both stimulate the growth of new neurons and transmit messages between them."[12]

wandering in nature

Wandering in nature is even better for us than walking on a treadmill or in a city environment because of the added positive effects of being in a natural setting. "After approximately 10 minutes of basking in nature's glory, research has shown that our heart rate slows, stress levels decrease, concentration is restored. Furthermore, taking note of the wonder around us begins to positively influence our physical and mental state."[13]

don't wait

Wandering is one of the many encounters with gratitude we are given at the beach. On the coast, the habit of walking leisurely seamlessly fits into our days and we thrive from its benefits. A walk on the beach or in a quiet pine-straw-laden forest is a journey not only for grounding and reenergizing, but also for exploration and discovery. Even when the to-do list is years old and we are racing (or skipping or lunging) from point As to point Bs, and when it seems like our only mode is off or on, remember that whenever we choose, we can take a mosey and switch into wander mode. ✦

A *Star Wars*-esque landscape of endless sand dunes, Jockey's Ridge is the tallest active sand dune system on the Atlantic coast, encompassing 426 acres. We love to go there when it isn't too hot out and you can make the trek barefoot. The most traveled path is by way of the main entrance, which features a wide low dune path to get to the big dunes where everything opens up but you can wander off at any point into the wilder shrubs, grasses, and trees. Off the beaten path and down steeply sloped dunes you can slide into the forest where it's shaded and cool. Mushrooms sprout up through the cool sand and dune grasses. There are often lots of sightseers on the dunes, but you won't see anyone else down there in the woods and you will feel completely alone in the secret landscape.

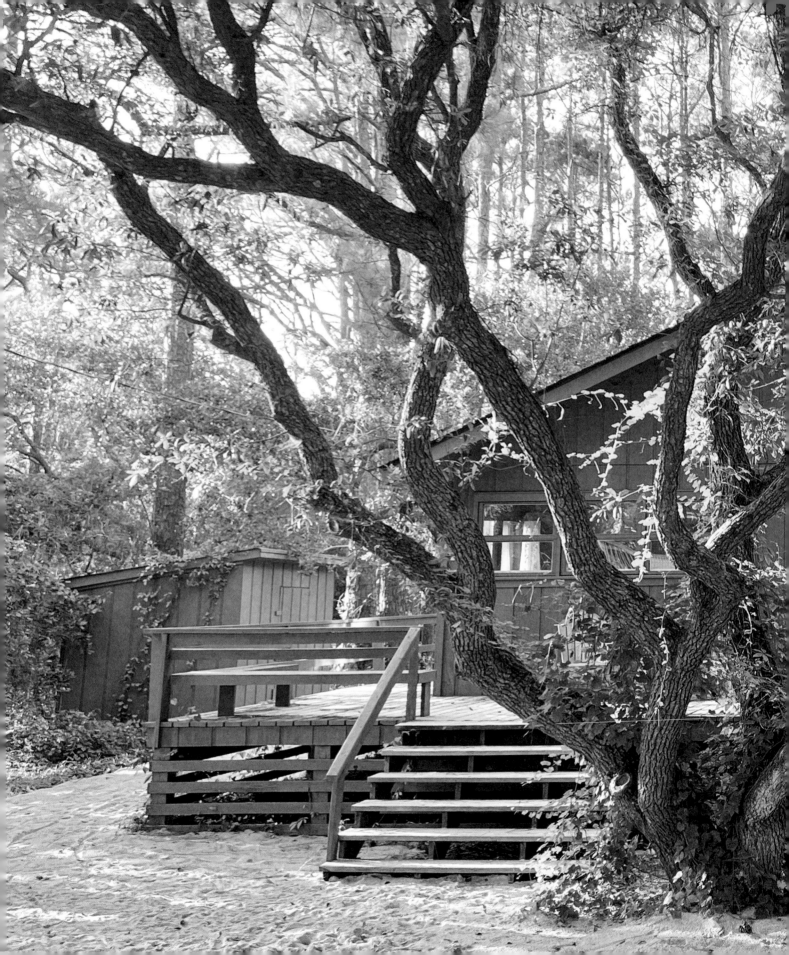

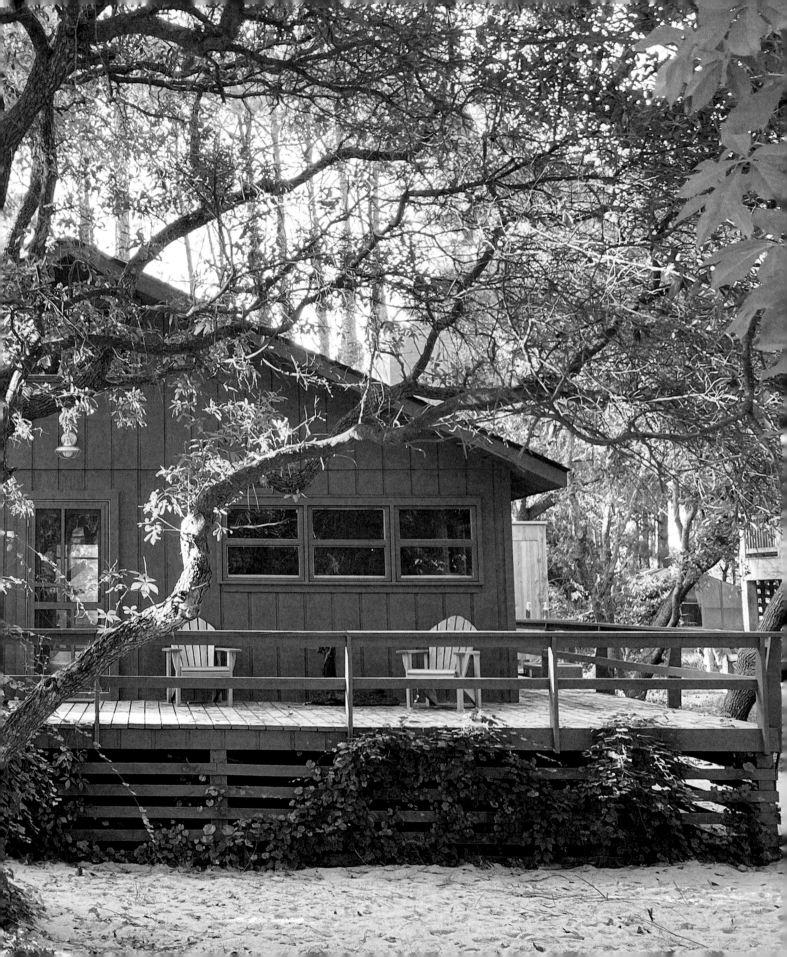

the beach cabin

One of our most-walked wanders at the beach in Corolla took us past an empty green cabin built in the late 1960s. It's one of the oldest houses around, from when Corolla was just a small hunting and fishing village. Surrounded by mossy live oaks and pines, the house feels as if it was meant to be in that forest. Built lovingly by the owner's parents, the cabin had now sat unused for years, just waiting. Having the unceasing urge to fix things up and restore old homes to their former glory, I naturally had many daydreams about the cabin. I wasn't the only one, though, as there were more than twelve offers on the little house when it finally went on the market. We heard that some of the bidders were planning to tear down the little house and build new, which made the situation harder to stay away from.

We always told ourselves we wouldn't get involved if the cabin ever went on the market, because we didn't want to make going to Corolla about work, but the owner gave us a tour of the inside just before it went up for sale and told us all about how her mother had worked with an architect who had trained under Frank Lloyd Wright to build the perfect little cabin for her and her family. As I looked outside the back screened porch at the swaying pines and glanced into the house at the soaring ceilings, I recognized that scared quiet feeling inside me . . . the one that meant we might be entering house-renovation roller-coaster territory . . . again.

I don't really know why we made an offer. Our biggest fear was that someone would tear it down. There's a lot of love for this little place around town and many of us wanted to see it preserved. But it was more than fear that plunged us into our newest adventure . . . It was also the innate desire in me to see a vision to completion. I had already seen this beautiful vintage-inspired beach-

The Beach Cabin is a mood. It's a throwback to simpler days, and efficiency. My philosophy with the cabin was "tread lightly." I wanted it to feel as if I'd never been there. The cabin is a time capsule of sorts and transports all who enter to a bygone era, reminiscent of summer camp. We redid only what was necessary—some of the major systems and non-exciting things like the roof—and kept all the elements that made it charming: the pine board-and-batten, the copper-screen front door, the original awning window frames, the decks, and even the green exterior color.

OPPOSITE We loved having seafood boils on the front porch of the cabin. Check out our recipe on pages 269–271.

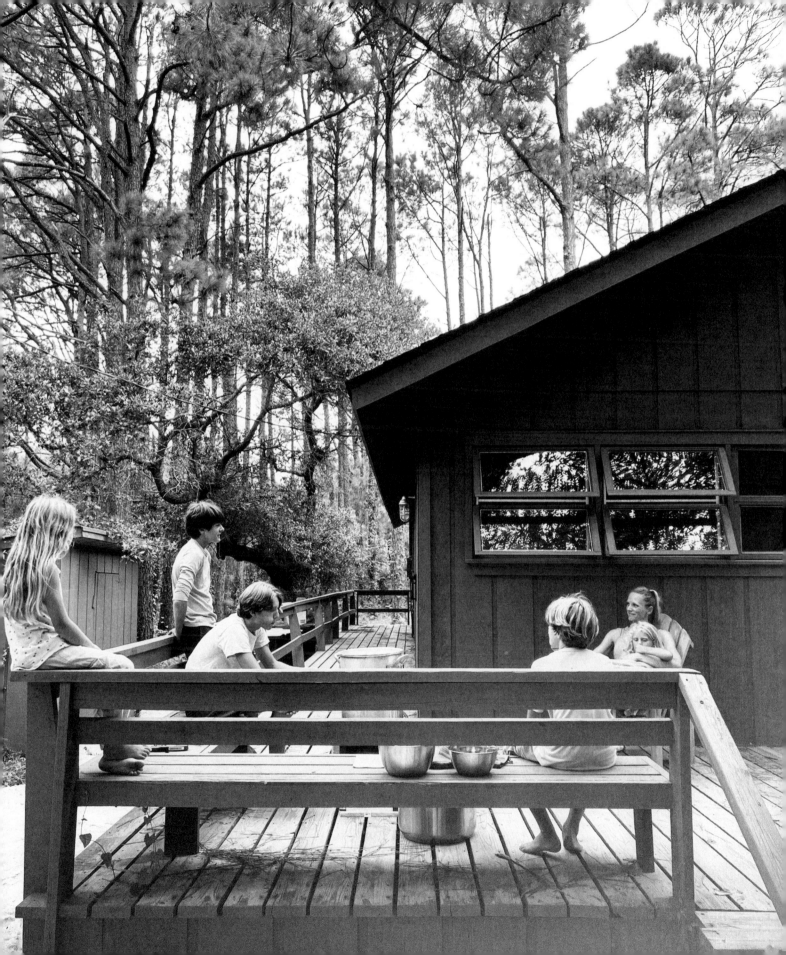

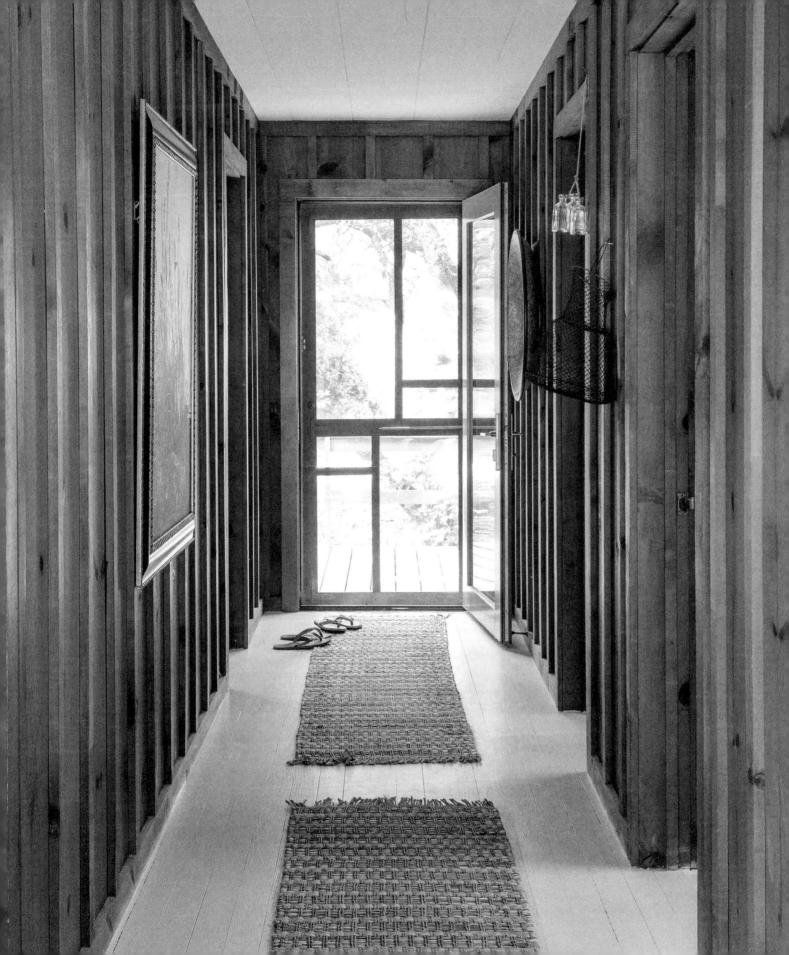

camp way of living in my mind and just couldn't get it out of my head. I wanted to make that for someone, though I didn't know whom. We were already knee-deep in the Dune House project—featured in the next chapter—which was going well at the time, and the last thing we needed was another project. Unlike our typical approach to buying rehab properties, we had no idea what we would do with the property if our offer was accepted. Would we rent it out as a part of our dream rental property business, or sell it to someone who would love it as much as we did? This house has been a wander for us in every sense of the word, with no destination in sight.

When our offer was accepted, we set about fixing up the Beach Cabin, as we came to call it, with the goal of making it look as if we hadn't done a thing. We let the Cabin tell us what it wanted, which was very little. I spent time in the empty house picturing it ever-so-gently revamped. My plans for the house evolved over time unlike most which are set from the get-go.

So much of life is painstakingly planned—something highly recommended for real estate deals—but sometimes, like a soft breeze drifting in through the window begging us to step outside, we are called to do something unplanned, something unknown. We are called to wander. ✦

lighten up

The first thing we did in the cabin was paint the floors with a white porch paint to lighten up the entire house. The front copper screen door was one of my favorite details in the house, but it was breaking, so we had a new one made by our talented team of carpenters.

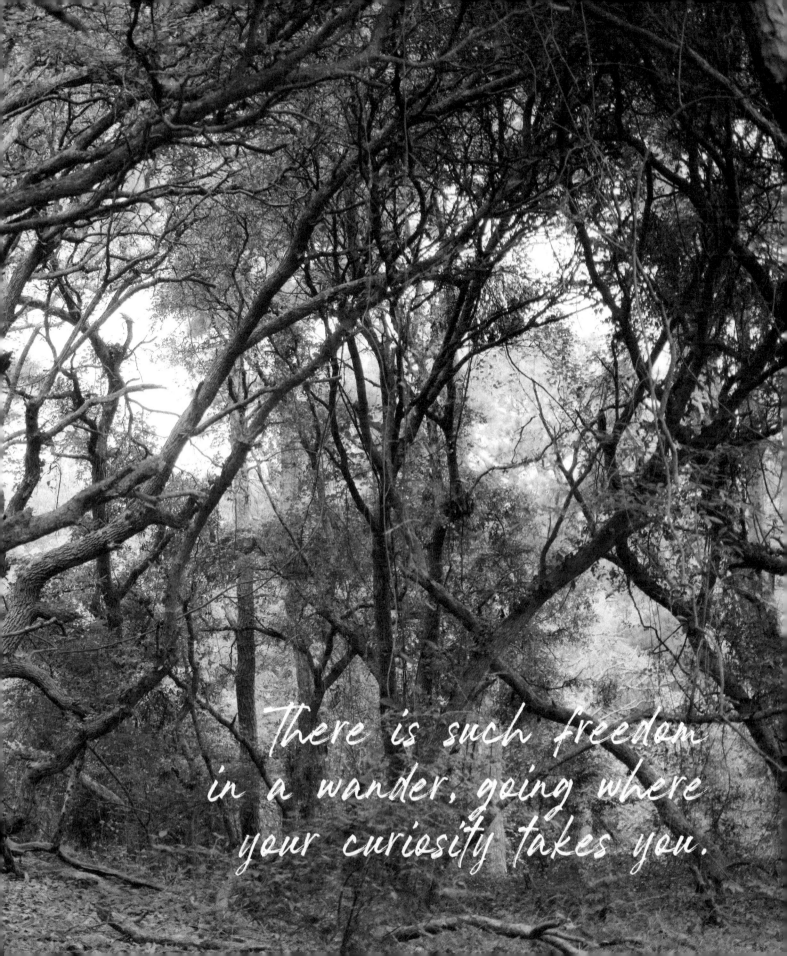

There is such freedom
in a wander, going where
your curiosity takes you.

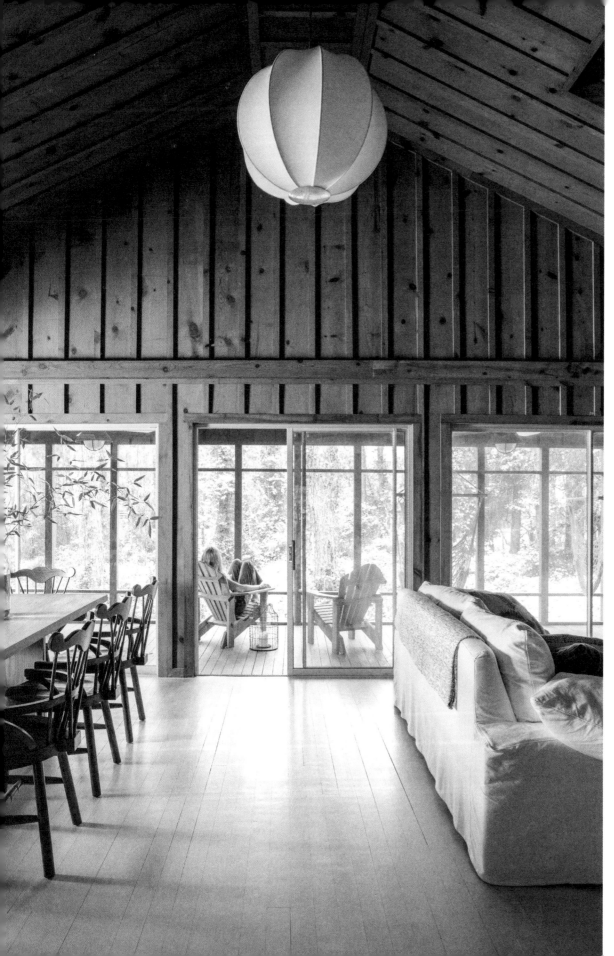

midcentury rustic

I played up the cabin's midcentury vibe and added rustic, "camp" details throughout. An overscale linen orb light with midcentury leanings plays well with rustic woods and folksy furniture.

subtle updates

We modernized the house in ways we felt made sense: adding wall-to-wall glass sliding doors in both of the front bedrooms for access to the porches and more sunlight, replacing old Formica countertops with stone ones, upgrading appliances, lighting, and plumbing, and adding an outdoor shower. We kept all the original board and batten pine cabinetry throughout the house. If you look at the photo on the right and follow a ceiling batten down, you'll see it continues perfectly down onto the cabinets.

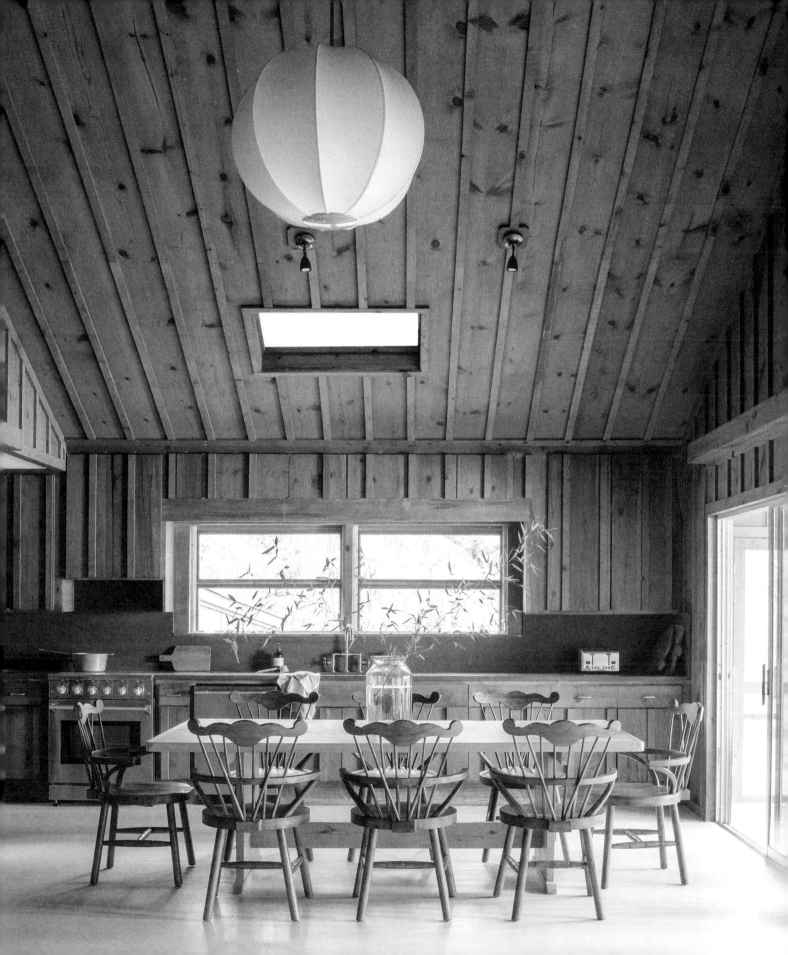

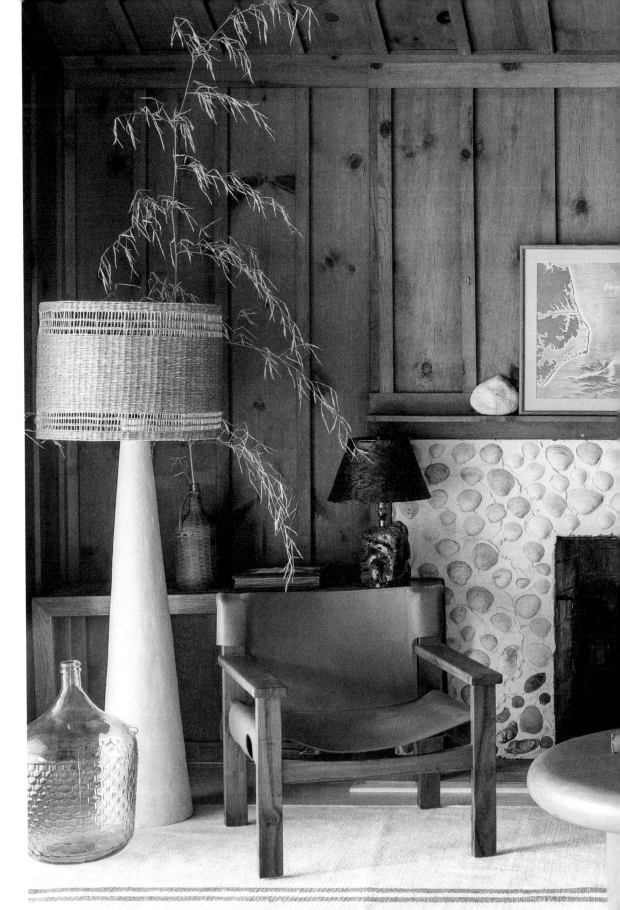

make waves

From the moment I saw the original cinder-block fireplace, I knew I wanted to cover it in seashells—a project I had been dreaming about. I sketched a wave on the cinder block and pressed seashells we'd collected over the years into brick mortar. The apparent motion of the wave creates a playful energy in the house.

floppable furniture

I wanted everything in the house to be comfortable and easy and made sure all the furniture invited long sits and "flopping."

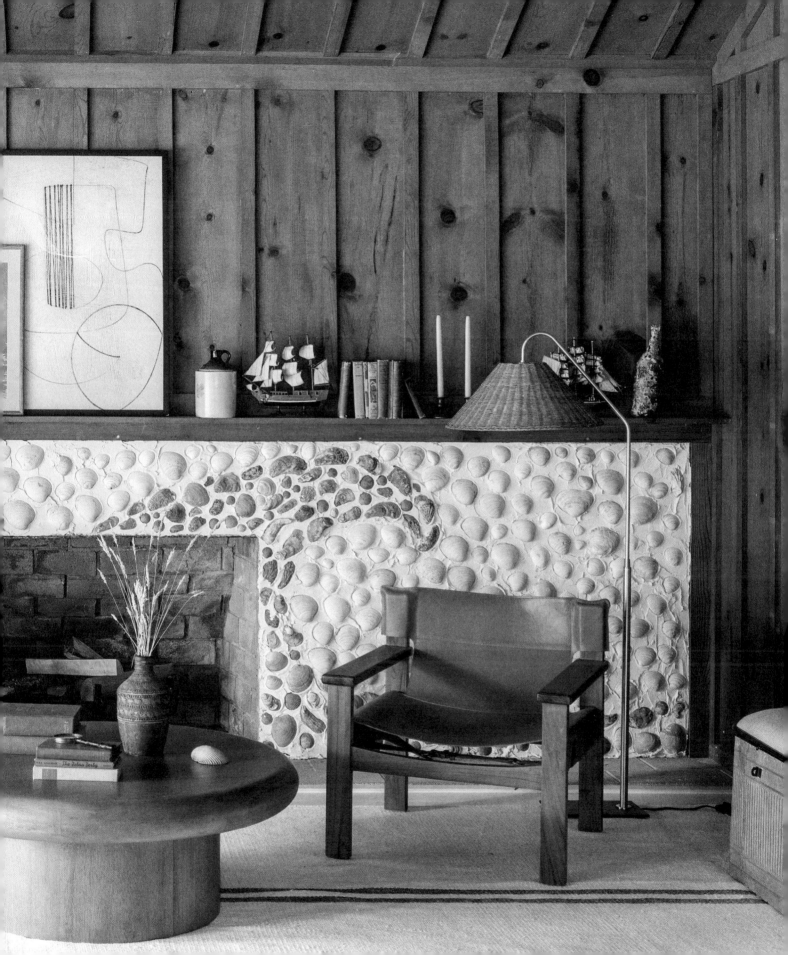

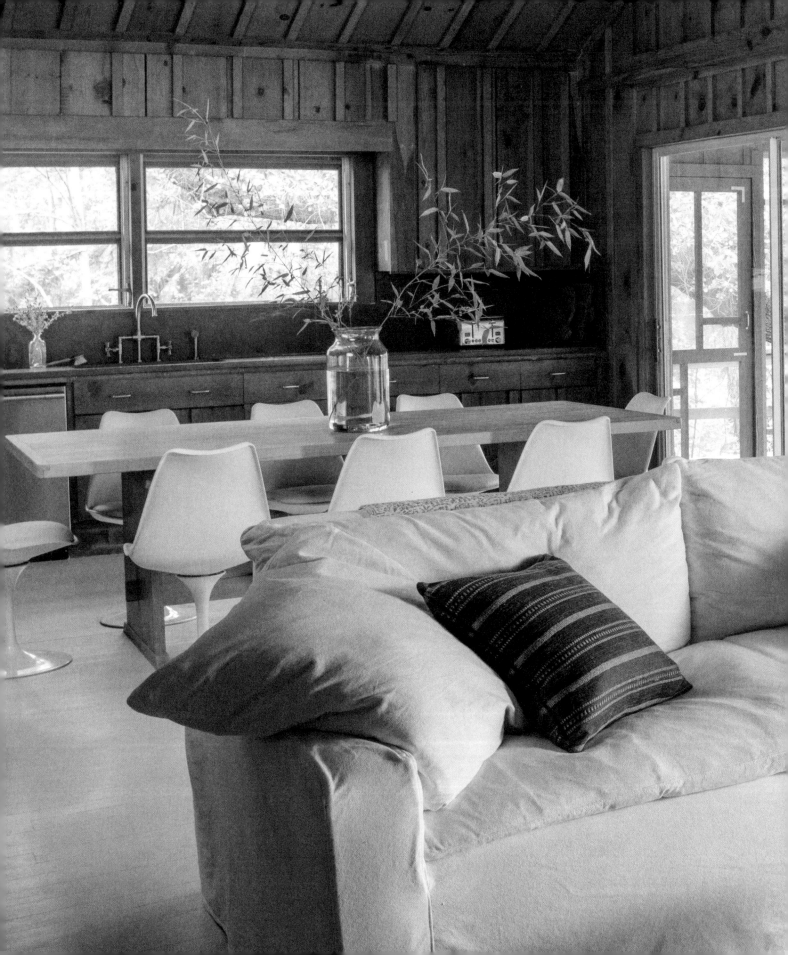

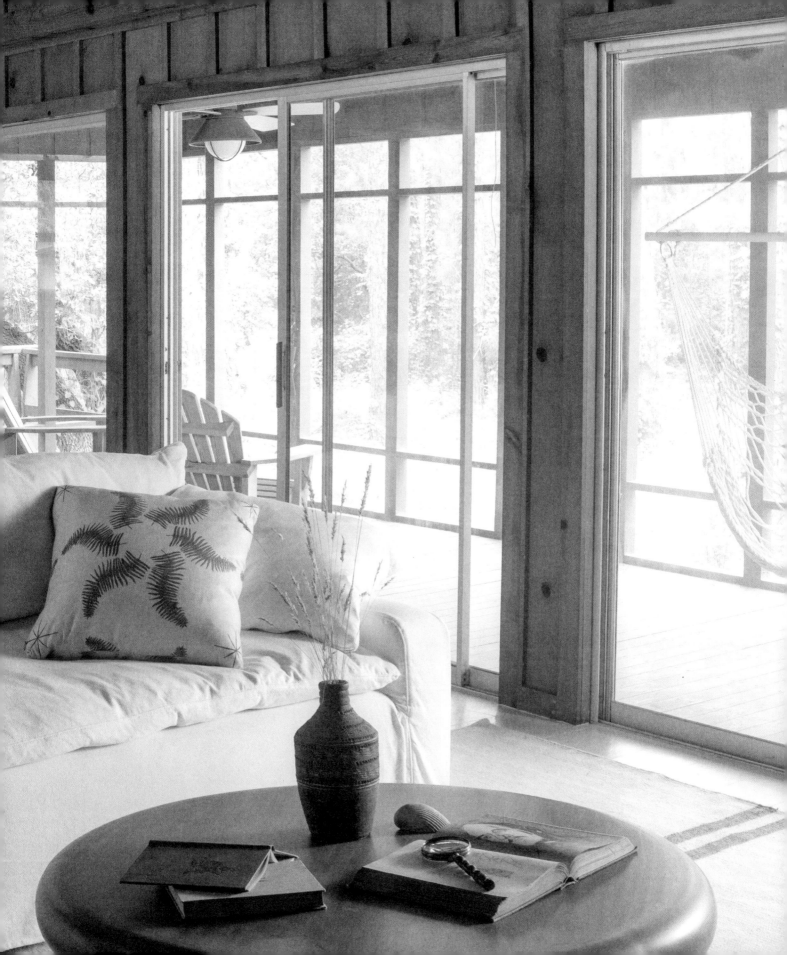

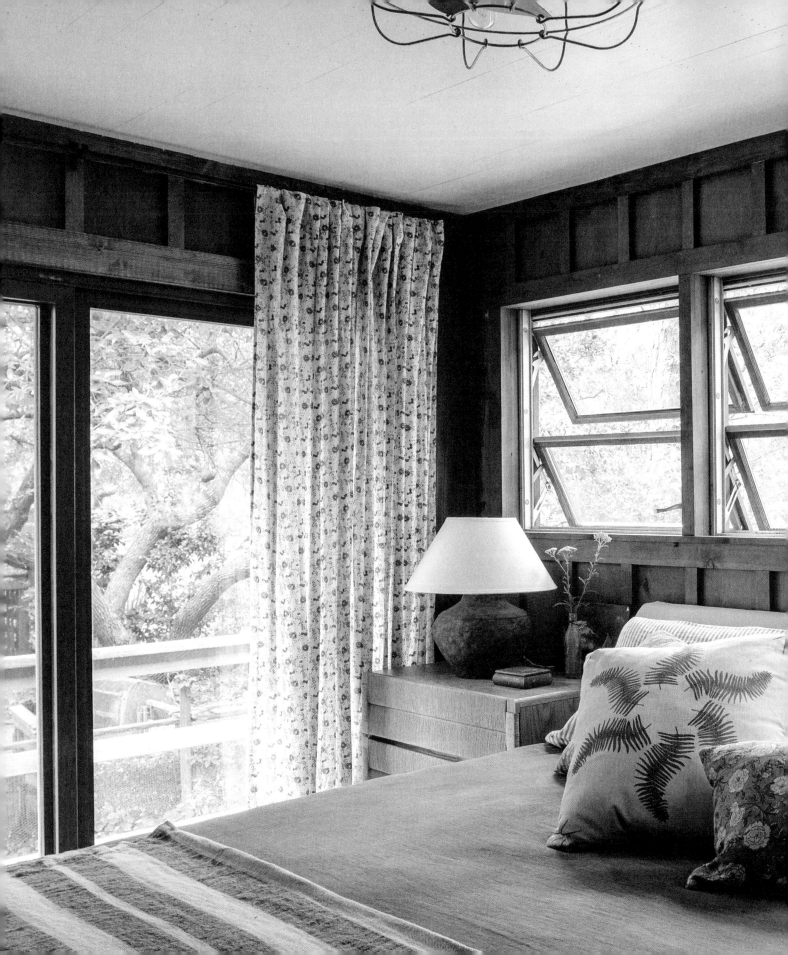

summer camp vibes

The cabin's vintage summer camp vibe inspired an earthy palette of olive green, browns, and rust tones. I mixed lots of patterns together for a charming, collected feel. We removed a closet to be able to fit a king bed, which now sits under the original refurbished awning windows.

sea cabin

FOLLOWING
Miniature vintage seascapes inspired the addition of blue in the queen bedroom. New sliding doors replaced broken awning windows on the sides of both the king and queen bedrooms to allow for more light, to give the rooms a strong connection to the outdoors, and to create easy access to both the decks and the outdoor shower.

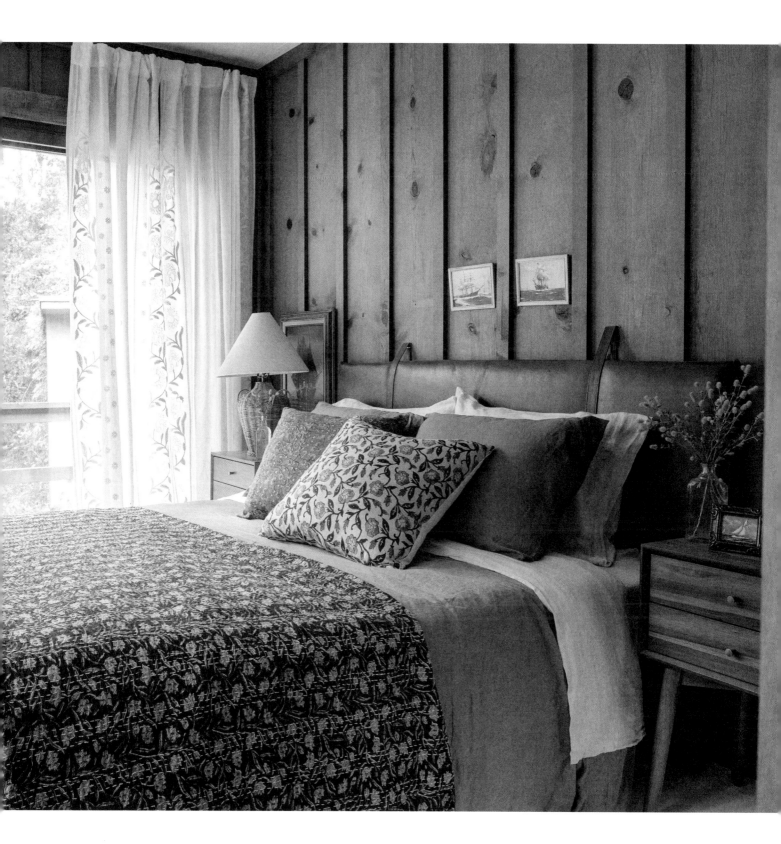

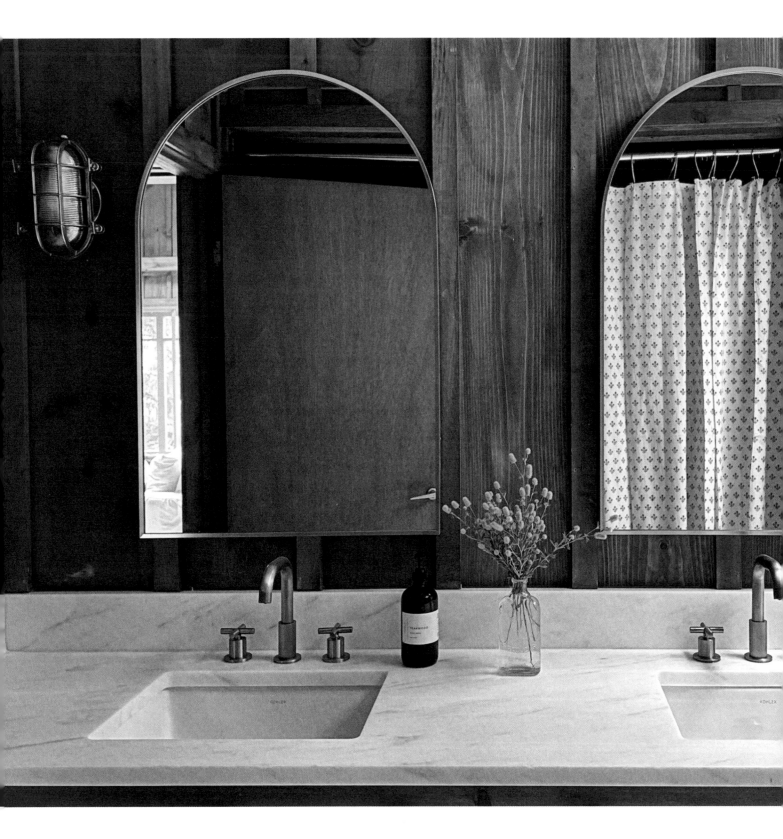

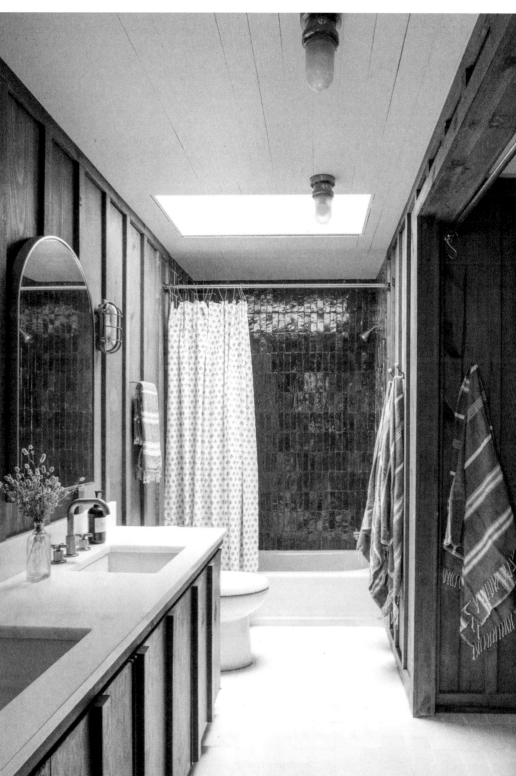

vintage charm

I leaned into the vintage vibes of the cabin with a pair of Jenny Lind beds and a mix of patterns, including mismatched vintage quilts, Lauren Liess textile and vintage pillows, and botanical café curtains. The rug feels like an antique but is actually a new machine-washable rug from my collection with Rugs USA. I drew the framed charcoal "heart keeper" sketch on the wall to plan out the fireplace design and hung it in the bedroom, because I hoped it would remind the guests staying there of their own love for the ocean.

secret attic

We conditioned the large attic, and it became our kids favorite spot to play in during the renovation and the following summer as we tried to figure out our plans for the cabin. I filled it with old treasures and curiosities that would be fun for the kids to find. The wallpaper is called "Captains log" and features a sea captain's log entries and findings while at sea. Stairs could easily be added up to the attic for easier access.

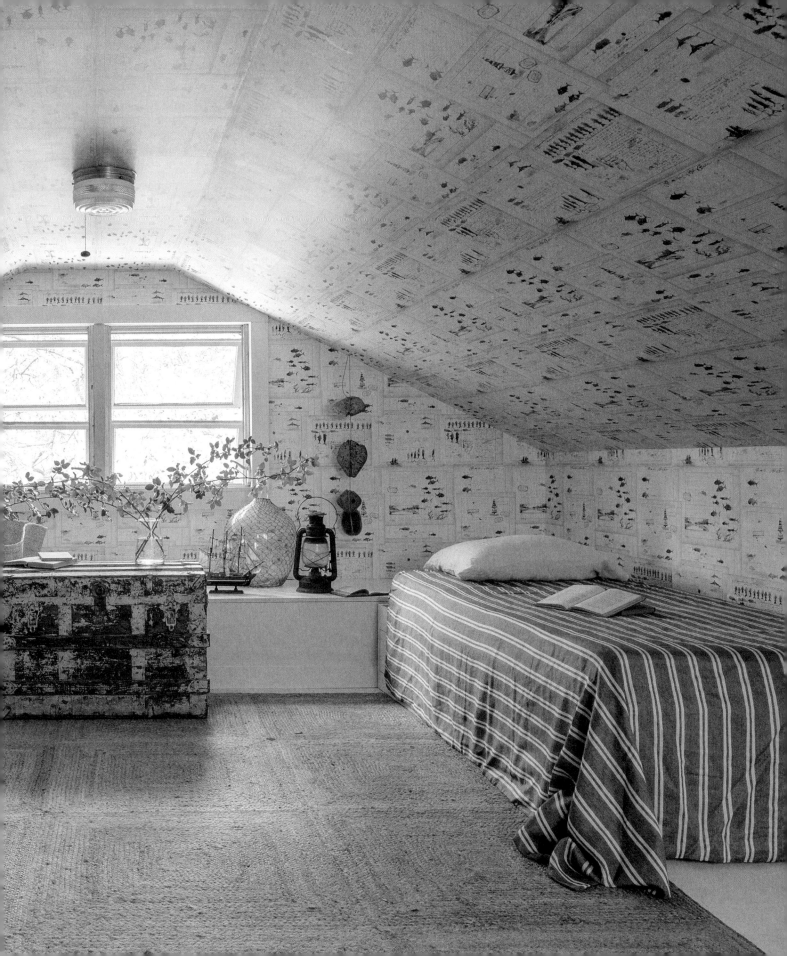

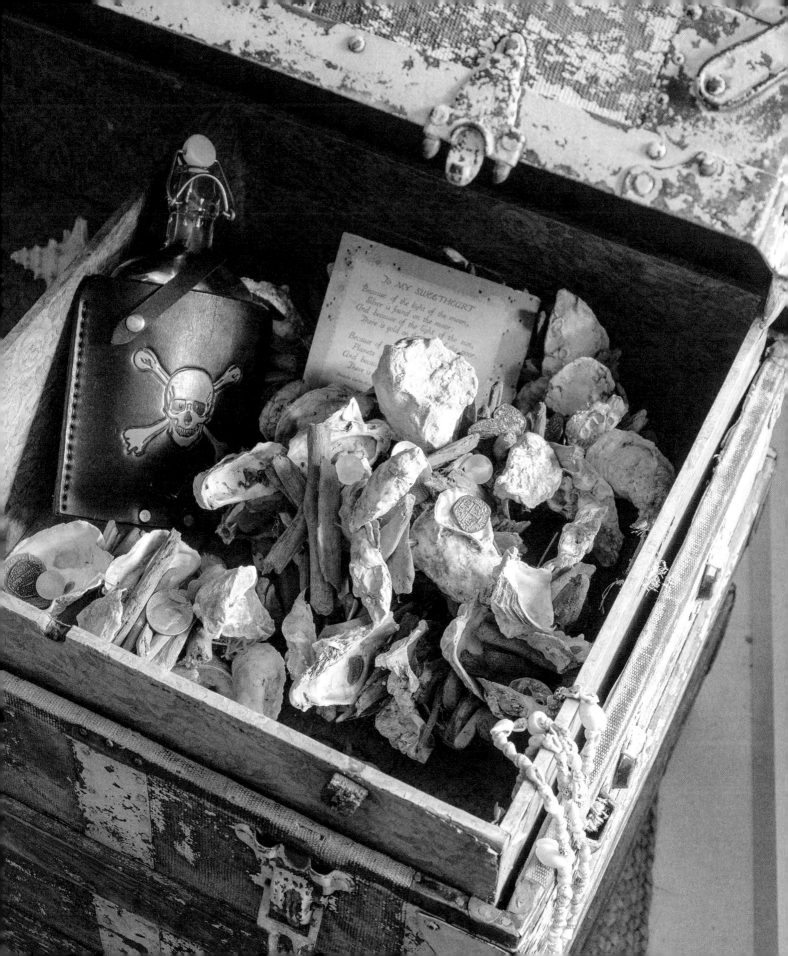

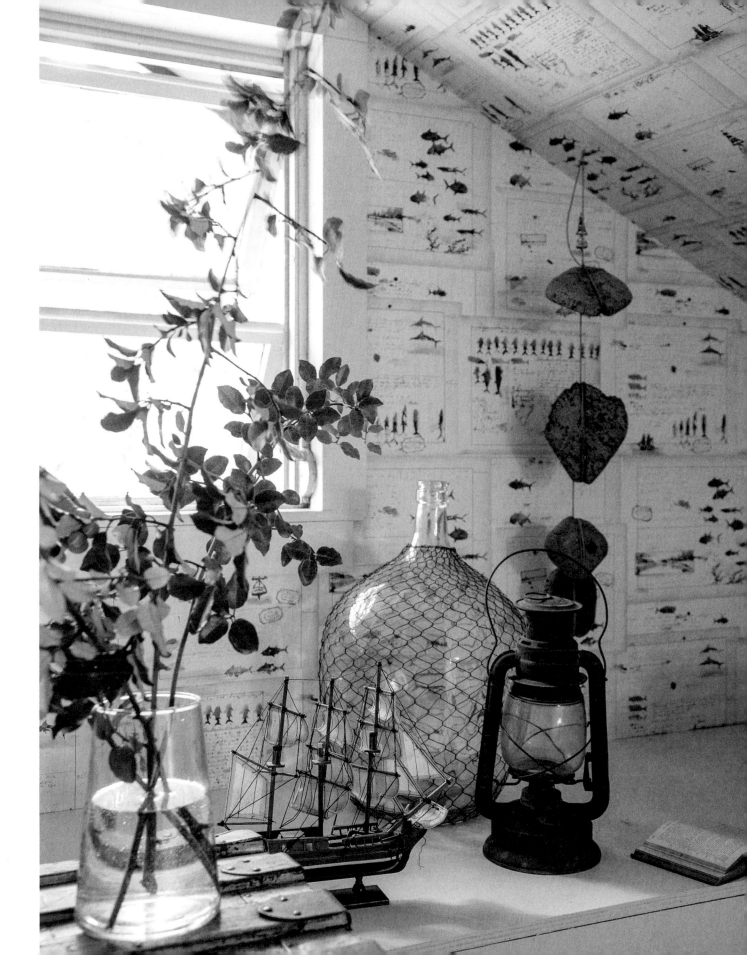

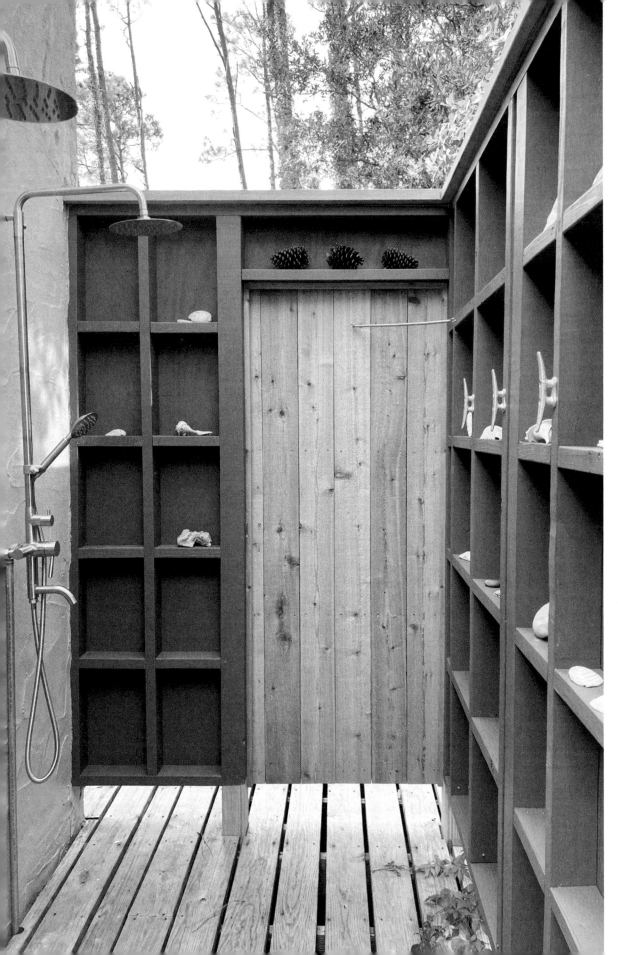

porch livin'

The porch wraps around the Beach Cabin on all four sides. The screened porch is a peaceful extension of indoor living space, with hanging swings and Adirondack chairs. We added the outdoor shower to one of the side decks, because nothing feels better than an outdoor shower at the end of a long beach day.

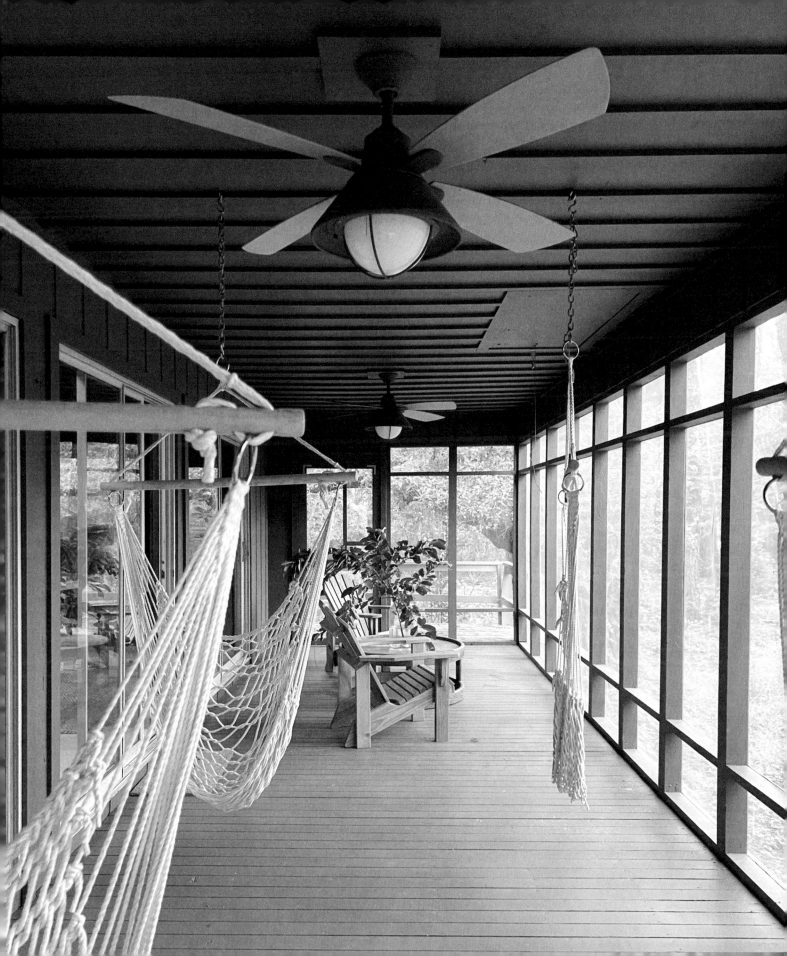

"You must go on adventures to find out where you belong."

SUE FITZMAURICE

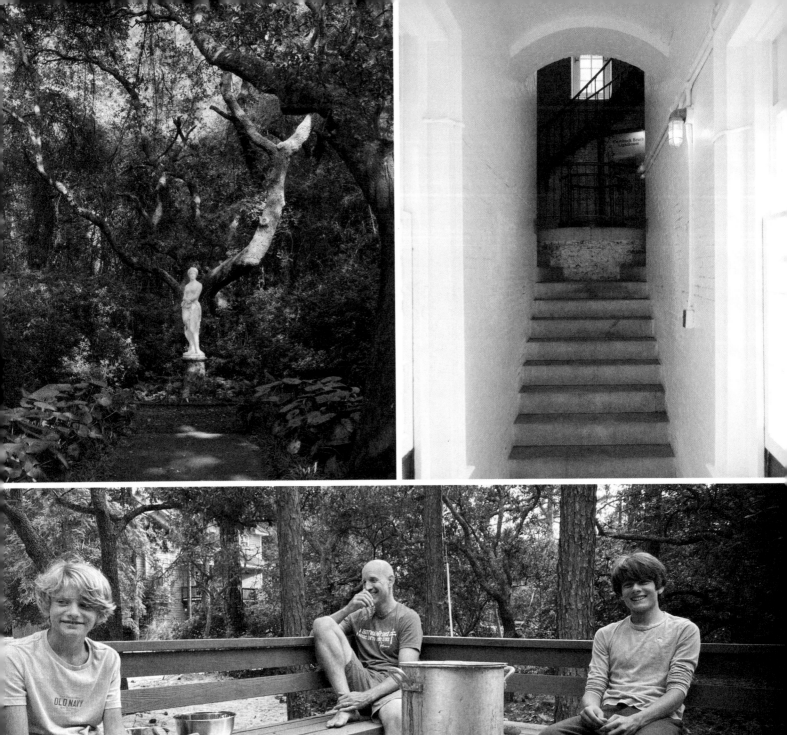

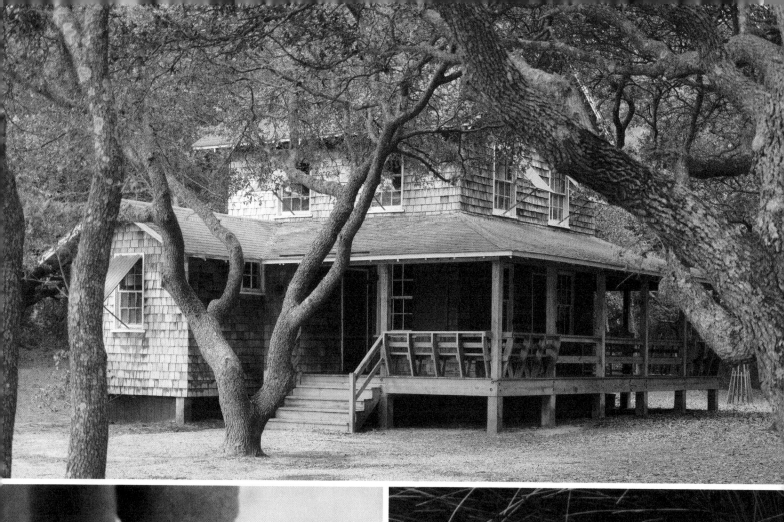

chapter 6
dream

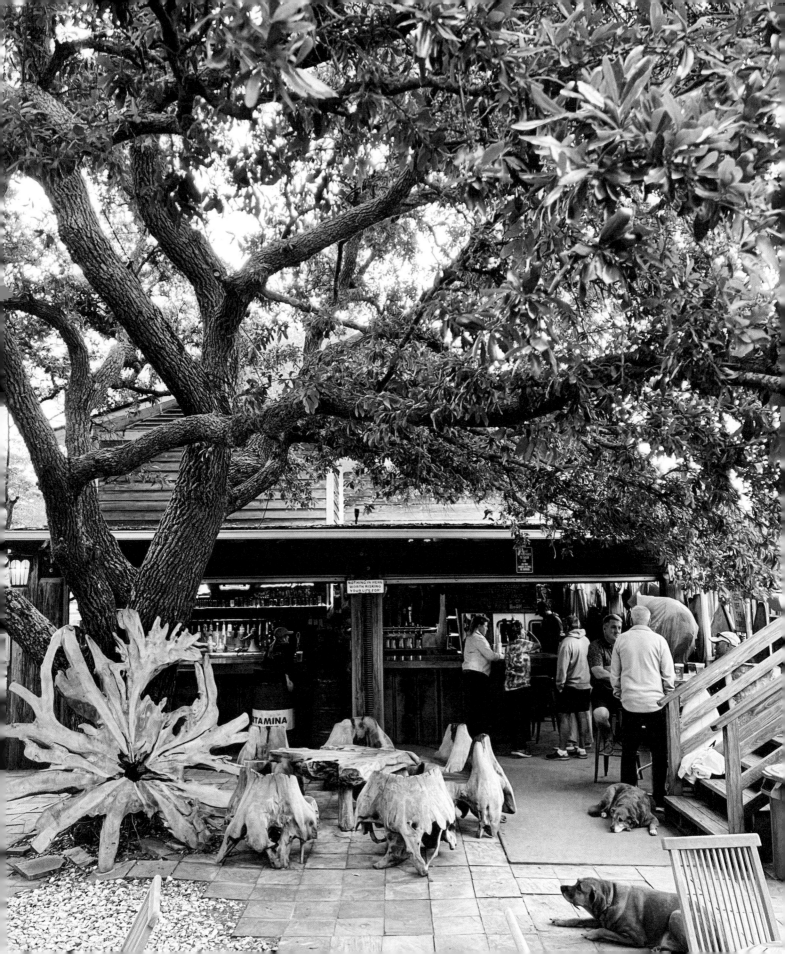

"What's your 'impossible'?" I asked the person.

"Here we go," said Dave, nodding over at me and laughing with the bartender, our close friend and next-door neighbor, also named Dave.

"Oh boy." He knew what was coming.

"What do you mean?" the person asked, taking a sip of beer.

"What's your 'impossible'? Your dream? The thing you want more than anything right now, that feels impossible," I said.

I've chatted with all sorts of people on nights like these—other moms, dads, locals, tourists, college students, grandparents, you name it. It's a thing I like doing sometimes, talking with people about their dreams.

Like most people, I am not a fan of small talk. And somehow, at the beach, it feels all the smaller. Whether about the weather—which I admit is my go-to when I don't really know what to say—or random talk about children or work, none of us really want to engage in small talk. But most of us genuinely enjoy having meaningful conversations with people... Conversations that are honest and productive... Conversations that get us thinking.

I get all sorts of reactions to the "impossible" question. "Nothing is impossible," some will say, ready to argue that point, which is in and of itself an interesting conversation and says something about the person.

OPPOSITE The Beer Garden is a favorite hangout.

FOLLOWING The Pea Island Lifesaving Station

"Sure," I'll say, "but what's the dream you're after right now?"

"I have to think about it," some will say. Lots of those conversations pick up later, after the person has had time to mull the question over.

"I'm doing my impossible in the fall," was a favorite I've heard. "I'm biking across the entire country."

"I want to be a firefighter," one young woman confided in me.

"I'm going to try out for a play," a friend told me.

"I want to start my own business," many have said. I have never had a boring conversation following this question. People are passionate about their dreams and passion makes for interesting conversation. Dreaming sparks our creativity and takes us out of the everyday.

The "impossible" question came to me one particularly hot and humid late afternoon at the beach. I was sitting with my chair down by the water's edge so the waves could wash up over my feet. I watched as the kids played in the surf, but was alone with my thoughts.

I do a lot of questioning, reading, and writing in those quiet moments at the beach, letting my mind wander and my thoughts flow freely.

Constant and awe-inspiring, the ocean surrounds us and grounds us, giving us the courage to think beautifully and bigger. The ocean helps us see the whole picture, and when we step back and look at our singular life from a more expansive perspective, we see that the things that feel so difficult, so out of reach, so impossible, are really right within our grasp.

I keep a running document of notes gathered from thoughts that come up, books I've read, and pertinent conversations. I typically work on it in the wee hours of the morning when no one is up yet or sometimes in the later afternoons on the beach when the kids are playing on their own. The ocean gets me thinking.

I scribbled the following notes onto the back pages of a book and later typed them into my document:

> *DO THE IMPOSSIBLE . . .*
>
> *What is the framework of mental barriers / norms associated with being a mom? A designer? With working? With everything I do?!*
>
> *Write down how that's limiting me.*
>
> *Rethink it ALL.*
>
> *Ask—how can I transcend these arbitrary man-made limits that are in place?*
>
> *Who says when and how you have to work? Who you have to be?*

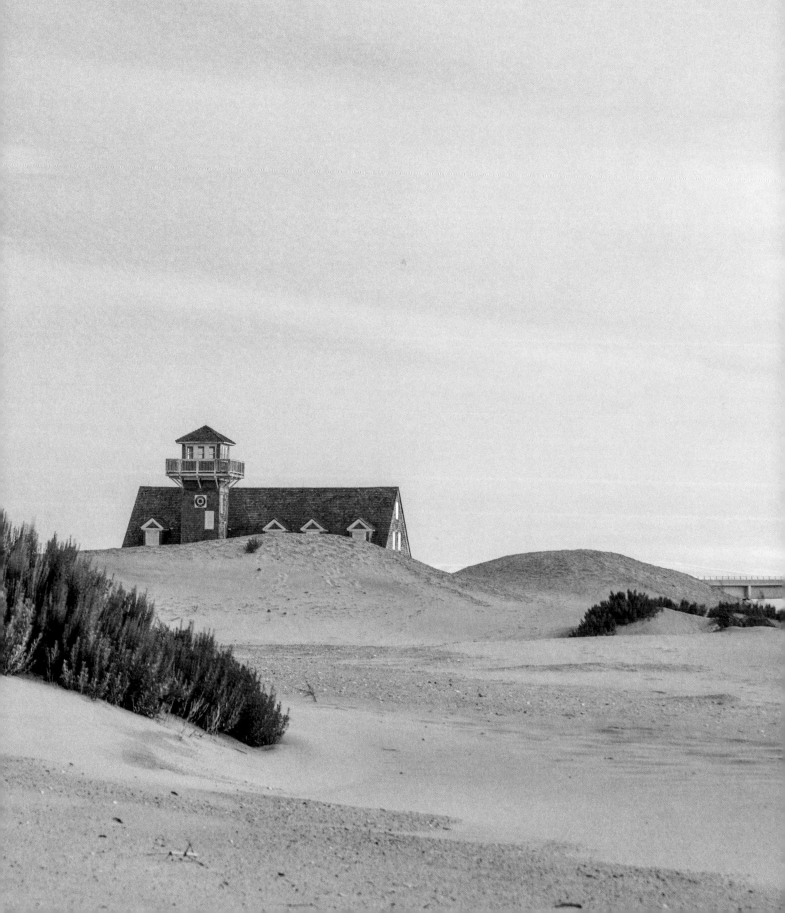

I saw that, up to that point, I had been consistently working within confines that I had not been a part of creating. I thought I had broken free from those years ago when, as a woman, I started a business I loved that eventually became our family's sole source of income. But I realized that I was only pushing boundaries; I wasn't breaking them.

What did I truly want? What was my impossible?

I worked backward from what I wanted my daily life to look like. How many things was I doing just because I had been told to do them? Just because society approved? I started to question all my habits, wondering how I could make life immeasurably better on a daily basis.

I sketched up a quick weekly calendar in the back of my book. I thought about the more creative aspects of my job I had always loved so much and how they were constantly getting put on the back burner—writing, designing new textiles, sharing recipes, foraging, gardening, styling, flower arranging, and more. I decided I would set aside Fridays for the creative activities that would enrich my home, life, and business at the same time. I would rebrand Friday as a "day off." I would no longer check emails and DMs and post on social media in the early morning before the kids woke up. That time would be for creative growth. And I would stop work every day when the kids arrived home to give them my full attention. I vowed not to open my email after dinner; instead I would open storybooks. This new schedule would give me only seven hours of traditional desk work per day, twenty-eight hours per week. (Now, I knew I was doing some creative accounting by calling Fridays "days off," but those activities would take the place of emails, meetings, and tasks directly related to my interior design firm, so I *was* losing a considerable amount of time that had previously been devoted to Lauren Liess Interiors.)

28-hour workweek? I wrote in the margin of the book.

I remember feeling uncomfortable and even a little guilty giving it credence by writing it down. I was raised in a family that highly values a strong work ethic and it has rubbed off on me. I have consistently overloaded my plate in order to achieve, so the idea of drastically reducing the number of hours I might work per week felt like slacking off. Working long hours had always felt like the "right" thing to do. Work had become a part of my identity. I was embarrassed to even be considering a reduction in formal work hours. It's hard for me, even now, to be sharing this with you because that attitude has been so ingrained in me. I know how fortunate I was to even be able to consider this possibility and hope that one day, for all, it won't be such an anomaly.

But the "28-hour workweek" symbolized a new way of life for me . . . a way of life in which I got to both have a thriving, creative business and be fully present with my family.

I stared out at the water, my feet now buried in sand from the waves' constant washing over them. Sometimes the expansiveness of the ocean makes you feel like anything is possible. *But twenty-eight hours a week?* I asked myself. *Can I do it? There's no way. It's impossible.* And with my earlier self-imposed limitations, it was. But the ocean roared on and told me nothing was impossible.

Over the next few weeks, after hearing so many people's ambitious and inspiring dreams, my impossible didn't seem quite so impossible after all, or even very interesting compared with most.

But a dream isn't just delivered to us, we have to go and get it. A dream is only the first step toward achieving what we want. We have to go back out into the real world and make it happen. Dreams can feel effortless, but achieving them takes careful planning, hard work, and grit. Dreams are made real by action. Dreams are made of habits . . . Hundreds of tiny little habits performed each day that make us who we are. When we have a dream, we need to *become* the person who gets that dream.

If I was honest, I could see that, though I was busy day in and day out, I wasn't maximizing my time. I would check emails in a loop, read the news, scroll social media, chitchat, get sidetracked, and partake in many other attention-stealing activities throughout any given day. Ironically, my dream of working less would require more work of another kind, the training montage kind. Hitting my impossible would require me to become a more efficient, focused, and healthier person. I would need to maximize every minute of work time I had, giving it my best effort, putting my best self on the job to do what to me didn't feel humanly possible. I would no longer check emails or DMs when I woke up in the wee hours of the morning. I would use that time for myself, reading, praying, meditating, and working out to get my days going. Eating would be cleaner, and I would need to stay more organized, cut back on screen time, and say no more often. My time at the beach had shown me a new way to approach life. It had shown me how to fulfill my dream, my impossible.

I went back home in September, vowing to hit my impossible. It wasn't flawless but I did it more weeks than not. I got to give the kids snacks when they came home from school and we chatted at the island, reviewing homework, as we cooked dinner. I felt like they had more of me and I know they felt it too. I had set a new standard for myself. The twenty-eight-hour workweek had become the norm, though it wouldn't stay that way as you'll see in the story of Dune House. ✦

"We dream in colors borrowed from the sea." —UNKNOWN

dune house

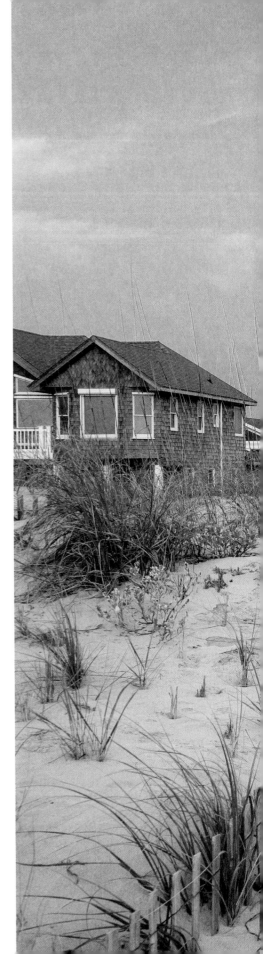

I'm not sure I'll ever stop dreaming about fixing up houses. Diamonds in the rough, as I like to think of them, certain houses have so much untapped potential that I can't seem to think of anything else but what they could be.

A few years after finishing the Lost Cottage, we thought about taking on another beach house project. There are so many old houses in need of love in the Outer Banks and we were hoping to fix one up to either rent out or sell as a part of our growing home rehabilitation business. This beach house dream was a risk, but went hand in hand with my new impossible workweek as the project would hopefully bring in additional income. It was a seller's market though, and we searched for months, looking for just the right investment property, missing out on multiple deals with multiple offers.

One morning at home in the fall, I awoke in the wee hours per usual, and though I practically had every Outer Banks real estate listing memorized, I felt compelled to open up the listings one more time on my phone. (Sound familiar?) A five-bedroom oceanfront house in Duck had popped up in the middle of the night. The listing said the property was most likely subdividable and could become two lots though it was listed at the price of only one lot! The house looked like it needed a lot of work but had massive ocean views. It was a Technicolor moment I remember in great detail, the slight energy buzzing feeling still palpable.

I woke Dave up (I'm super considerate like that) and showed him the listing. We ran numbers and I started designing the thing in my head. We made an offer and our contract was accepted and ratified before any other offers could

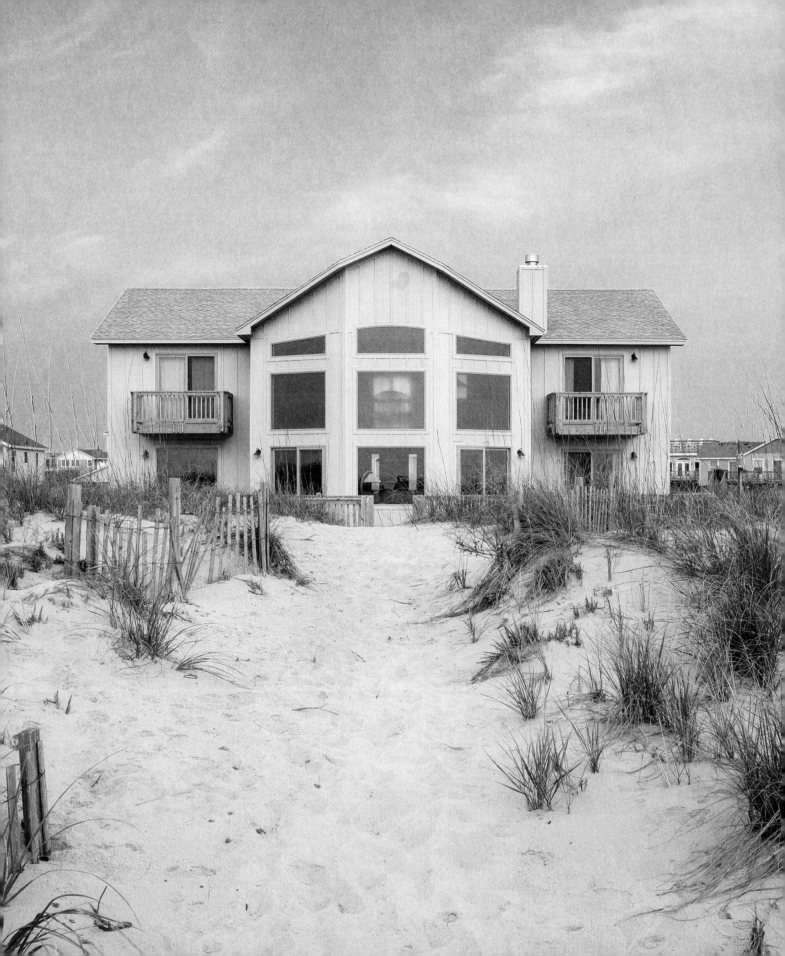

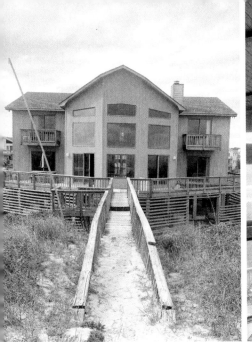
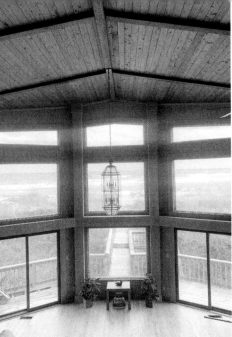
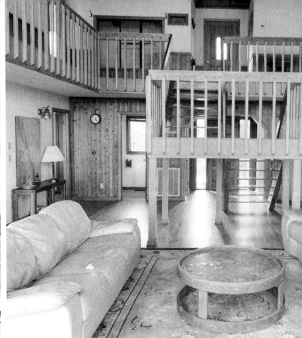

be made. By the time I got back into bed that night we had an oceanfront beach house project we had never set foot in! I was in shock. I'm not sure I expected to get it after so many false starts. It was an intimidatingly large project for the business to take on and would require an almost perfect execution on the renovation side to be done within budget and in time for next summer's market. We were taking one of our biggest risks yet.

When we drove down to see the house, we turned onto an old gravel road. I remembered going to parties at the first house on the street during college and realized it was a street I knew well! As we pulled up to the house at the end of the road, we could see that, true to what the real estate listing had said, it needed a *lot* of work. One of the decks had fallen completely off and all the decks would need to be redone along with all the siding, the roof, the electrical, all major systems, the windows, and all the oceanfront interior walls, which had suffered damage.

The good news was that the house sat just behind a large dune on the water and had sweeping ocean views from almost every window. The private beach walk-up was out of a dream and the house itself was well-built and structurally sound.

The renovation would consist of rearranging the floor plan considerably—moving bathrooms, the kitchen, and adding a loft and a family room—in order to maximize the house's function. I wanted the place to be the perfect vacation house for big groups of friends or families to hang out. But a renovation and subdividing the lot, we were told, wasn't the most financially lucrative approach to the property. We would have been better off tearing

PREVIOUS Dune House sits just beyond the dune and feels like the bow of a ship. This was my favorite spot to sit and take in the ocean during the much-longer-than-anticipated project, as seen in the Dune "before" photos.

ABOVE Dune House was a much-loved rental for many years. I was smitten the moment I found the listing but knew we could make it even more functional by rearranging key spaces throughout the house.

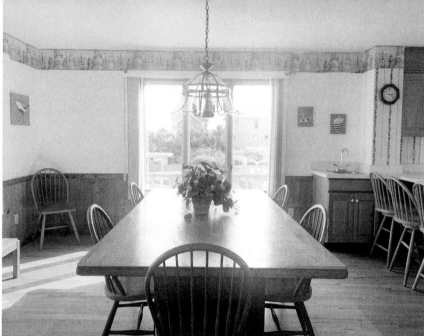

down the house and building a mansion on both lots that would sell for a considerably larger amount of money, but I could see what the house was supposed to be and it just didn't feel right to let it be anything else.

We set about drawing up plans for the renovation, subdividing the land, and putting the work in motion. As much as I'd love to say the process was a true dream, by the following summer, a little while after we had purchased the Beach Cabin, it had taken a turn. Full of lawyers, red tape, delays, and sleepless nights—which prevented us from putting the house on the market within our expected time frame—our "dream" became a time of high highs and low lows for us. My dream of the twenty-eight-hour workweek and being home for the kids went out the window as we took on additional work to hold on to the house for an additional year. I leaned on my skills of compartmentalization, and for the most part felt fine, choosing instead to focus on being grateful for our family and the work that we did have, but that didn't stop me from waking up in the middle of the night, my heart beating like crazy, tossing and turning with worry.

Despite the seemingly never-ending setbacks and stress that plagued this project, every time I entered that house and looked out at the water through the glass, I was given a bit of peace. I'd step through the construction mess knowing we were months behind and missing the summer market, but then walk out one of the many sliding doors and just breathe in the ocean. It is so loud there because you're so close to it. Right on the dune, the sea just fills up your soul. The ocean would continue to remind me to be grateful for this opportunity when I myself forgot.

"A smooth sea never made a skilled sailor."

—FRANKLIN D. ROOSEVELT

pink palette

Dune House is located in Duck, North Carolina, which is just south of Corolla but has very different sand coloring and texture. Corolla's sand is whiter and more fine, whereas the sand in Duck is more tan with a beautiful pinky peach mixed in. I wanted the house to feel like an extension of the dune and used those pinky-peach grains of sand as inspiration for the house's palette.

We were able to salvage much of the original local juniper paneling and added in more of it to envelop the entire great room on both levels. Large jute rugs ground the space, adding soft natural texture throughout. A playful vintage Turkish rug in shades of brown, beige, and pink establishes the palette. A favorite vintage kitschy sea captain painting of mine (page 240) finally found its home above the raw terra-cotta-tiled fireplace. The pale pink sofa has cushions slipped in machine-washable linen and the chair slipcovers are machine washable, both from my upholstery collection with Taylor King. Side tables that do double duty for corralling books and magazines are from my collection with Woodbridge and the coffee table is by my friend Leeanne Ford for Crate and Barrel.

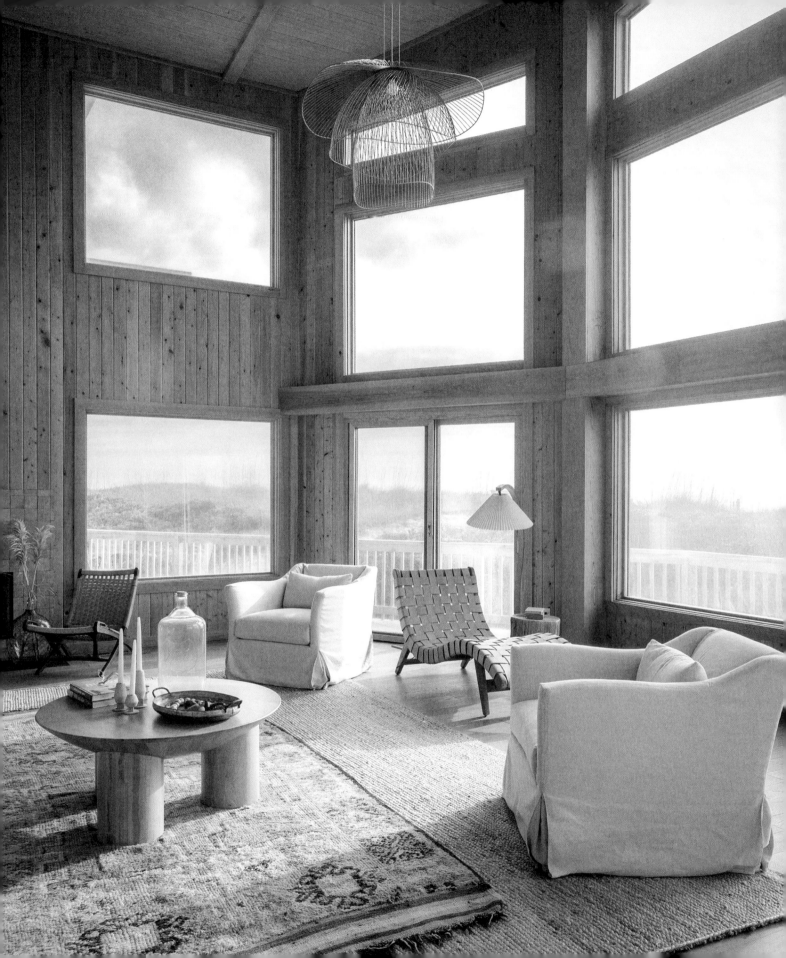

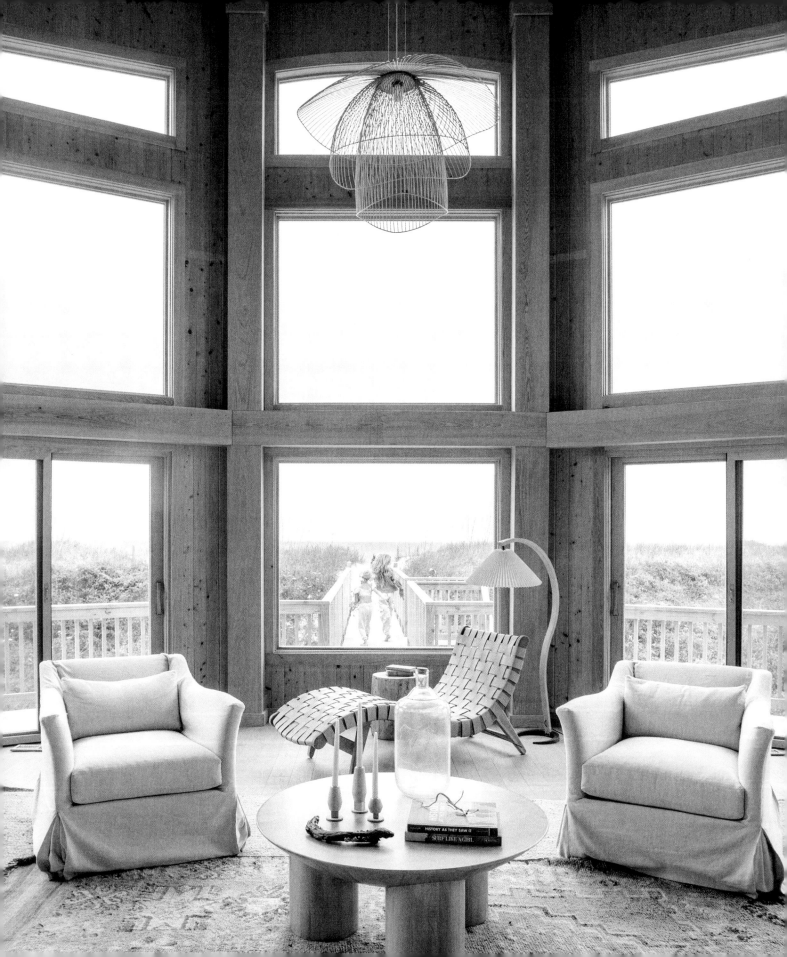

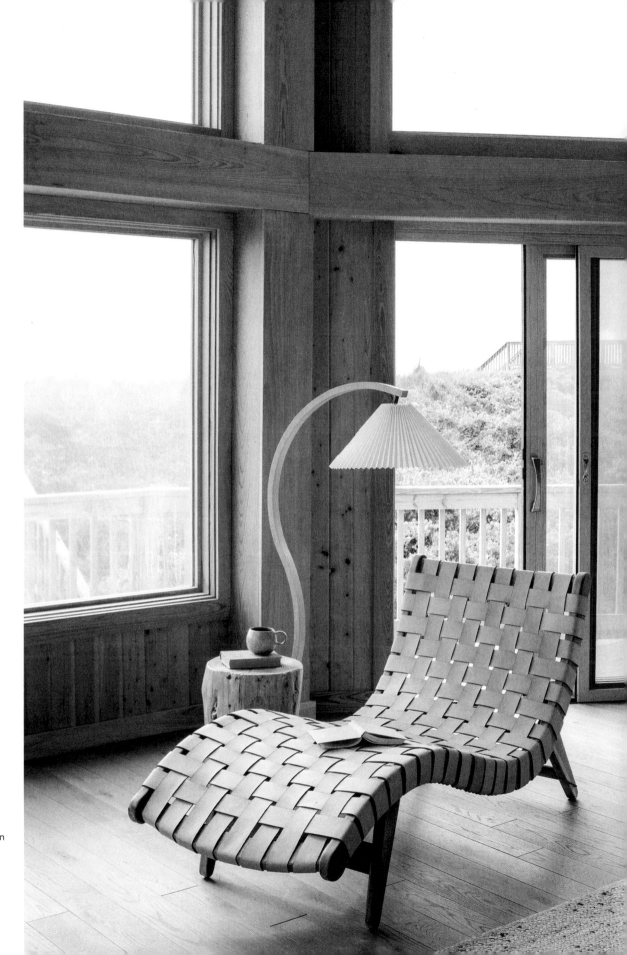

alone time

Arguably the best
spot in the house,
a mid-century-
inspired curvy
leather chaise
sits in front of the
center window,
away from the main
seating area.

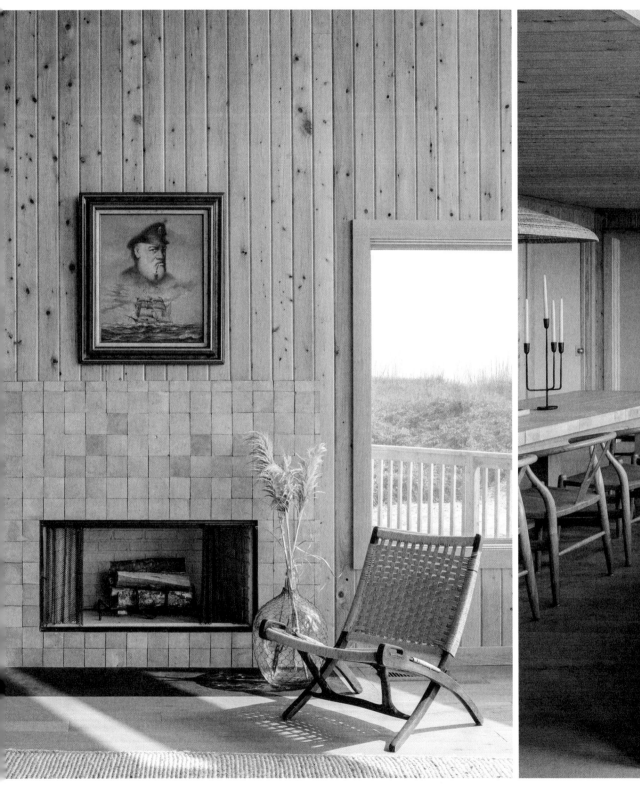

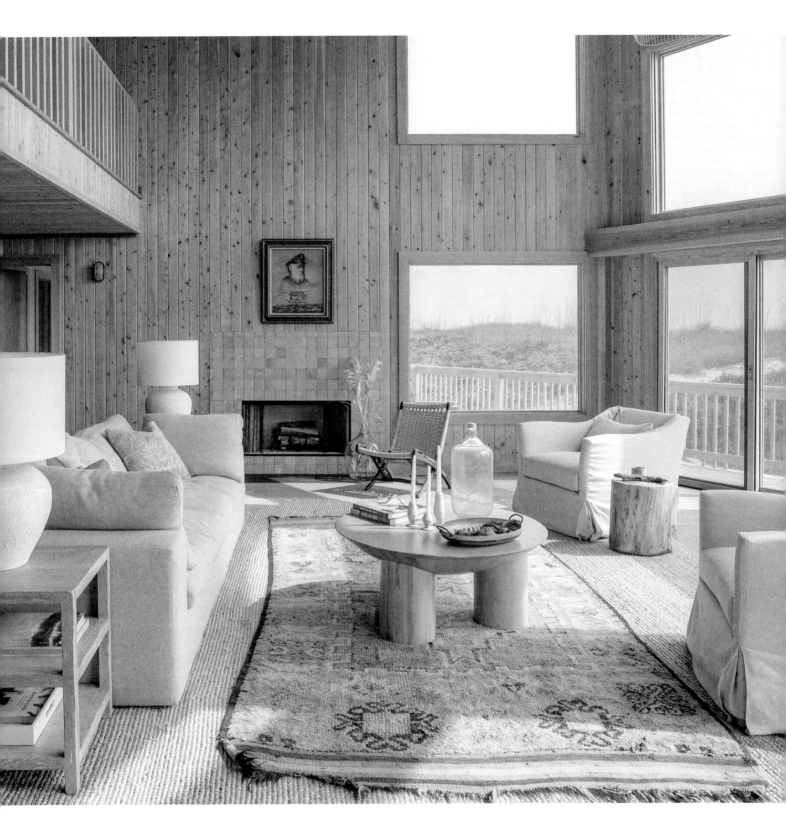

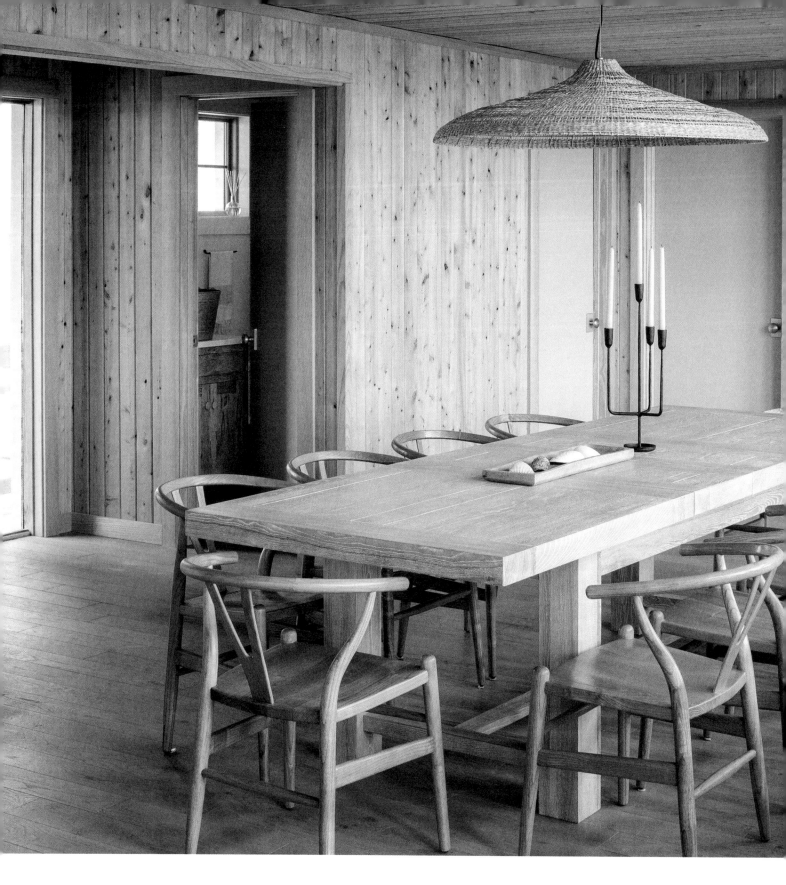

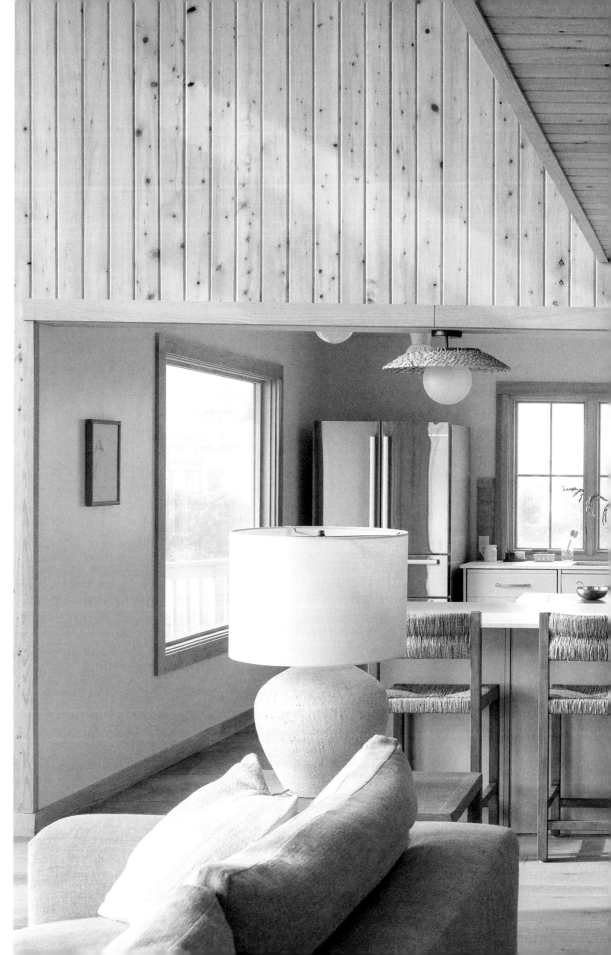

reimagine

PREVIOUS A large set of stairs was moved from the great room to the foyer and we had a loft built upstairs to separate what is now the dining space from the living area. An extra-long table holds a crowd.

open up

RIGHT + FOLLOWING Cabinets are done in the "Primitive" door style in "dune" from my collection with Unique Kitchens and Baths. Simple cutouts in lieu of hardware keep the vibe simple and streamlined.

Countertop hutches have both open and closed storage for showing off pretty things and hiding not-so-pretty things. The raw terra-cotta-tile backsplash continues on behind the glass cabinet doors, adding depth and texture.

A new triple window over the kitchen sink provides big views of the dunes and ocean. A horse painting leans on a floating shelf made out of the original cypress wall paneling.

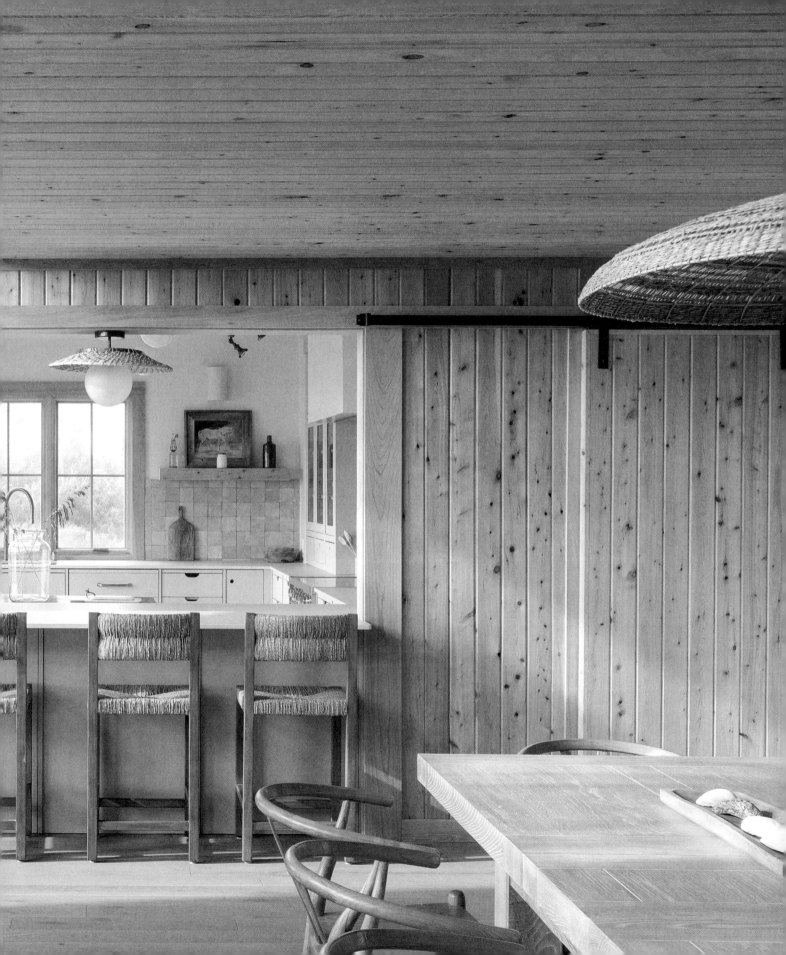

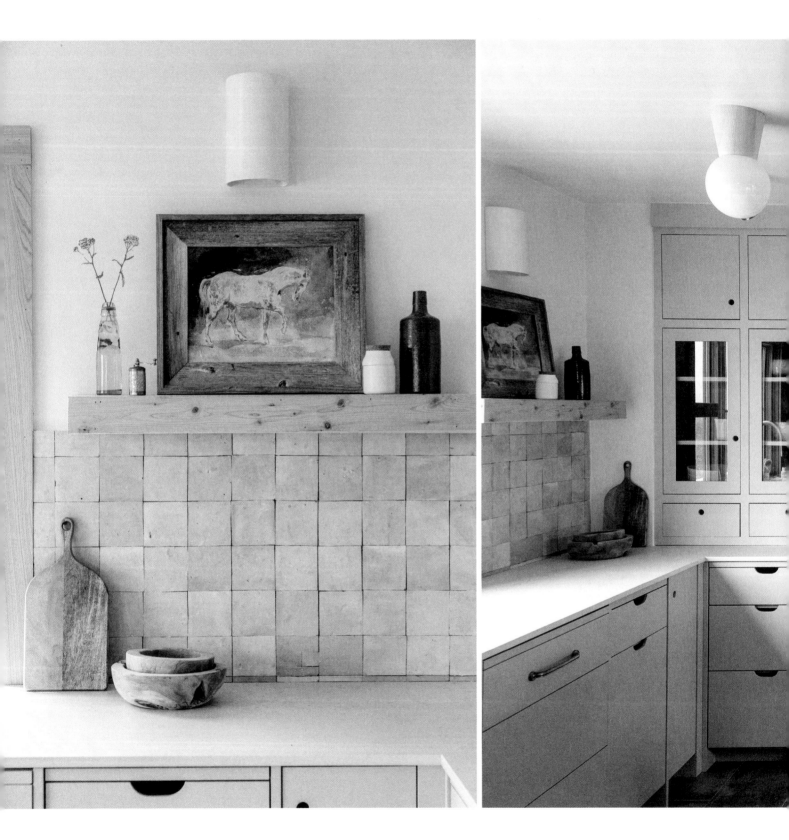

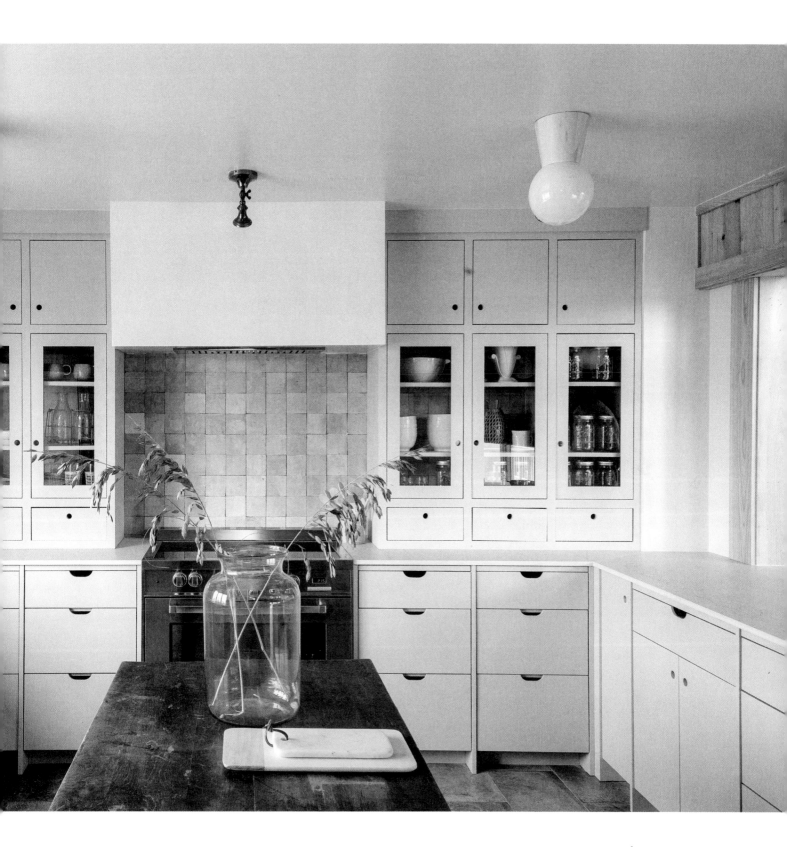

create cozy corners

The den, formerly the kitchen, with its sliding planked door for privacy, is a cozy little room we added for watching movies. I pictured it as the perfect spot for stashing kids when the adults wanted adult time, and paneled the room in wood for added sound absorption.

OPPOSITE The sofa is Ikea, and we upgraded it with cushions for comfort. The roll-up shades are ready-made (in lieu of custom ones) that we cut down to size in order to save money.

mix it up

Art throughout the house is a mix of vintage originals and new prints downloaded from Etsy and framed in old frames.

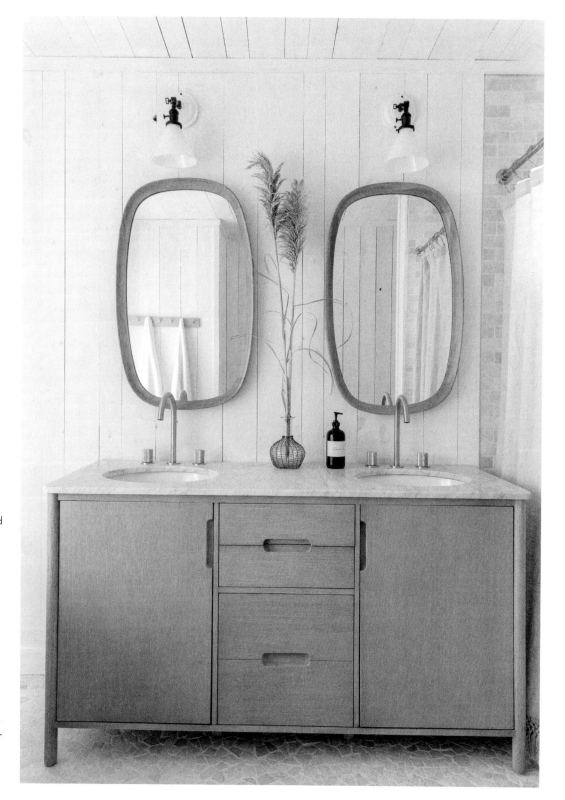

oceanfront suite

OPPOSITE The main-leve primary suite walks right out to the dune. The "saltwater" bed from my collection with Woodbridge Furniture has colonial rope detailing, an apt seaside touch.

RIGHT The main-level bathroom was expanded into what used to be a storage room. Soft beiges and ivories in the natural stone flooring and shower walls continue the house's relaxed, natural palette.

the sky bar

The "sky bar," as I like to call it, is a game and gathering space on the upper level with the biggest, most awe-inducing views of the ocean.

stay wild

FOLLOWING LEFT
Each of the three king bedrooms has its own quirky sign over the bed. I love a playful vibe in a beach house.

the trundle bedroom

FOLLOWING RIGHT
Tiny and sweet, the trundle bedroom is decorated in relaxed earth tones, which contrast with slightly more feminine elements like bedding and a rug from my collection with Rugs USA.

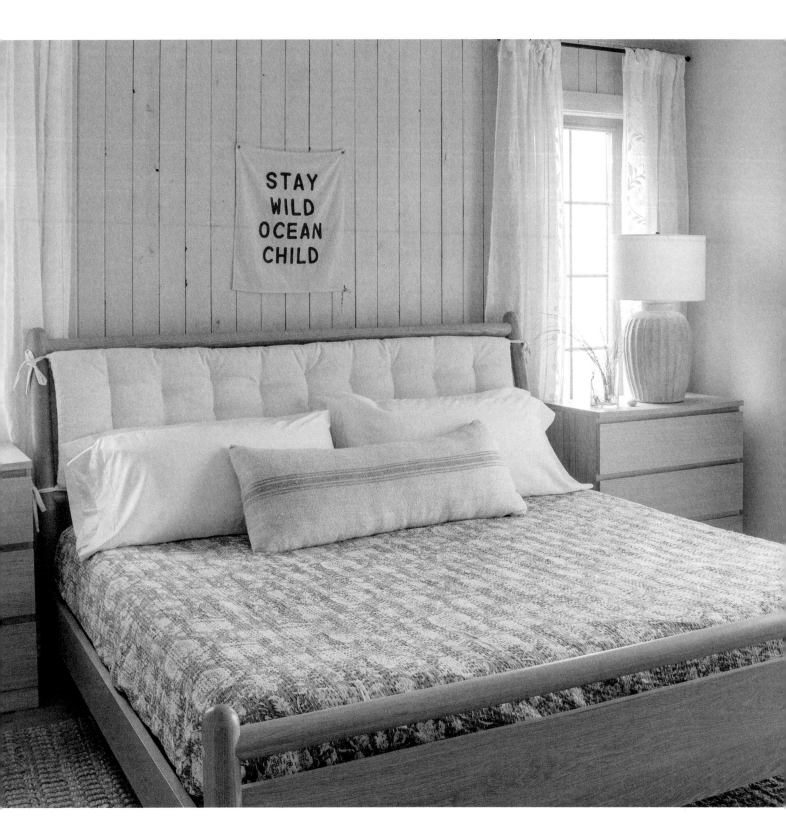

STAY
WILD
OCEAN
CHILD

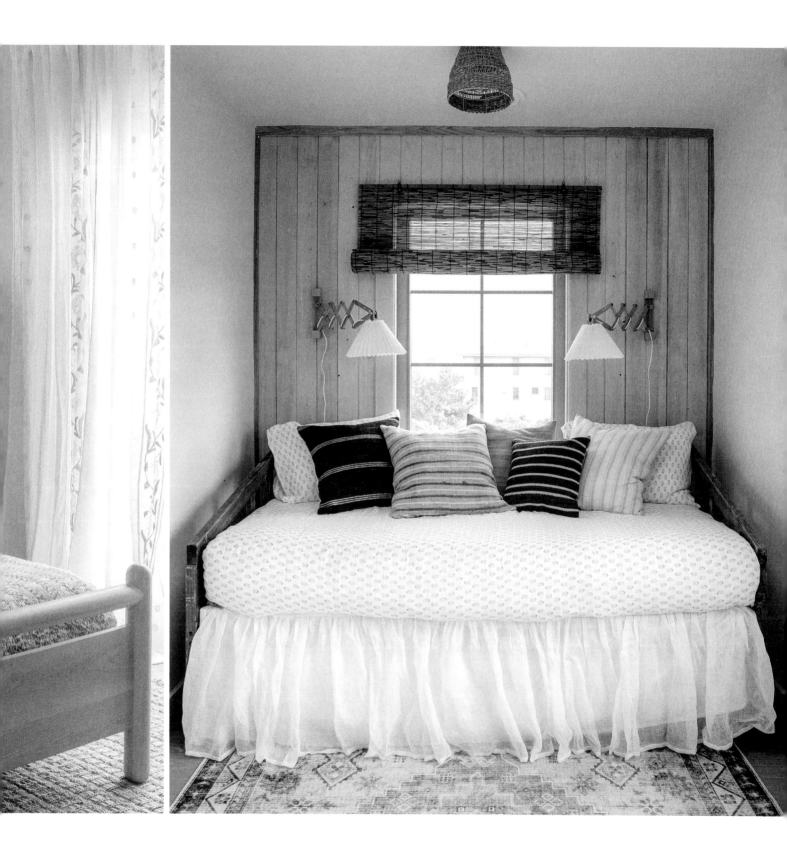

capture the breeze

Whenever possible in a beach house I like to select curtains that will blow softly in the sea breeze. I typically go with light, unlined cottons or linens.

I love unexpected color palettes like peachy pink and deep blue.

FOLLOWING Our talented team of carpenters built the bunks and strung up the rails with rope.

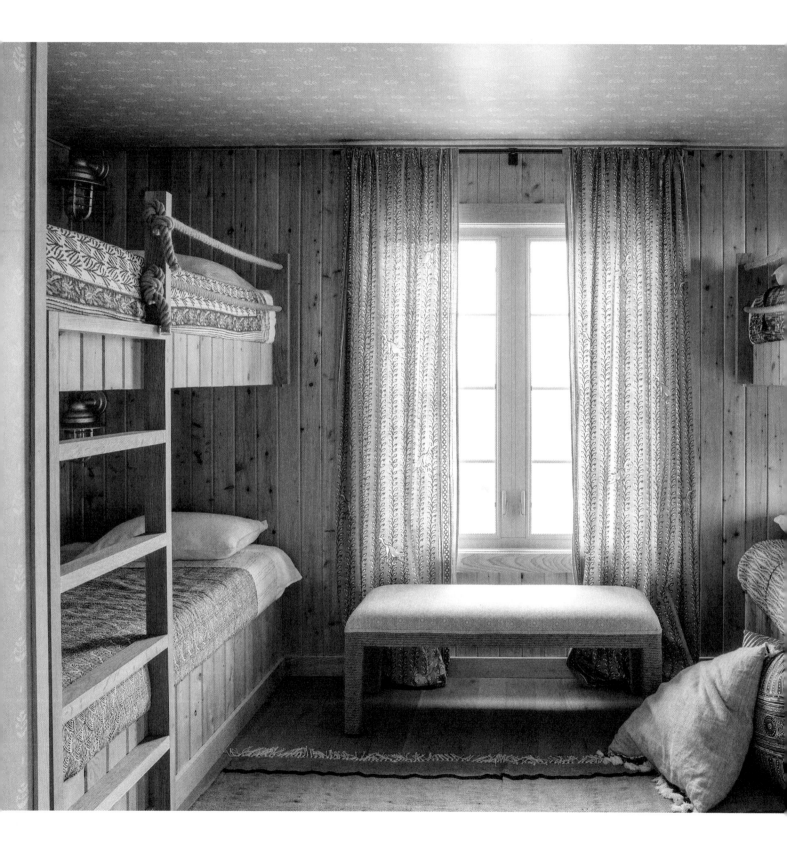

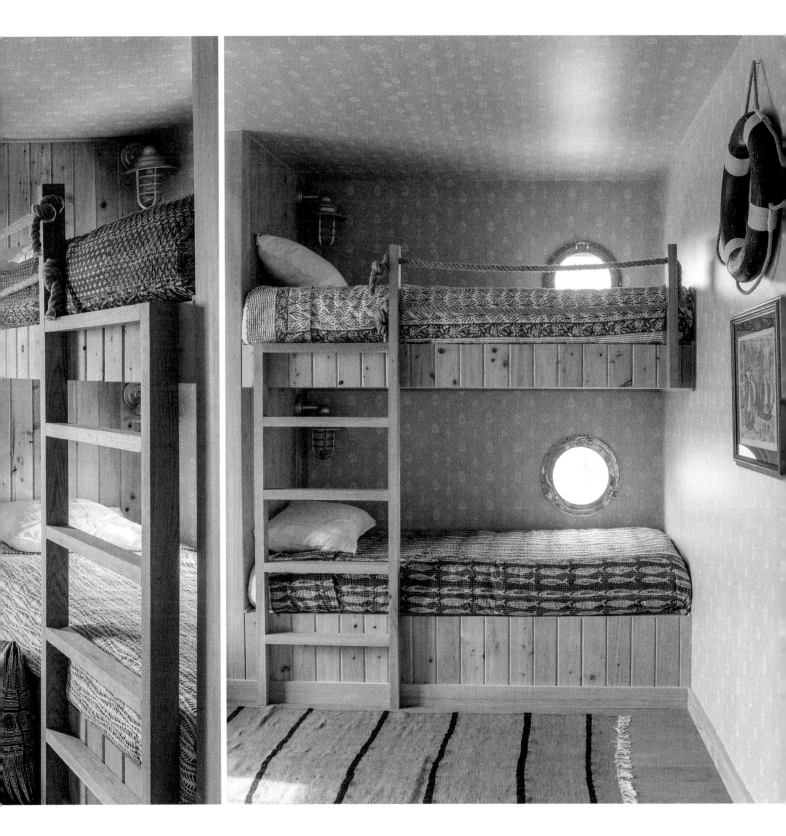

"It's the sound of the sea that makes you believe in mermaids."

—ANTHONY T. HINCKS

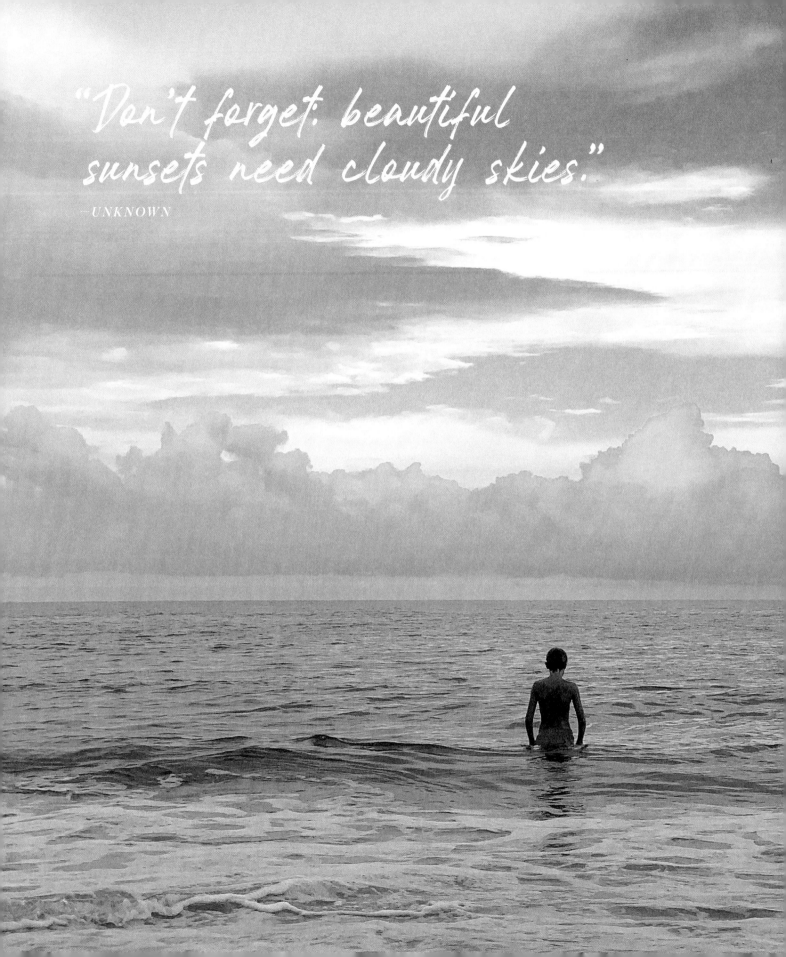

"Don't forget: beautiful sunsets need cloudy skies."
—UNKNOWN

a new dream . . .

As I write, having owned the property for almost a year longer than expected, with Dune House finally about to go up for sale in a couple of weeks in a down-turning real estate market, I don't know how this story ends, where the dream will have gotten me.

I know it didn't get me twenty-eight-hour workweeks, that's for sure. This dream has taken its own path, not mine.

This could easily be a "be careful what you wish for" story but I don't see it that way. Life takes its twists and turns that we can't always understand, but we go through what's needed to make us who we are meant to be. We grow in the hard times, seeking to reach the sunlight from under the rocks.

The house has been designed, decorated, and sits waiting. My part is done. After trying everything I could to make my external situations better, and failing, I have realized that everything is completely out of my control except for one thing: what's going on inside.

All I can work on right now is myself.

On a recent cool evening at the beach, I sat in front of the ocean, thinking back on my implementation and then subsequent de-implementation of the twenty-eight-hour workweek, the implementation and de-implementation of my dream. I thought of Dune House and the unknown ahead of us, felt the familiar pit in my stomach. I have wondered, countless times this past year, why we were meant to go through this situation.

Watching the waves, feeling them pound on the shore, my hands playing with grains of sand at my sides, I breathed in and I breathed out. Would my older self one day look back on me now and tell me that everything will be okay, that I am exactly where I need to be? I felt deep down beneath the worry that none of this mattered, that it was simply a season in time. And it's a precious one at that. Though I know there are still more lessons to unpack, I think ultimately this has been an exercise in learning to trust, and be okay inside when things aren't okay on the outside, when I feel lost. I felt the wind whip my face and I wiped at the tears I hadn't wanted to well.

I didn't have paper to write on, but it didn't matter. It was time for a new dream, a new impossible.

I would learn to be okay in each and every moment. I prayed I would remember what I had been shown here.

The "being okay" wouldn't be about never getting upset or not having negative feelings—because they are real and raw and need to be felt. It would be about being comfortable with feeling the negative feelings and releasing them so they couldn't fester and hurt the spirit. This dream is a deep-seated desire to maintain perspective and gratitude throughout all kinds of times.

To me, that feels almost impossible. But the thing about a dream, an impossible goal, is that somewhere deep down, you really do believe it's possible or it wouldn't have come to you. The dream tugged at your heart. Just like that fluttering of summer spirit we might feel on a spring breeze, our dreams are trying to tell us something. Underneath the mayhem and rush of modern life, we are being guided by an inner knowing that speaks in dreams, in visions of impossible goals.

Beach life opens us up to hearing those dreams. It's about living effortlessly and authentically, grounding ourselves in nature and with loved ones. Beach life is a dropping of pretenses, a wander that takes you away. It's about living both freely, with the abandon of our summer spirits, and quietly, comfortable alone with ourselves. But in the end, it's about living soulfully, which the ocean demands of everyone who visits, if they listen for it.

◆ ◆ ◆

Thank you, dear reader, for coming along on this journey with me.

May you find your summer spirit and have a lifetime of beaching and dreaming.

xo,

Lauren

P.S. You might be happy to know that I've been sleeping soundly again.

"Stay wild ocean child." -ANONYMOUS

beach eats
simple seaside meals

I feel my best at the beach when I'm working out most days and am eating lightish food. We spent so many of our early years overeating junk on vacations and coming home feeling awful that we now try to use our vacation time to recalibrate and focus our family on eating healthy. We try to avoid sugary meals with simple carbs as much as possible—though we'll absolutely enjoy the occasional meal that puts us in a food coma—but for the most part, we try to eat in a way that leaves us feeling nice and refreshed when we wake up the next day.

For breakfast, we typically start out with some sort of vegetable—carrots, celery, peppers, spinach—so we don't take in too much sugar. We make simple things like avocado toast, eggs, or smoothies. Our "special" breakfasts happen at the Juice Jar where they make the best acai bowls, smoothies, and breakfast burritos.

We do lunches either at the beach or at home. We love hummus and I'll either make it from scratch or "doctor" store-bought stuff with fresh garlic, lemon juice, herbs, and salt. We do sandwiches for the kids and we all love to roll up meat with spinach, lettuce, or arugula, and tomatoes or cheese.

I premake salads at dinnertime to store in the fridge for an easy beach meal or breakfast starter the next day. A few of my favorites that keep easily in the fridge are chickpea salad, cabbage slaw, and the Shaved Fennel Salad (page 273). We keep a lot of cheese and charcuterie around and love heading to beach cheese shops to try out new things to bring home. I'll often put a board out with fruit and veggies while we're getting dinner ready. For dinner, we usually grill meat or fish and serve with a side and a salad. Soup is another favorite around here and in the summer we do cold soups like gazpacho or chilled avocado. Steamed spiced seafood is a total treat and our family devours every last morsel whenever we have it.

When we have dessert at the beach, we often go for local fruit pies and ice cream. Dark chocolate is also a house staple. ✦

no-fuss beach picnic

SUPPLY LIST

+ a beach blanket or two
+ cutting board
+ napkins or a roll of paper towels
+ plates
+ silverware or plasticware
+ cups
+ knife
+ garbage bag

FOOD & DRINKS

+ drinks
+ charcuterie board
+ premade salad
+ raw vegetables or fruit on a board
+ main dish: anything from steamed crabs or steamed spiced shrimp to oysters, to mussels, to gazpacho, to fried chicken or pizza fresh out of the box

Each recipe on the following pages has an accompanying playlist on LaurenLiess.com.

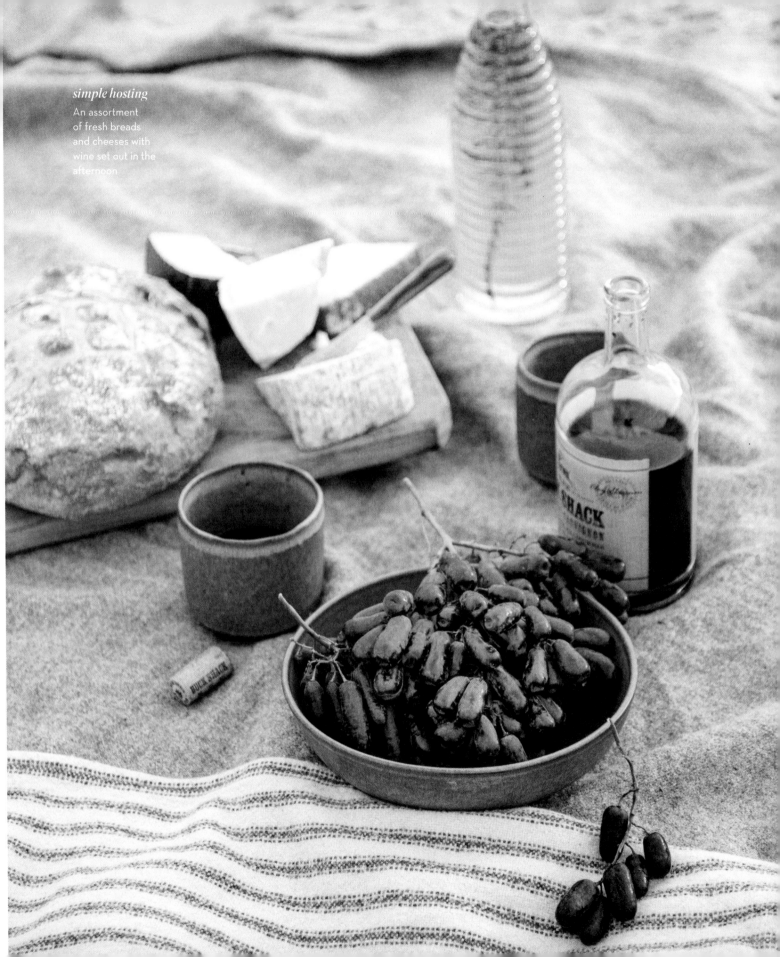

simple hosting
An assortment
of fresh breads
and cheeses with
wine set out in the
afternoon

avocado cucumber bites

PREP TIME 10 minutes
SERVES 4 to 6
PLAYLIST LL Reggae

These delicious bites are my beach-body alternative to avocado toast; we eat them for breakfast. You can keep them simple for breakfast or go all out and make a mean guacamole with all the fixings, such as fresh cilantro etc., to serve for a party.

INGREDIENTS

+ Cucumbers, peeled and sliced crosswise into ¼-inch "bites"
+ Ripe avocados
+ Minced fresh garlic (optional)
+ Fresh lemon juice (optional; if you're eating the bites right away, you don't need this, but if these will sit out awhile, add the juice to keep the avocado from browning as quickly)
+ Sea salt, to taste
+ Lupini beans (pictured), capers, or garnish of your choice

DIRECTIONS

1 Lay the cucumber slices out on a board or platter.
2 Peel and pit the avocados and mash in a bowl. Mix in the garlic and lemon juice, if using, and sea salt to taste.
3 Use a knife to spread the mashed avocado mixture on each cucumber bite.
4 Top each with a lupini bean or other garnish and serve.

seafood boil

PREP TIME 15 to 20 minutes
COOK TIME about 30 minutes
SERVES 12 to 15
PLAYLIST LL Bayou

There's nothing like a seafood boil at the beach! Delicious, fun, and communal, boils are a bonding experience. The ingredient list is simple but they're a lot of work, so if you don't feel like tackling one, our favorite place in OBX for boils brought to your door is the Outer Banks Boil Company. Our next-door neighbor gave us his old turkey fryer (thanks, Dave!) and we ordered a vintage-style newspaper oilcloth tablecloth to have on hand for boils, which have become a favorite beach tradition. I like to get all the chopping and food prep out of the way before guests arrive, setting each ingredient in its own bowl, lined up in the order it needs to go in the boil. I make sure the tablecloth is on the table and we put on the "LL Bayou" playlist, pour drinks on the porch, and play yard games as we boil.

INGREDIENTS

+ 6 lemons
+ 1 recipe Doctored Spice Seasoning (recipe follows); 1 cup separate and the rest set aside in little bowls
+ 16 cloves garlic, smashed
+ 2 onions, peeled and quartered
+ ¼ to ⅓ (750 ml) bottle white wine or 1 (12-ounch) bottle of beer (we use a dry pinot grigio, because it's my favorite wine)
+ 2 pounds Yukon gold potatoes, quartered
+ 8 ears corn, husks and silks removed, cobs quartered
+ 8 tablespoons (1 stick) butter
+ 4 tablespoons (about 1 bunch) chopped fresh parsley

PICK YOUR COMBINATION OF SEAFOOD

(You're only limited by the size of your pot! Do two if you need to!)
+ 4 to 6 clusters pre-cooked crab legs (we love Alaskan snow crabs)
+ 3 lobster tails (we only do lobster for special occasions like the photo shoot for this book!!)
+ 2 to 3 pounds precooked Andouilles sausage, sliced into 3-inch pieces
+ 3 pounds raw shrimp (peeled and deveined is a nice treat, but we also love doing our own)

DOCTORED SPICE SEASONING BREAKDOWN

+ 1¼ cups J.O.'s #2 Crab Seasoning
+ 1 teaspoon True Lemon Crystalized lemon powder
+ Chili pepper flakes to taste (we add a couple of tablespoons because we like it a little spicy)

SUPPLIES

+ Massive pot (we use a turkey fryer and like to do the boil outside)
+ Oilcloth tablecloth for pouring the hot seafood directly onto (our preferred method, seen in

the photograph), or a bunch of
platters and large bowls

+ Little bowls for the melted
butter and the spice mix

DIRECTIONS

1 Cut ¾ of the lemons into
quarters. Cut the remaining
lemons into wedges and set
aside.

2 Fill a large pot with 1 gallon
water. Put the lemons in the pot
with 1 cup spice seasoning, the
garlic, and onions. Bring to a boil
and then add the wine or beer.

3 Drop in the potatoes and
cook for 8 minutes. Drop in
the lobster tails and cook for
6 minutes. Drop in the corn,
clams, and crab and cook for 5
minutes. Drop in the scallops,
shrimp, and sausage and cook
for 2 to 3 minutes.

4 Melt the butter in a separate pot
for serving. Prep little bowls of
melted butter and separate ones
with extra spice seasoning.

5 Drain the seafood, being extra
careful not to get burned. Pour
the seafood out onto a protected
table, sprinkling with extra spice
seasoning as desired. Garnish
with the remaining lemon
wedges and the chopped parsley.
Serve with little bowls of the
melted butter and the remaining
spice seasoning.

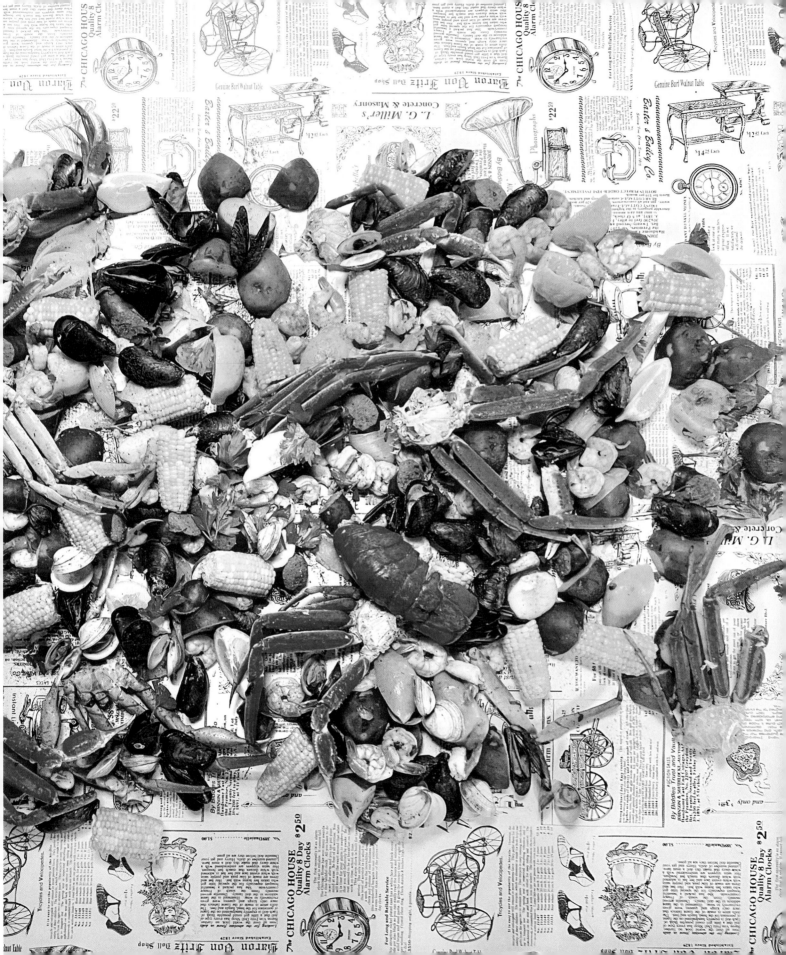

raw basil oysters

PREP TIME 25 minutes
SERVES 6
PLAYLIST LL Lost Cottage

An herbal take on a seaside classic, I love the mix of green herbs with fresh oysters.

INGREDIENTS

FOR THE BASIL DRESSING

+ ⅓ cup basil, finely chopped
+ ⅓ cup Italian parsley, finely chopped
+ 2 green shallots, finely chopped
+ 2 cloves garlic, minced
+ ¼ cup olive oil
+ 1 tablespoon white wine vinegar
+ ⅛ teaspoons crushed red pepper flakes
+ Sea salt to taste

+ 24 fresh oysters, in the half shell
+ 1 small bunch Italian parsley, chopped
+ 3 to 4 thyme sprigs, whole
+ 1 lemon, cut into wedges

DIRECTIONS

1 Mix all the ingredients for the basil dressing and set aside.
2 Shuck the oysters and arrange them in the half shells on a serving platter. Drizzle with the basil mixture. Garnish with chopped Italian parsley, thyme sprigs, and lemon wedges. Serve and eat right away.

shaved fennel salad

PREP TIME 15 minutes
SERVES 4 to 6
PLAYLIST LL Folksy Upbeat

A vibrant medley of mild fennel, textural walnuts, punchy vinegar, and crumbly gorgonzola, this salad is a staple in our house and one of my favorite easy salads for entertaining because you can make it in advance and it gets better as it sits.

INGREDIENTS

+ 2 bulbs fennel, shaved
+ 1 tablespoon chopped Italian parsley
+ ¼ cup crumbled Gorgonzola cheese
+ 2 tablespoons olive oil
+ 2 to 3 drops balsamic vinegar
+ Salt and freshly ground black pepper
+ 2 scallions, chopped
+ ¼ cup raw walnuts, crushed

DIRECTIONS

1 Shave the fennel bulbs (we use a vegetable peeler) and place the fennel in a medium bowl. Add the parsley and Gorgonzola.

2 Drizzle on the olive oil and vinegar and mix well. Season with salt and pepper to taste. Top with the chopped scallions and crushed walnuts and enjoy!

clam linguine

PREP TIME 15 minutes
COOK TIME 45 minutes
SERVES 6 to 8
PLAYLIST LL Feel It Mix

A take on my Maestranzi family's clam linguine, this pasta dish is a total crowd pleaser. It blows everyone away!

INGREDIENTS

+ ¼ cup olive oil
+ 5 bunches parsley, minced
+ 1 clove garlic, minced
+ Salt and freshly ground black pepper, to taste
+ ½ cup white wine, preferably pinot grigio
+ ¼ cup chicken broth (optional)
+ 8 tablespoons (1 stick) butter, cut into tablespoons (optional)
+ 30 to 40 fresh littleneck clams in the shell, or 5 to 8 small (6 ounces) cans of clams
+ ½ to 3 teaspoons crushed red pepper flakes (optional)
+ 1 pound dried linguine
+ 1 white onion, minced
+ ¼ cup grated Parmesan cheese, or to taste
+ ½ teaspoon freshly grated lemon zest

DIRECTIONS

1 In a large saucepan, heat half the olive oil over medium heat. Add the parsley and sauté until softened. Stir in the garlic and season with salt and pepper to taste. Once the garlic has become aromatic and the parsley is fully cooked, pour in the wine and the chicken broth (if using).

2 Allow the sauce to simmer for about 30 minutes, stirring occasionally. Once the sauce has cooked through, drop in the butter, if using, and raise the heat to medium.

3 Clam time! If you're using fresh clams: prepare them properly by giving them a thorough cleaning under cold water. Add the washed clams in the shell to the sauce and allow the shells to pop, signaling they are cooked; toss any clams that do not open. (If you're using canned clams, dump the clams into the sauce with a little bit of the clam juice from the cans and cook.)

4 Add the red pepper flakes (more or less, depending on how spicy you want the sauce!). Bring the heat back down to low once the clams have been heated through and are cooked.

5 Meanwhile, in another large pot, bring water to a boil and cook your linguine until al dente (it will cook an additional 1 to 2 minutes in the sauce). Toss the linguine in the sauce, letting it heat for a minute or two, and serve immediately, or keep over low heat until serving time.

5 Top each serving with a sprinkle of Parmesan cheese and some freshly grated lemon zest.

clam chowder

PREP TIME 15 minutes
COOK TIME 30 minutes
SERVES 10 to 12
PLAYLIST LL Celtic

INGREDIENTS

+ 6 tablespoons butter or olive oil
+ 1 large onion, diced
+ 4 celery stalks, diced
+ 1½ cloves garlic, minced
+ Salt and freshly ground black pepper, to taste
+ ¾ cup all-purpose flour
+ 3 cups chicken stock
+ 3 cups milk, plus more if needed
+ 8 (6.5-ounce) cans clams and clam juice, separated
+ 5 bay leaves
+ 6 large russet potatoes, peeled and diced
+ ¼ cup to ½ cup heavy cream (optional to taste)
+ About ⅓ bunch fresh parsley, chopped

DIRECTIONS

1 In a large saucepan, heat the olive oil over medium heat. Add the onion and celery and sauté until softened. Add the garlic and season with salt and pepper to taste. Whisk in the flour for about 1 minute. Slowly whisk in the chicken stock, milk, and clam juice, add the bay leaves, and continue to whisk until slightly thickened, 1 to 2 minutes. Add the potatoes.

2 Increase the heat and bring the broth to a boil. Reduce the heat and simmer until the potatoes are tender, 10 to 15 minutes. Stir in the heavy cream, if using, and season with salt and pepper to taste. Add more milk or heavy cream to thicken the soup as needed.

3 Garnish with chopped parsley and serve.

salmon with dill sauce

PREP TIME 15 minutes
COOK TIME 10 to 20 minutes
SERVES 6 to 8
PLAYLIST LL Bluegrass

Sockeye salmon is coated in a simple dill sauce and cooked inside foil on a hot grill or in the oven. It's easy to prep the salmon in the morning for this family favorite, wrapping it in foil to pull out for dinner.

INGREDIENTS

+ About 1½ pounds wild-caught salmon
+ Salt
+ About ¼ cup mayonnaise
+ 1 whole bunch fresh dill, chopped
+ Freshly ground black pepper to taste
+ ½ clove garlic, crushed
+ Juice of 1 lemon, for squeezing

DIRECTIONS

1 Preheat a gas grill to medium heat (about 375°F) or the oven to 375°F. Set the salmon on a large sheet of foil (it will need to be large enough to loosely wrap over the top of the salmon when you're done preparing it) and season with salt.

2 In a small bowl, stir the mayonnaise with the chopped dill and crushed garlic and season with salt and pepper to taste. Spread the mixture over the salmon and drizzle with fresh lemon juice.

3 Add about 2 tablespoons of water to the bottom of the foil (make sure to avoid pouring it over the salmon) and loosely wrap the foil closed over the salmon, trying to keep the foil off the sauce if possible. Put the foil packet on the grill on until cooked to your preference. We like medium/moist, 10 to 20 minutes.

4 Unwrap and serve.

epilogue

IT TAKES MONTHS of editing before a book goes to print, and in that time since I wrote my last "p.s.," life has moved along here in the Outer Banks. Corolla has experienced more loss and, once again, has banded together as a family to grieve and heal. Resilience is a wondrous thing, and I see so much of it in life here by the ocean, but I pray Corolla isn't called on for much more of it. My heart is still raw from the pain some of our friends are currently going through.

After much deliberation and wondering if we should keep it as a rental, we ended up putting the Beach Cabin on the market and sold it to another family. We said goodbye to the cabin yesterday, making fresh beds and sweeping the floors, shutting the door as we have so many times before, only knowing that this time it was the end of our sweet little wander with the place. In hindsight, I can see that the cabin was a call back to our roots—laying the seashell fireplace by hand and teaching our children to work alongside us. Its presence was a constant comfort, making me feel as if I could take on the world the way I once had.

The Dune House did not sell as planned this summer, as the housing market dropped and buyer after buyer deliberated on it. Our hopes were raised and dashed a few times, but throughout it all, I felt an innate trust that things would eventually work out. Because it wasn't selling, we made Dune House available as a vacation rental, and it's now the first (of hopefully many!) of the "LL PROPERTIES" available for rent. It hasn't gotten me any closer to the twenty-eight-hour workweek, but a

perk is that we get to enjoy it every now and then when it isn't rented! Yesterday was Labor Day—the unofficial last day of summer—and as I sat on the almost-empty beach in the late afternoon sun in front of Dune House beside Dave, who had fallen asleep under the umbrella, I thought about the Dune House project. Having just finished our first successful season of summer rentals, I remembered all the times I'd worried or vowed not to worry in front of the ocean about this project because my plans weren't working out, and how God had better plans all along. I let the sun hit my face and closed my eyes, breathing deeply in gratitude. I prayed for the upcoming year and reaffirmed a new impossible dream of not only being okay but being joyful, even when life didn't go as planned.

Dave woke up, and we decided to go for our last swim of the summer. We held hands and floated in the water, marveling at how things had worked out and how in the future we shouldn't waste our energy on worrying.

A wave rolled in, and we dove under it. A few more came, as they usually do, and we dove under them to keep from getting pummeled. At some point we drifted apart, and I realized I'd lost my footing and couldn't stand anymore. Wave after wave crashed on us, and, as I tried to swim back toward shore and ride the waves in, I was pulled farther and farther out into the ocean.

I turned my back on the pounding waves for a moment to peek back at the shore, and dread washed over me as I realized how far out we were—too far out for anyone to notice us or hear us . . . Too far away to call for help.

"Are we okay?" I called over to Dave as he attempted to swim toward the shore and ride the waves in, losing ground as the riptide pulled him farther out to sea.

Our eyes met but he didn't answer me. We don't lie to each other.

We periodically made eye contact as we both attempted to catch wave after wave back to shore, to no avail.

I swam with everything I had, but the ocean's pull was stronger than me. I know that when you get tired in a riptide you're supposed to let the current take you out and then swim out sideways and back to shore, but I couldn't bring myself to swim away from the already minuscule shore. "Should we go out and swim sideways?" I called over to him. He shook his head. We were too far out already. "No. Just go!"

Wave after wave crashed, and each time as I resurfaced it became harder and harder to take a good breath. I felt panic set in and looked over at Dave. I saw it there too.

Is this how it ends for us?

Both of us are going down?

God please save us.

And then the negotiating:

At least save him.

The kids need one of us.

I knew deep inside that if I didn't suppress the fear, I wouldn't make it.

I breathed in and out.

I exhaled, treading water, so small and alone with the pounding ocean and my racing thoughts.

I'm not going down like this!

Dave and I continued to make eye contact between the breaks to signal whether to go under a wave or try to take it in, to let each other know we were still there even as we were sucked farther and farther out. It went on like this for a while and I couldn't compute that this was our reality.

"We got this!" I yelled. "We're okay!" I called over and over in my strongest voice. I believed it because I had to. He never agreed with me—which scared me—but he yelled "Swim!" every now and then. I saw my husband fight for his life with every ounce he had, as I did for mine. One of us had to make it back, and I felt a profound sadness when I realized we couldn't physically help each

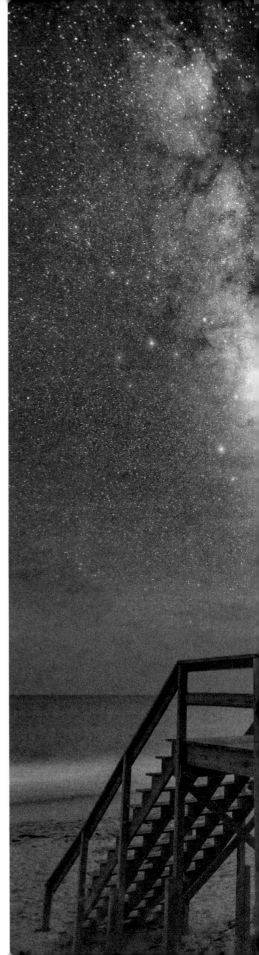

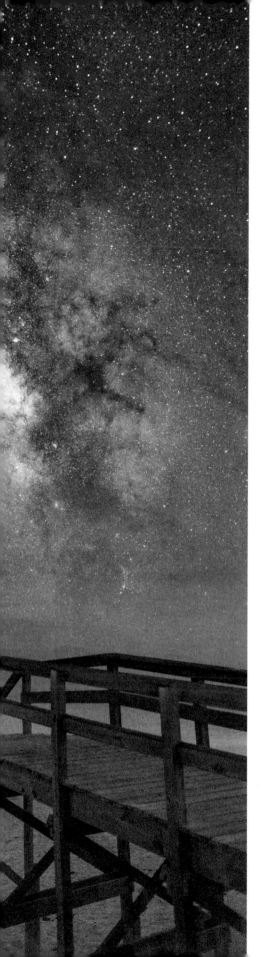

other. We were on our own to contend with the ocean's currents. I nodded as he forged ahead of me, silently giving him permission and willing him to go.

I swam more furiously than I'd ever swum, throwing myself into wave after wave, in hopes that I'd catch one, grateful for each time I was slammed by a wave and brought a little closer to shore. When it felt as if it might never end, about twenty feet in front of me, I saw him stand up. And then my toes grazed the sand as the ocean threatened to drag me back out. I swam until I reached his outstretched hand, and he pulled me to him where I could stand.

We trudged out, chests heaving, our hearts pounding, now only thigh-deep. I chuckled wryly as I watched a lifeguard race by on a four-wheeler, completely unaware of what had just transpired, but I was too exhausted to comment on it. As we made it to shore, my ears and lungs started to burn. Funny how you feel no pain when you're in it and the adrenaline's with you.

We hit the beach blanket and said a yet another prayer, thanking God for being alive, and I experienced a completely different type of gratitude from the one I'd felt thirty minutes earlier: Gratitude floating in an almost empty mind cleared out by shock. Nothing else mattered but that we were alive; the rest was just details.

Once again, the ocean had given me a dose of perspective. What happened yesterday was a gift. Our complacency had put us in danger, and the ocean promptly reminded us of its power, of our need to be vigilant. I had forgotten that the ocean doesn't let you ignore it. The ocean demands we pay attention. Yet it was a free pass, and for that, I'm grateful. I don't expect another.

That night we hugged our kids tightly (after much lecturing about the ocean, riptides, and how we will never again not have a board on the beach). After midnight as we lay in bed, the balcony door open to the black-and-silver-tinged water, the sound of the waves crashing and the moonlight washing over us, yet unable to sleep—the adrenaline hit earlier that day maybe having something to do with it—I thought about how, once again, the ocean, the same yet different, watched us, the same couple—who were, once again, the same yet different.

We've had laughter, love, joy, simple pleasures, big dreams, broken hearts, worry, pain, and now fear, struggle, overwhelmingly sweet relief, and deep, mind-numbing gratitude. The ocean has witnessed our little life, as it has so many others. And I know that—try as I might to avoid it—it brings the present moment crashing to the forefront. Once again, I'm reminded that beach life strips away all that isn't real, leaving us to experience life in its purest, most soulful form, so that we might go on a little kinder, a little brighter, a little more free. ✦

"Sky above,
sand below,
peace within."

—UNKNOWN

thank-yous

From the bottom of my heart I'd like to thank everyone who was a part of and who helped make *Beach Life*: the team at Abrams Books and especially my patient and insightful editor, Rebecca Kaplan; my talented book designer, Sarah Gifford; my incredibly supportive agent, Berta Treitl; my interior photographer Helen Norman for making these houses shine on paper; photographers Mark Buckler, Diane Diederech, Nate Smith, Daniel Pullen, and Mike O'Shell for capturing the place I love so beautifully; our contractor Travis Costin and his team—Kelly, Omar, Scott, Miguel, and all the others who worked to bring these houses back to life; the irreplaceable Lauren Liess & Co team—Lauren Bowen, Tara Trainer, and Carolyn Pirnat—for your tireless work and care with all that you do to make homes magical; my friends and family, without whom the beach wouldn't be the same; our kids—Christian, Justin, Louie, Gisele, and Aurora—for making life so sweet; Dave, for making our life go round and for always making me feel so loved; and finally, thank you to God for it all, but especially for making the sea. ✦

resources

LOST COTTAGE

INTERIOR DESIGN: Lauren Liess Interiors

CONSTRUCTION: Costin Creations

EXTERIOR PAINT: Custom Color

WOOD FLOORS: Cochran's Lumber

WALLS: Raw cypress

CEILINGS: Raw white cedar

KITCHEN CABINETS: "Yesteryear" in raw maple, Lauren Liess for Unique Kitchens & Baths

COUNTERTOPS: "Fresh Concrete," Caesarstone

REFRIGERATOR: Big Chill

BACKSPLASH TILE: "Folk Bouquet," Lauren Liess for Architectural Ceramics

SOFA: "Libris" sofa, Lauren Liess for Taylor King

COFFEE TABLE: "Modern Ming"- Lauren Liess for Woodbridge Furniture

END TABLES: "Leftover" Tables- Lauren Liess for Woodbridge Furniture

BUTTERFLY CHAIRS: West Elm

RUGS THROUGHOUT: Vintage from Lauren Liess & Co.

HILL COTTAGE

INTERIOR PAINT, MOST WALLS: Sherwin Williams- High Reflective White

WOOD FLOORS: Cochran's Lumber

GREAT ROOM CEILINGS: Raw white cedar

KITCHEN CABINETS: "Cottage," Lauren Liess for Unique Kitchens & Baths

KITCHEN COUNTERTOPS: "Airy Concrete," Caesarstone

KITCHEN PENDANTS: Basket Pendants, Lauren Liess & Co.

KITCHEN CHAIRS: Shoppe by Amber Interiors

BATHROOM VANITY: Lauren Liess for Unique Kitchens & Bath

BATHROOM FLOOR TILE: Wayfair

BEACH CABIN

EXTERIOR: Custom color match to original

INTERIOR WOOD: Original stained pine

PAINTED WOOD FLOORS: Benjamin Moore "Sea Wind"

FOYER RUGS: Lauren Liess x Rugs USA

FOYER DUNE GRASS PHOTOGRAPHY: Lauren LIess x One Kings Lane

KITCHEN COUNTERTOP: Soapstone

DINING CHAIRS: "Storybook" chairs, Lauren Liess for Woodbridge

GREAT ROOM PENDANT: Troy Lighting

GREAT ROOM LEATHER CHAIRS: Francois & Co.

GREAT ROOM SOFA: "Ever," Leeanne Ford for Crate & Barrel

GREAT ROOM FERN PILLOWS: Lauren Liess Textiles

GREAT ROOM CHARCOAL ART: Lauren x One Kings Lane

GREAT ROOM STRIPED RUG: Lauren Liess x Rugs USA

GREAT ROOM COFFEE TABLE: Lauren Liess & Co.

BATHROOM CEILING: Sherwin Williams Pure White

BATHROOM COUNTERTOP: Honed bianco aurora marble

BATHROOM FLOOR TILE: White terracotta Cle Tile

SHOWER WALL TILE: Zio & Sons

SHOWER CURTAIN: Les Indiennes

KING BED: "Serenity" Bed, Lauren Liess for Taylor King

KING BEDROOM LAMPS: Lauren Liess & Co.

KING BEDROOM CURTAINS: Anthropologie

QUEEN WALL-MOUNT LEATHER
HEADBOARD: The Citizenry

QUEEN BEDROOM CURTAINS:
Anthropologie

QUEEN BEDROOM RUG: Lauren Liess x
Rugs USA

BEDROOM CEILING FANS: Arran More
Lighting

TWIN BEDS: Crate & Barrel

TWIN BEDROOM CURTAIN FABRIC: Serena
and Lily

TWIN BEDROOM NIGHTSTAND: "Serenity"
table, Lauren Liess for Woodbridge
Furniture

TWIN BEDROOM LAMP: Magnolia Home

TWIN BEDROOM RUG: "Bayberry" in Rust
washable rug, Lauren Liess x Rugs USA

DUNE HOUSE

EXTERIOR PAINT: Benjamin Moore
"Winterwood"

INTERIOR PAINT, MOST WALLS: Sherwin
Williams Porcelain

INTERIOR PAINT, TRIM: Sherwin Williams
Tawny Tan

RUGS: Lauren Liess for Rugs USA + vintage
from Lauren Liess & Co.

FLOORING: "Dune" 5.5-inch planks, Lauren
Liess for Wellborn Wright

KITCHEN CABINETS: "Spartan" in "Dune,"
Lauren Liess for Unique Kitchens & Baths

KITCHEN FLOOR TILE: Tile Bar

COUNTER STOOLS: Pottery Barn

PALE PINK SOFA: "Glad" sofa, Lauren Liess
for Taylor King

SLIPCOVERED CHAIRS: "Evolution" chair,
Lauren Liess for Taylor King

COFFEE TABLE: "Tom" Three-Legged Table,
Leeanne Ford for Crate & Barrel

CHAISE: Lauren Liess & Co.

END TABLES: "Triad" Table- Lauren Liess for
Woodbridge

FIREPLACE & KITCHEN BACKSPLASH: Zio
& Sons

BLACK SOFA IN DEN: Ikea

PRIMARY "PRAY FOR SURF" BEDROOM
WALLPAPER: Love Vs. Designs "Swirling
Vines"

PRIMARY BED: "Saltwater" bed, Lauren
Liess for Woodbridge

PRIMARY NIGHTSTANDS: Lauren Liess & Co.

PRIMARY BATH VANITY: Pottery Barn

PRIMARY BATH TILE: Wayfair

LOFT CHAIRS: Lauren Liess & Co.

LOFT LAMP: Crate & Barrel

LOFT COFFEE TABLE: "Modern Ming,"
Lauren Liess for Woodbridge

SOUTHEAST "DON'T GIVE UP THE SHIP"

BEDROOM PAINT: Sherwin Williams Quaint
Peche

SOUTHEAST BED: Crate & Barrel

SOUTHEAST CURTAINS: Amber Lewis for
Anthropologie

TRUNDLE BEDDING: Garnet Hill

NORTHEAST "STAY WILD OCEAN CHILD"

BEDROOM PAINT: Sherwin Williams
Romance

NORTHEAST BED: Crate & Barrel

NORTHEAST BEDSIDE DRESSERS: "Malm,"
Ikea

references

1 Shu-Ye Jiang, Ali Ma, and Srinivasan Ramachandran, "Negative Air Ions and Their Effects on Human Health and Air Quality Improvement," *International Journal of Molecular Sciences* 19, no. 10 (September 28, 2018): 2966, doi: 10.3390/ijms19102966.

2 Shu-Ye Jiang, "Negative Air Ions."

3 Minjeong Kim, Guk Jin Jeong, Ji Yeon Hong, et al., "Negative Air Ions Alleviate Particulate Matter-Induced Inflammation and Oxidative Stress in the Human Keratinocyte Cell Line," *Annals of Dermatology* 33, no. 2 (April 2021): 116–21.

4 Beth Sissons, "Is Saltwater Good for the Skin? What to Know," Medical News Today, May 30, 2022.

5 "Six Benefits of Sea Swimming," CarePlus Pharmacy, January 23, 2020.

6 "Breathing Humid and Salt-Enriched Air Reduces Respiratory Droplet Generation, Study Finds," Science Daily, August 31, 2021.

7 Calvin Holbrook, "The 4 Science-Backed Health Benefits of Living by the Sea," Happiness.com, 2023.

8 Jeanine Barone, "Pink Noise for Sleep," Berkeley Wellness.

9 Shia T. Kent, Leslie A. McClure, William L. Crosson, et al., "Effect of Sunlight Exposure on Cognitive Function among Depressed and Non-depressed Participants: A REGARDS Cross-sectional Study," *Environmental Health* 8 (July 28, 2009).

10 Imke Kirste, Zeina Nicola, Golo Kronenberg, et al., "Is Silence Golden? Effects of Auditory Stimuli and Their Absence on Adult Hippocampal Jeurogenesis," *Brain Structure & Function* 220, no. 2 (March 2015): 1221–28.

11 Marily Oppezzo and Daniel L. Schwartz, "Learning, Memory, and Cognition," *Journal of Experimental Psychology* 40, no. 4 (2014): 1142–52.

12 Ferris Jabr, "Why Walking Helps Us Think," *The New Yorker*, September 3, 2014.

13 M. M. Hansen, R. Jones, and K. Tocchini, "Shinrin-Yoku (Forest Bathing) and Nature Therapy: A State-of-the-Art Review," *International Journal of Environmental Research and Public Health* 14 (2017): 851.

14 Simon Franklin, Michael J. Grey, Nicola Heneghan, et al., "Barefoot vs Common Footwear: A Systematic Review of the Kinematic, Kinetic and Muscle Activity Differences during Walking," *Gait & Posture* 42, no. 3 (2015): 230–39.

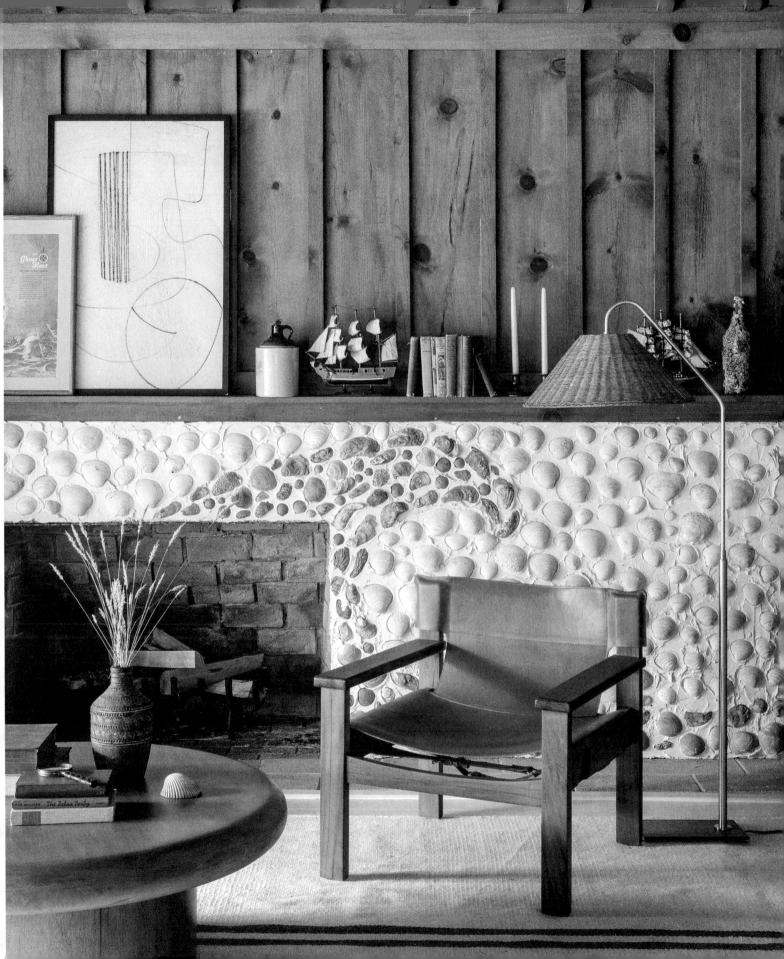

Editor **REBECCA KAPLAN**
Designer **SARAH GIFFORD**
Design Manager **DANIELLE YOUNGSMITH**
Managing Editor **LISA SILVERMAN**
Production Manager **ANET SIRNA-BRUDER**

Library of Congress Control Number: 2023946462

ISBN: 978-1-4197-7186-6
eISBN: 979-8-88707-376-7

Printed and bound in the United States
10 9 8 7 6 5 4 3 2 1

Abrams books are available at special discounts when purchased in quantity for premiums
and promotions as well as fundraising or educational use. Special editions can also be created
to specification. For details, contact specialsales@abramsbooks.com or the address below.

Abrams® is a registered trademark of Harry N. Abrams, Inc.

ABRAMS
The Art of Books

195 Broadway
New York, NY 10007
abramsbooks.com

photography and image credits

HELEN NORMAN Interior photography
and pp. 93, 138–39, 147, 151, 152, 154–55,
181 (top right), 219 (bottom left), 232,
267, 272–73

DANIEL PULLEN pp. 2–3, 35, 42 (bottom
left), 52–53, 57, 219 (bottom right), 279

MARK BUCKLER pp. 6–7, 8–9, 24, 25, 32,
33, 37, 80–81, 162–63, 280–81

LAUREN LIESS pp. 4, 6, 7, 10, 12–19, 22,
23, 35, 42 (top left), 43 (top right), 54,
82, 84–85, 87, 88, 90–91, 92, 97, 103,
115 (right), 118, 121, 122, 124 (top), 125,
127, 129, 130, 133, 135, 137, 140–41, 142,
156–57, 176, 182, 184, 187, 188–89, 191,
214–15, 218 (bottom), 234–35, 243, 261,
262, 276–77, 283

LOST DOG ART & FRAME CO.
(www.ilostmydog.com), p. 21

NATHAN SMITH pp. 30, 31, 38–39, 42
(top right), 43 (top left, bottom right
and left), 48–49, 50–51, 61, 68–69, 71, 72,
78–79, 146, 174–75, 180, 181 (top left and
bottom), 185, 186, 194–95, 216–17, 218
(top), 219 (top), 225, 226, 229, 230–31

DAVID LIESS pp. 40, 45, 87 (bottom left),
89, 92, 120, 123, 126, 131, 143, 179, 265

MIKE O'SHELL PHOTOGRAPHY pp.
46–47, 58–59, 144–45, 148–49, 220–21

"The Lost Colony," design by William
Ludwell Sheppard, engraving by William
James Linton (from *A Popular History of
the United States*, 1876): p. 86

DIANE DIEDERICH p. 125 (bottom)